ALBERT
and the
WHALE

ALBERT
and the
WHALE

*Albrecht Dürer and
How Art Imagines Our World*

Philip Hoare

PEGASUS BOOKS

NEW YORK LONDON

ALBERT AND THE WHALE

Pegasus Books, Ltd.
148 West 37th Street, 13th Floor
New York, NY 10018

ISBN: 978-1-64313-726-1

10 9 8 7 6 5 4 3 2

Printed in the United States of America
Distributed by Simon & Schuster
www.pegasusbooks.com

For Lilian and Freddie

Some years ago, I visited a friend and his monkeys in a converted church on the outskirts of a city in New England. It was February; there was snow on the ground. The address he gave me lay outside the centre, somewhere beyond the historic trail and gracious brick houses. I had to take the subway there, and I came out the way you do, not knowing which way to go.

The street was wind-blown, lined with a few stores and nondescript dwellings that may or may not have housed people. My friend met me at reception and took me up to his office. There was nothing remarkable about it, except that he shared it with primates other than those of our own species.

It was odd to be in a building that smelled so strongly of animals, as if an accountancy firm had installed a stable next to the water cooler. My friend and I chatted—probably about whales, since they had brought us together, out there in the bay. Then he asked if I'd like to meet his colleagues. I thought he was referring to his fellow workers. In fact, he meant the monkeys.

The room in which they were trained was a mock-up home. It contained wheelchairs, the kind their clients might use. There were other items of household furniture. The space was clean and clerical. One of the trainers, a young woman with shiny tied-back hair, produced Felix from a floor-to-ceiling cage.

He came to her confidently, but looked at me warily, the way animals do.

He was a reduced version of me, a human shrunk in the wash, with thin limbs, big eyes and a furry cowl round his head. A capuchin monkey, a little monk. He disrupted everything because I couldn't predict how he would move or what he thought. He was like me, but entirely different. He was eighteen years old, had diabetes, and a prolapsed stomach; he didn't sound as happy as his name. He wore a nappy like an old man. He was himself disabled, and unable to go to a client.

My friend said the monkeys could answer doors, switch on lights, turn the pages of books. They could even put videotapes in recorders; such technology was still in use then, though this was only a few years ago. Felix climbed onto his trainer's shoulders and perched there like a parrot, his long tail dangling down her back. He took the peanut butter and walnuts I offered him from a blue plastic bowl. He ate without any acknowledgement of me. He affected to be looking at something in the distance. Gorillas consider it rude to stare. I felt I was being interviewed for some post I hadn't applied for. He snatched the bowl from my hand. His trainer said the monkeys could recognise a hundred different words, but Felix remained silent. He returned to his cell, and I left the church.

Philip Hoare

The next day, feeling lost in the city and eager to escape my over-heated hotel room, I went to visit a grand building designed to look like a fifteenth-century villa. It might have floated across from Venice, towed by baroque dolphins with twirly tails. Its benefactor had it built to display her art collection, salvaged from the crumbling palaces of Europe. I walked swiftly through the gloomy galleries. It was oppressive, all this brown art, and I felt oppressed.

Leaving the villa, I crossed the road to the modern museum. There were the usual facilities: white rooms, clean toilets, and a drinking fountain. No one would ask what I was doing here. It was OK just to look at things; the labels said so. I stood in another gallery lined with pictures. They had been engraved five hundred years ago, by Albrecht Dürer.

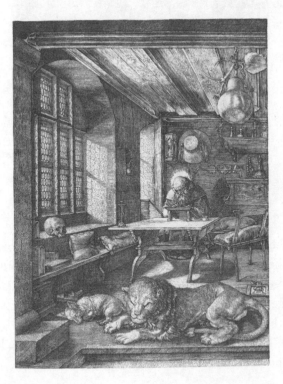

As I moved round the room, the engravings seemed intensely familiar and utterly strange, as though I'd lived with them a long, long time ago. Their stark spaces drew me into a world full of animals. Monkeys and parrots scampered and flew about; a saint sat with his pet lion at his feet, on the floor, having taken a thorn from his paw, and a dog dozed cosily. I heard the rise and fall of their breath. I almost felt it on my face.

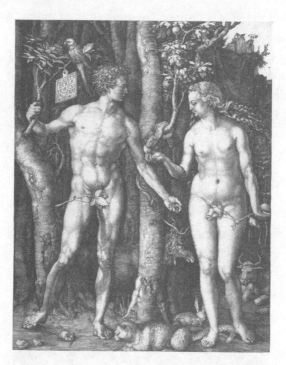

In another scene, from Eden, other animals slipped out of the forest, the humans as naked and content as them, until then. The scene receded, three-dimensionally, in layers. In the distance, a goat teetered on a cliff. Maybe this is where the world began. This new world, with these creatures in it.

Then, in a third picture, I saw an angel. A real one, head on hand. Another sleepy dog dozed at the hem of their robe, a comet

Philip Hoare

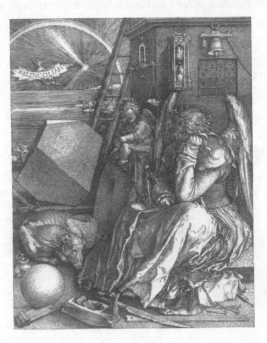

burst over the distant sea. The whole thing seemed to be a dream, seen through a watery screen.

I couldn't work out why I felt so moved by them: these images, so far away from me in time, yet here in front of my face. They came from a different space. Why were they made at all? For love or money? To ease someone's soul?

Outside the museum, next to the roaring road, stood a life-sized sculpture of a rhinoceros. It might have been an abandoned car on a roundabout. It ought to have been the delight of children climbing over it, riding its back or crawling inside. Instead, tethered to this lonely corner, the rhino snorted and stamped, and having decided discretion was the better part of valour, set to cropping the scrappy grass as the traffic raced by.

It was cold and it snowed and I felt like an actor. I'd been away too long and I wanted to go home.

A few days later, after I got back, a package arrived by airmail. Inside was a little canvas, with the imprint of a tiny blue hand.

Philip Hoare

Mercy

All of Europe drains away through this harbour, all that mass surging in and out, day after day. The ferries bounce on the tide, bumping up to rubbery quays like little whales. There it is.

The sea.

Like any sea, this could be anywhere. All ports are always the same. Open to the world and closed off to the land, they are the most vulnerable, most defended places, because this is where all the laws run out. Customs give way, order gives up, history is left behind. They have the same dredged channels, the same ships in search of someone to relieve them of their load; the same liners and their dead-white superstructures, gliding like ghosts in the dark as an innocent swimmer swims past, as other, ramshackle boats set out.

At the end of this quay in Rotterdam is a defiant old building, with a pair of towers and a verdigris dome. It's now a smart hotel, but it was once the headquarters of a company that shipped a million people over the ocean. They didn't do it for free. It was a bureaucratic business, an efficient exchange. If they could get here, then let them come. For a fee.

The posters promised bright new opportunities, pasted on street corners far inland; the company's entwined, flying flags of two countries, the Netherlands and America, said so. They

formed an orderly queue, a continent long: all the men wore the same caps and overcoats, and all the women carried the same bags and the same children. And the same scenes were replayed around the world; the same red-brick buildings, the same official forms, the same standing orders.

Then it all came to a halt, as if someone had objected to the trade.

One night, the centre of this city was destroyed. In an attack lasting fifteen minutes, fifteen hundred bombs fell, a thousand people died, and eighty thousand were made homeless. Two thousand shops, seven hundred warehouses, twenty-four churches and sixty-two schools were reduced to rubble. A port busy exporting people had itself become homeless. In a place already two metres below sea level, all those hopes seemed to be sunk.

Six months later, the same planes, the same pilots peering down from their cockpits, visited the same fate on my home town across the sea.

On 25 November 1940, the government in Berlin issued a press release, published in America next to newspaper articles saying Santa Claus Is On His Way. The communiqué claimed squadrons of 250 planes had dropped 300 tons of high explosive and 12,000 incendiary bombs on Southampton. The trans-Atlantic port, it reported, was left a smoking ruin.

They were trying to destroy the sea.

People crawled into the ground like animals. Those unable to make it to the shelters—some of them medieval crypts—stood in doorways, watching their town fall around them. My mother came home from work to see smoke hanging over her street. She had no idea, till she reached the end, that it wasn't her house which had been hit. I get nearer the past as I inherit those memories. I was born in that port, still pockmarked by bombsites. I grew up with the sound of foghorns and rumbling docks. As a boy, I felt the endness of a place where everything else began. People

were always leaving here to find new identities, as if we who were left behind had none of our own. No port is a home. No one is free.

There's always this sense of rebuilding and making, says Ellen, as we step off the ferry into Rotterdam. She and Edgar are working in a wharfside studio, making deep blue images out of the sea and the sky. Their building, which once housed imported fruit, has a great slit sliced into its floor through which their art works can be shipped out like cargo. Ellen tells me not to swim in the dock below, for fear of things submerged down there.

In the evening we leave the city, passing sprawling refineries as we drive out to Zeeland. The light is clear, unabsorbed. The houses are clamped to the land like limpets, steep-shouldered roofs shelter behind green dykes. Their windows lack curtains; it shows they have nothing to hide, says Ellen. You could see any-body or anything coming or going.

We drive on until the land runs out. I'm not sure human beings should still be here, any more than the cows grazing in the fields. Five hundred years ago Dürer came here, in search of a whale. It was the turning point of his life.

1519 had been a bad year for the artist. His patron, Maximilian, the Holy Roman Emperor, had died, leaving him without a steady income. All that surety, gone.

Dürer is in bad shape, said his friend, Willibald.

He was the most famous artist north of Italy, but Dürer was worried. He was no longer a young man; his body was beginning to fail him. If I lose my sight and dexterity my affairs will not be good, he said.

More than ever, he was ruled over by the melancholy of Saturn, whose influence had always dogged him. All his life he had lived in his imagination. Was it all downhill from now on? He had to take control of the situation. Hearing that Maximilian's heir,

his nineteen-year-old nephew, Charles, was to visit the English king, Henry VIII, Dürer planned to follow and petition for a new pension.

He weighed up his chances. It would have been risky and expensive; he might have been stranded with no one to speak for him. I imagine him landing in Southampton, at low tide, among the warehouses and the mud and the oystercatchers. (The new emperor did come here, on his second trip to England two years later, bringing seven hundred horses with him. Cardinal Wolsey was not best pleased.)

Then it was announced that Charles would be crowned in the Low Countries, so Dürer determined to go there instead. But he had a far more pressing reason to leave Nuremberg. The plague was raging in its narrow streets, and the heat of summer was about to make things worse. The council had declared an emergency administration, and townsfolk feared for their lives. Those who could afford it, like Dürer's wealthy merchant friends, the Imhofs, were fleeing the city. And so, on 12 July 1520, the artist, his wife, Agnes, and their maid, Susanna, set off, travelling west, towards the coast.

We know how it all panned out—this journey through the heart of Europe, by horse and by boat, down rivers, to the sea— because Dürer wrote it all down. His diary of the year-long trip is the most complete record of his daily life we have, and it is the least interesting.

Dürer had always been a journeyman—a journey being a day's work as well as a day's travel—and his journal is filled with expenditure and income, the opposite of his wild imagining. Four centuries later, in 1913, when the Bloomsbury artist and critic Roger Fry edited Dürer's journal, he was surprised to find that the artist's attitude as a traveller was essentially contemporary, as if he had a Baedeker to hand. His daily accounting was a contrast to another journal that Fry cited. It was written only fifty years before Dürer's, but it described another world.

Philip Hoare

In 1465, Baron Leo von Rozmital had set out from Prague via Nuremberg with a retinue of fifty-two horses and forty fellow countrymen; their long Bohemian hair attracted much attention. On his travels the baron met French women with shaved heads, and saw a mother and child fall in the Loire, only to reappear two miles downriver, having travelled underwater by miraculous aid. He described England as a garden enclosed by the sea, said the King of Portugal snorted civet dung to ward off the plague, and passed through an Iberian valley filled with winged dragons. He was Professor Challenger back from the Lost World, watching a pterodactyl fly down Regent Street.

This was nothing like the ordered Europe Dürer knew, a place of taxes and printing presses. Yet none of the baron's stories would have surprised the artist's audience, since Dürer himself had filled their heads with hydra-headed monsters, pig-eyed demons and worm-eaten riders rampaging over a blasted terrain. They were fictions, his creatures of the Apocalypse, chimeras put together from bits of the real world, which he really knew. And even as he drew them, the artist was vanquishing these beasts, sending them into extinction. Before Dürer, dragons existed; after him, they did not. We were left with only the dragons of our unconscious, as Carl Jung would say.

Fry, who'd been reading the works of Jung's rival, Sigmund Freud, put Dürer on the couch. He decided that the artist had been ruined by domesticity. In his rational, psychoanalytical opinion, the German had become irretrievably bourgeois, constrained by marriage and money, which had broken the gaiety and elasticity of his nature. Where von Rozmital told tall tales, the great artist was reduced to boring details, forever reporting how he'd shown his passport from the prince-bishop of Bamberg and they let him go free at the border; adding up exactly how many florins he spent on a bottle of wine or what he paid for his shoes; or exchanging engravings for an Indian cocoanut, a Turkish whip, two parrots in a cage, a fur coat made of

rabbitskin, a piece of red chalk, fir cones, a shawl, and a little ivory skull.

Fry was exasperated. What was his hero doing with so many childish curiosities, all those sugar canes and buffalo horns? And how came it, Fry said, that we hear so little of great Flemish works of art? The way he exchanged his beautiful works for parrots!— Goethe, the great dramatist, would agree—I find a poor fool of an artist like that really touching.

Neither of them realised that all this clutter and accounting was a disguise, a cover for his childlike wonder. He seemed to be concerned with grown-up bills, but Dürer was shoring up his imagination with the glorious thingness of things. He was a little boy sitting on the floor of the museum, drawing a dinosaur.

To Lazarus Ravensburger—a German trader with a raptorish name—Dürer gave a print of St Jerome in his cell, plus three large and expensive books. In return, he received a big fin, five nautilus shells, two dried fishes, a white coral, and a red coral; plus four bamboo arrows, and four silver and five copper medals. It was a good deal, so far as he was concerned. He sent great chests of this stuff back to Nuremberg, but he would only trust a friendly priest with his most treasured acquisitions: a large tortoise-shell, a buckler of fish-skin, a long pipe, a long shield, a shark fin and two little vases with citronate and capers. In an age of extraordinary trade, Dürer was trading in dreams.

I have received 8 fl. in all for 2 prints of Adam and Eve, he noted, 1 Sea-monster, 1 Jerome, 1 Knight, 1 Nemesis, 1 Eustace, 1 whole sheet, further 17 etched pieces, 8 quarter-sheets, 19 woodcuts, 7 of the bad woodcuts, 2 books, and 10 small woodcut Passions.

I bought a pair of socks for 1 stiver.

The artist spent that summer selling and giving away his work, seeking new diversions, new sensations. He was not without honours of his own. He was entertained in princely cities, from

Cologne and Brussels to Antwerp, where the painters' guild stood up on both sides of the table as he was led into dinner. He was their lord for the day; they tried to get him to stay.

Antwerp was the wealthiest trading port in northern Europe, and it was getting ready for the coronation. In a warehouse used to skins or wool, dozens of painters were preparing a triumphal display for the emperor: four hundred arches, forty feet wide, to be set along the street, with plays enacted in them and young women as living statues (albeit not naked, as some suggested).

Dürer watched the procession like a boy at the carnival, holding a stick of paper streamers. The pole-candles and Frankish trumpets passed by, and the Three Holy Kings rode on great camels and on other rare beasts, very well arranged, and at the end came a great Dragon which St Margaret and her maidens led by a girdle. But Dürer was about to witness something even more sensational. Not on parade in the streets, but in the town hall.

I saw the bones of the giant, he marvelled in his journal. His leg above the knee is 5½ ft long and beyond measure heavy and very thick, so with his shoulder blades—a single one is broader than a strong man's back—and his other limbs. The man was 18 ft high, had ruled at Antwerp and done wondrous great feats, as is more fully written about him in an old book, which the Lords of the Town possess.

These relics—a shoulder blade, rib, and some bristly stuff like a broom—were said to have come from a slain giant whose hand had been chucked into the sea, giving the town its name: ant, hand, and werpen, thrown away. In fact, they were the bones of a bowhead, an Arctic whale that may live for three hundred years; rivalled only by the Greenland shark, one of whom born in Dürer's time could still be swimming in the dark green sea today. It was impossible, even for an artist, to imagine such creatures, to conjure up what flesh had clad those bones. And no sooner had he seen these remains than another display came his way.

It was as if the beasts were leading him on. In Brussels town hall he saw a vast monstrosity, which looked as if it were built up of square stones. It was a fathom long, he said, very thick, weighs up to 15 cwt., and it has the form as is here drawn:

His sketch hasn't survived, but in his eyes these bones were almost architecture. This was understandable, since whales had a habit of bedecking buildings with their ribs and their suffering. In the Cathedral of St Stephen in Halberstadt, Saxony, for instance, a vertebra, thought to have belonged to the fish that swallowed Jonah, hung from a pillar as protection against flood; strung around another column was a belemnite, a cylindrical fossil created by a thunderbolt that could ward off an inferno by virtue of being born of fire. Other giant charms bedecked God's houses like hagstones on a fisherman's cottage. In Cracow cathedral, the jawbone of a whale joined the bones of a woolly rhinoceros and a mammoth. In London's Palace of Whitehall, a courtyard was

named Whalebone Court on account of the bones arrayed there. And in Verona, a whale rib swayed from an arch in the street the way a lover might hang over a balcony. The citizens became blasé. In Pieter Saenredam's painting of 1657, another rib dangles from Amsterdam town hall. Merchants sit round chatting, ignoring the judgement over their heads.

Whales became what we wanted them to be. It was what we expected of them: to do their duty by God. Still, they retained their sense of the sensational, even when they'd been boiled down for their oil. Dürer was stirred by such wonders; for an artist they presented a great challenge and allure, since they were so difficult to comprehend. Like God, no one could agree what they really looked like, or what they might be capable of.

Whales bore all this ignorance on their backs, burdened by scholars and artists balanced up there. Dürer knew better. He'd been reading about these creatures since he was a boy, even though his source was as old as a whale or a shark.

The thirteenth-century monk, Albertus Magnus, Albert the Great of Cologne, lived up to his name. Zoologist, astrologer, astronomer, mineralogist, philosopher, and alchemist, he was the first modern writer to describe, with any degree of accuracy, the appearance and behaviour of whales. Albertus's insatiable curiosity and academic achievements earned him the honorific of doctor universalis; his experiments gained him the reputation of a magician. His greatest trick was truly impressive: to receive, in a vision, the plans for Cologne cathedral, though it took six centuries to complete: the crane still stood on its half-built tower when Herman Melville visited it in 1849, inspiring the young American to bemoan, Oh, Time, Strength, Cash, and Patience!

Albertus may have been history even to Dürer, and long dead these many years, but he continued to exert an extraordinary

power. He not only lent Albrecht his name, but he initiated his fellow German into the secrets of the natural world.

Born in Bavaria, near Nuremberg, around 1200, as a youth of manly beauty and robust endurance Albertus had attended the university of Padua where, in a remarkable tutorial, a statue of the Virgin Mary addressed him, telling him to join the Dominicans and study science. Thus he resolved to quit the ocean of the world, so fruitful in shipwreck, and seek refuge in the secure port of the monastic life. Labouring in the darkness and dullness of his intellect, Albertus prayed for the gift of scientific philosophy. As he did so, the Virgin reappeared, flooding his cell with light. She consented graciously to his request, with the proviso that at the end of his life he would return to the condition of an innocent child. Albertus agreed to the contract; although he also believed that a thousand years hence Satan would be loosed on the world.

After teaching in Freiburg, Regensburg and Strasbourg, Albertus arrived in Paris, to become the most prolific author of the Middle Ages. Reviving ancient knowledge from Pliny and Aristotle, he introduced a new sense of investigation to the medieval world. His experiments included dipping a scorpion in olive oil and placing it in a glass container for twenty-one days to discover if this would act as antidote to its venom. It died on the twenty-second day. In another test—as retold by Professor Kenneth F. Kitchell Jr of Massachusetts—the monk placed one spider on a red-hot grill and another in the flame of a candle to investigate the proposition that the animal had a cold complexion like the salamander and was impervious to fire. It was not.

Prof Kitchell noted that while Albertus's conclusions often lacked any scientific value, his methods were of the greatest interest, although they veered into alchemy; al-kimia, from the Arabic, the original chemistry. He even claimed to have witnessed the transmutation of base metal into gold.

While he was away one day, his apprentice, Thomas Aquinas, entered his master's workshop and discovered strange instruments and vessels. Behind a scarlet curtain was a lovely talisman, the figure of a young girl, which addressed him: *Salve, salve, salve*. Imagining her to be a demon, Thomas said, Get behind me, Satan, and smashed the figure to pieces; at which point Albertus appeared, telling him, You have destroyed in an instant the labour of thirty years!

It seems Albertus used mercury and steam to power his medieval robots; they were said to be able to walk and talk. Little wonder his writings would inspire another doctor, Victor Frankenstein, who said they were treasures known to few but himself. (On their way to Switzerland in 1816, John Polidori and Lord Byron stopped in Cologne, where they saw Albertus's manuscripts and a sketch of Christ's head by Dürer. They continued on to Lake Geneva, to meet Mary and Percy Shelley and read some German stories of ghosts that fell into their hands.)

Albertus said friendship was nothing other than the harmony between things divine and human, with goodwill and love. When his beloved Thomas, who was himself said to possess the ability to levitate in a state of ecstasy, suddenly died of a fever, Albertus was hundreds of miles away at the time, at dinner, but he declared, at the table, Thomas, my son in Christ, the bright luminary of the Church, passes at this very moment from the world to his Lord. It was the price he paid for loving too much. Forever afterwards Albertus would sob at the mere mention of his former pupil's name, calling him the flower and splendour of the world. His fellow monks, shocked at such extreme emotion, believed their brother's tears stemmed from a weakness of mind.

And so it was: Albertus's debt to the Virgin was repaid and his earthly faculties were taken away. Probably suffering from dementia, Albertus died on 15 November 1280 and was buried in the Dominican church in Cologne. There, in numerous exhumations, it was discovered that his body remained incorrupt.

Albertus had become his own experiment. In 1482, Pope Sixtus IV ordered that the tomb be reopened. The monk's right arm was detached and sent to the pope; other relics were placed in a glass case to be viewed by the faithful. Even then he was not left in peace. In 1693 another piece of him was harvested, for the bishop of Regensburg, and in 1804, under the fear of an invasion by Napoleon, what remained of Albertus—picked over as if Frankenstein had come in search of parts—was transferred to a new church, to be bombed in the Second World War. It wasn't until the late twentieth century that the monk found eternal rest: in a third-century Roman sarcophagus placed in the church's crypt, a nuclear shelter against future attacks.

By then Albertus's memory had been preserved, not in reliquaries, but by the printing press. In 1932 an elegant typeface was named after him; it was a year after his tardy canonisation by the Vatican. His great work of encyclopaedic brilliance, *De animalibus*, also took a long time to get through the press: written in 1250, but not published until 1478, when Dürer was seven years old.

It was a heady introduction. Recorded in Albertus's compendium were 113 mammals, 114 flying and 140 swimming animals, 61 serpents and 49 worms. Dürer crouched over it in awe, the way I would open my children's encyclopaedia, too scared to touch deep-sea fishes for fear they'd drag me down.

Albertus had moved above and below, backwards and forwards in time, to collect his book. He'd tramped across Europe, from the flat Russian steppes to the high Italian alps—nicknamed Big Boots because he refused to ride a horse—examining everything along the way. Ancient seabeds on mountain tops, errant stars in the sky, squirrels in dark forests. When he came to the northern shores, he was especially interested by marine mammals, being of the sea but also of the air, as he said. In-between, almost human. Some aquatic animals have a great deal of cleverness, he noted, especially those that bear live young and breathe, like the dolphin, the whale, and the one called the koky, which the Latins say is a

sea calf. The hairs on the latter's hide, for instance, will, no matter where the hide is, indicate by their composition and erectness, the ebb and flow of the tide. (I had a sealskin purse from Norway that performed the same trick.)

It was the first time these creatures had been sorted out. Wading in, in his big boots, Albertus separated the baleen from the toothed whales, and reported on recognisable details of killer, sperm and right whales. These facts about the nature of whales have been gleaned from our own experience, he said. He knew they were not wallowing, sea-swallowing monsters, but the prey of humans who lured them with songs and musical instruments and slaughtered them with harpoons infected with the decayed fat of dead whales, so that they would succumb slowly without endangering the lives of their hunters.

Albertus left it to the artists of the future to reveal this information. Sir Isaac Newton is said to have avowed, as Victor Frankenstein noted, that he felt like a child picking up shells beside the great and unexplored ocean of truth. So closely did Dürer's own alchemical search in the ocean of truth follow Albertus that you might think the one the reincarnation of the other, a creature rebuilt from the same parts. In 1500, Dürer's friend Conrad Celtes composed a poem comparing the two. He said God had given them the same powers of observation, and Dürer was the fulfilment of Albertus's assertion: that every aspect of creation participates in the beautiful and the good.

Albertus laid stress on seeing; it was a physical affect. He thought that the sight of some creatures, like the bat, was totally shattered by sunlight, but the vision of others, like human beings, may be briefly directed to the sun. Some, being weak, could do so without their eyes trembling; others, such as the golden eagle, could see the sun in the round. Like an eagle, Albertus saw light itself. His was a new way of seeing—that was his appeal to a radical artist like Dürer—but it depended on divine radiance. You needed faith to know.

It was Albertus's faith in knowledge that Dürer remembered when he set eyes on the giants of Antwerp and Brussels. He would have done well to take Melville's advice: that you can't tell the leviathan's true nature from its bones. What if he saw the animal itself, agonising on some remote shore? Would he have trundled it back to Nuremberg on a juggernaut, the way a tarred whale would tour Europe on the back of a lorry with the artist standing there like a demagogue-showman, speaking on behalf of his charge; or like the whale in Béla Tarr's film *Werckmeister Harmonies* that arrives in a cold-war square and turns the citizens crazy with its dead-or-alive stare?

Then came the news he was expecting. He'd been warned by those bones, like seaweed predicting bad weather. The report is specific; it might have been delivered in Morse code.

At Zierikzee in Zeeland a whale has been stranded by a high tide and a gale of wind. It is much more than 100 fathoms long. No man living in Zeeland has seen one even a third as long as this is. The fish cannot get off the land; the people would gladly see it gone, as they fear the great stink, for it

is so large that they say it could not be cut in pieces and the
blubber boiled down in half a year.

Dürer's heart beat faster. He couldn't afford to miss this beast. It could turn his life around, more surely than any imperial pension. One hundred fathoms, six hundred feet? That was a prodigious measure, by any means. His knowledge of Albertus would have discounted that.

But faith—what of that? Two years later, after a similar stranding on the same shore, Martin Luther declared the leviathan to be a portent from God. Based on ancient examples, he warned, such a sea monster was a certain sign of wrath.

May the Lord have mercy on our souls.

The medieval world knew that the whale showed how deceptive the devil could be, assuming the shape of an island or a tree, or the mouth of hell itself. Dürer ought to have known better than to go fishing for such monsters.

You could smell them a mile away.

SEA

The sea. How little of it he'd seen. There was a certain excitement in his plans, that rising sense of adventure as the line casts off and the boat floats free. What had he let himself in for, untethering from the land?

On St Barbara's Eve, 3 December 1520, Dürer rode north from Antwerp to the seaside town of Bergen-op-Zoom, south of Rotterdam. He'd prepared for his expedition by buying three pairs of shoes, a pair of eyeglasses and an ivory button.

I paid 12 stivers for the horse.

He had left his wife behind, as usual. He liked to go out with the boys.

I have spent 5 white pf. on a bath and for drinking in company.

In Bergen he met my Lords of Nuremberg, Georg Kötzler, Sebastian and Alexander Imhoff— these wealthy refugees from the plague, here for the healthy sea air—along with the Antwerp merchant, Bernhart von Reesen, whom Dürer called little Bernard. He drew another member of the party at sea: Markus Ulstett, a soldier from a good Augsburg family. With his wide open face and his wide open eyes and his three-pointed hat, he looked ready for anything. In the same sketchbook was a rougher, unnamed sailor with straggly hair, stubbly chin, and a furry cap. He looks out to the horizon while Nicholas, saint of Amsterdam

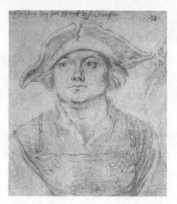

and sailors, blesses them with his clenched hand. His feast day had just passed, when good mariners went to Mass to seek protection from storms.

They set off into a watery world. These flat lands were drowned, never really land in the first place. The town's paths, patterned in herringbone, wound down to the sea; church towers stood like lanterns, sinking in the mud. There was nothing for miles and miles, then something, then nothing again.

We passed by a sunken place, said Dürer, and saw the tops of the roofs standing up out of the water. Zeeland is fine and

wonderful to see because of the water, for it stands higher than the land. The great ships sail about as if on the fields.

They spent their first night at anchor. It was cold and they had no food or drink. Their leader's preparations—the shoes and the glasses—were not as practical as his companions might have liked. They were relieved to sail on the next day, for the island of Walcheren. The sea lay around, bleak, clouds gathering grey.

Suddenly everything's out of control. The ship lurches, the princes panic. In the chaos and confusion, it's the artist who brings them to their senses.

As we were pushing ashore and getting out our rope, a great ship bumped hard against us, and in the crush I had to let every one get out before me, so that only I, Georg Kötzler, two old wives, and the skipper with a small boy were left in the ship. The rope tethering to the land snapped, and in the same moment, a storm of wind arose, which drove our ship back with force.

They're about to be swept away.

It seemed as though we were lost, said Dürer. Then we all called for help, but no one would risk himself, and the wind carried us back out to sea. Thereupon the skipper tore his hair and cried aloud, for all his men had landed and the ship was unmanned. We were in great fear and danger, for the wind was strong and only six persons in the ship.

The artist called on heaven.

(Centuries later his followers, the Nazarenes, will compare this scene to Christ stilling the Sea of Galilee.)

I told the skipper that he should take heart and have hope in God, and that he should consider what was to be done, says the artist.

And what shall we do then? said the captain.

My advice was to hoist the small sail, said Dürer, and turn the boat by that means.

People watched from the shore. They'd already given them up for dead.

Philip Hoare

Together, we managed feebly to get the sail about half-way up. Slowly the ship came about and moved back to land and safety. It took them a day to recover from their terror. In Middelburg, the capital of Zeeland. Dürer's friends win three Indian cocoa-nuts, which they gave to him. They knew he wanted them. He also got a sprouting tulip bulb. But it wasn't a whale.

Early the next morning, they set off again to get a sight of the great fish. He had been seen at Zierikzee. But the storm tide which brought him in took him away again. All that effort and nothing. The men stood down. The monster, too awful to witness, fled of his own accord. Dürer started to feel unwell.

A strange illness overcame me, he said, such as I never heard of from anyone.

And this illness I have still, four months later.

Some would claim his malady was malaria—bad air—as if this were a poisoned place. (It was from Middelburg that the slave ship *Zong* sailed, the same ship Turner would show throwing its living cargo into the sea.) In 1809, the British would attempt to take the island of Walcheren and thereby control Europe. The invasion fleet of six hundred vessels and forty thousand men was the largest ever assembled in Britain. (The commander, Lord Chatham, took his pet turtles with him, and his commodore, Sir Home Popham, was described as a hippopotamus, an amfiberous hanimal, wot cannot live on the land, and wot dies in the water.) But when the troops landed on the island, their officers discovered that the bottoms of the canals were thickly covered with an ooze which, when the tide is out, emitted a most offensive effluvia.

The whole island is so flat and near the sea, said one inspector, that a large proportion was little better than a swamp, and good drinking water could hardly be procured. Even the human inhabitants seemed affected, pale and listless. Four thousand soldiers sank into the arms of death, recalled a survivor, as if they'd drowned in disease. The rest retreated to England, where the

venture would be remembered only by a lonely naval building in Portsmouth harbour named Walcheren, set on Whale Island.

Dürer's own abortive, amphibious expedition would shorten his life, from a condition he couldn't name, because of an animal he didn't see. It was a lesson in too much faith, like the saddest scene in cinema when, in *Whistle Down the Wind*, two young children, a brother and sister, arrive hand-in-hand to see Jesus in a barn, only to be told he has already gone. He's a convict on the run and has been arrested; but they believe he's ascended to heaven.

It was an extraordinary irony. Dürer had fled the plague at home for a healthier place, only to contract an infection from an infested shore. He might have blamed it on the stars. Yet his failure to see the whale had an unexpected effect. It gave him new inspiration, as if he'd breathed in the whale's bad air. His sense of mortality allowed him to see anew, even more clearly, like Albertus. He'd always been restless, unable to stay still; his hand could never stop drawing, as if it were automatic, independent of the rest of him. His trip to the Netherlands was the most important event of his later years, his biographer, Erwin Panofsky, would say.

Far from marking the decline of his talent, Dürer's experiences there would prompt what Panofsky calls further manifestations of his genius. As if he'd signed a contract. And, in fact, he did draw a sea monster. As to where he saw it or if he saw it at all, I can't tell you, despite having swum through libraries and sailed through oceans.

But I am in earnest, and I will try.

The sub-sub-librarian shuffles out of the archives and dusts down his book, with its tales of ancient whales. Ohthere, a Norse trader, told Alfred the Great about the horse-whales. He reported that these strange beasts had bones of very great value for their teeth, some of which he brought to show the king. This animal went by many other names, murmurs of otherness. In German, Rusor

Philip Hoare

or Rostiger, the Russian whale; in Dutch, Rosmarus, sea horse. The English preferred the Scandinavian walrusch and Old Norse hvalross, hairy whale or whale-horse. The Russian or Lapp morsz was more to the point, meaning biting thing to beware. In 1456, William Caxton recorded one in the Thames: This yere were taken iiij grete fishes bitwene Eerethe and London, that one was called mors marine, the second a swerd fisshe, and the othir twenyne were wales.

Monarchs in their riverside palaces would do well to tremble at such monsters; Caxton warned of warre and trouble soon to ensue. In 1590, after Martin Frobisher returned from the Arctic with a unicorn horn for his monarch—along with three Inuit, a man, a woman and a child, all of whom soon died—Edmund Spenser published his Faerie Queene, stocking his epic poem with sea-shouldering Whales and Mighty Monoceros with immeasured tayles, and greedy Rosmarines with Visages deform.

They might have been the eyes and ears embroidered on the Virgin Queen's gown; a strange fraternity, as the modernist poet Marianne Moore would write in 1924, seeing sea lions and land lions, land unicorns and sea unicorns as interchangeable shapes, growing stranger as we looked on. Natural history had little bearing on these visions. Art and poetry stood a better chance. Like their narwhalian peers, walrus tusks deceived; they led Albertus to believe walruses were male whales, using their teeth to hang from the rocks as they slept; just one of the mysteries repeated in Olaus Magnus's later *History of the Northern Peoples*, with its starfishes with faces, walruses as giant boars, and sea serpents snatching sailors from their ships, in the storyboard for a Renaissance horror film.

Albertus had only ever seen bits of these creatures: tusks carved into sacred and profane objects, hides made into ropes to be sold in Cologne's market and used for raising huge weights on ships' pulleys. One account claimed that to catch a walrus, a hole would be made in the hide near the tail; this was then secured and as the animal scared off, it unpeeled itself. Yet out of all this cruelty and fantasy, the walrus performed a most spectacular trick: to rear up out of Dürer's sketchbook.

This local animal, whose head I sketched here, was caught in the Netherlandish sea. It measured XII Brabant ells long with four feet.

| PLATE I |

Where and when did he draw it? I'd dearly love to say. The past tense suggests Dürer added his caption later, just to confuse things; as if his text were more poetry than explanation. Some believe that he made the drawing after an earlier sketch; that this is a trace of a copy of a memory. His reference to the Netherlandish sea may equally apply to the northern sea of the Arctic. Whatever the truth, it is clear the artist never encountered a living walrus. Rather, he witnessed a miraculous showing, a kind of offering.

In 1519, as Dürer was considering his travel plans, Pope Leo X received an unusual gift. It was sent from Norway by his archbishop, Erik Walkendorf, who was keen to claim Greenland in his see, along with a lucrative Arctic trade in skins, furs and ivory. The bishop's tribute—a walrus, no less—was intended to impress the pope with the surprising riches of this barren place, which was full of surprising things. In his letter, Walkendorf describes the dreadful animal, commonly called a Rosmer, that measured up to thirteen ells long. It was an angler's exaggeration—an ell is the length of a human arm, making Walkendorf's beast the size of a mammoth.

But you could hardly blame the bishop for getting excited.

Philip Hoare

The Arctic was brimming with wilful creatures, best kept at a cro-
zier's length. Travelling in his icy diocese, Walkendorf claimed
he avoided whales and krakens only through the intercession of
Olaf, his country's patron saint. As to what else he'd seen in that
watery wilderness, he preferred not to speak, for fear of offend-
ing the Holy Father. After all, these were places where the Word
of God had yet to be heard.

Leo's present was sent to Rome: not a whole animal, but the
head of a walrus, salted in a barrel like a dead admiral. This trophy
was then toured round Europe; at Christmas 1519 it arrived in
Strasbourg town hall, accompanied by German doggerel pasted
on the wall like a gloomy carol.

> In Norway they call me walrus,
> But I am cetus dentatus.
> My wife is called Balaena.
> I am well known in the Eastern Sea.
>
> Had I lived my life to the full
> I would not have devoted it to whales.
> The bishop of Nidrosia had me stabbed on the shore
> The Pope Leo had my head sent
> To Rome where many men saw me.

The regrets of the walrus, the sorrows of the whale. There's no
mention of the walrus in Dürer's diary. Did he see this relic in
Strasbourg? His walrus appears alive, but the head wobbles from
side to side, with a woozy droog stare. He couldn't find the words
for the animal, because he saw the light extinguished in her eyes.
He did something no pope, no matter how infallible, could do. He
became the walrus: the piton tusks, the flaring nostrils, the pitiful
bristles and brows, the way that Melville would invent Nantucket,
an island he had never seen, with its sleepy sailors dreaming of
whales and walruses swimming beneath their pillows.

From the depths of a storeroom smelling of formaldehyde, I'm handed a hefty skull, dense as marble, a fossil cyclops. I hold it to my head, suddenly able to speak in its owner's voice.

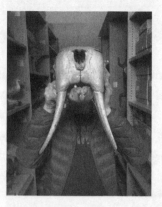

Dürer was fond of his walrus: he reused her in a design for an altarpiece in which Margaret, the virgin martyr, who was eaten by a dragon, only to burst reborn from its belly like Jonah, held her symbolic beast on a leash. But this domesticated morse was only a remorseful ghost.

Philip Hoare

We cannot capture living, quivering creatures, their flesh and bone, tusks and fur, instincts and apprehensions. Yet Dürer got close, even when he didn't see the real thing. In the most famous image he ever created, he drew another fabled animal. And like the walrus, this one was beyond any ordinary expectation.

To the Renaissance the rhinoceros was a legend, a classical creature, a myth. Pliny had considered it the natural enemy of the elephant, which prepared for battle by sharpening its horn on rocks; its skin was the colour of boxwood, he said. Albertus equated it with the unicorn, as if all one-horned creatures must perforce be related. They were all waiting for the real thing to appear.

He arrived on 20 May 1515, the day before Dürer's birthday, a surprise present. A young single-horned bull rhino, from India; known as a ganda in his homeland, he became Ganda to the foreigners. Like the walrus, he was a diplomatic stratagem, given by the sultan of Cambaia to the Portuguese ambassador, along with an ivory chair. In return, the ambassador offered silver pieces, Persian brocades and a dagger studded with rubies and pearls. None of these trinkets could rival this living tribute. An eyewitness described a sweet animal: low body, a little long; the leather, the feet and the elephant's feet; the head as long as that of a pig; the eyes close to the muzzle; and on the nose has a thick and short horn, sharp at the time. Eats grass, straw and boiled rice.

The diplomat had no idea how to deal with such an envoy; he was more interested in women and opium. So he sent Ganda on his way, accompanied by an unnamed attendant, as a gift to his king, Manuel I. It was a long haul. The ship, a caravel named *Our Lady of Mercy*, called at Mozambique, St Helena and the Azores, where he was allowed ashore for exercise and fresh food. One hundred and twenty days later he landed in Lisbon, where his arrival would be commemorated with a carving on a waterside

tower, his horned face looking sadly across the sea. The city was now the great entry point for western Europe; one in ten of its population was African, and as in any considerable seaport nigh the docks, the streets were filled with people from foreign parts. The king's palace was full of gazelles, antelopes, monkeys and parrots. Nuremberg had its agents there, too, and when Dürer received intelligence of the rhino, it came as a fantastical report, like the one he had of the whale.

Ganda was duly installed in an outbuilding of the Palace of Ribeira, kept apart from the rival court of Indian elephants in the neighbouring Palace of Estaus. On the Feast of the Holy Trinity, the king and queen gathered on a patio which had been enclosed by a wooden fence to create a temporary coliseum. Ganda was hidden under some carpets so as not to scare his opponent before the battle began. A young elephant was led in, but as soon as he saw his opponent, he fled in panic and, forcing his way through a lattice window, ran back to his quarters. Ganda the gladiator remained in the arena, unvanquished and clearly untameable. Manuel had no idea what to do with him either, so like an unwanted Christmas gift, he decided to pass him on to Leo x, who—as we know—had a penchant for the exotic and the bizarre. Indeed, the pope had already received a white elephant from the Portuguese king the year before. The animal, named Hanno by its humans, died after being given a gold-enriched laxative to cure his constipation. Leo mourned his loss and commissioned Raphael to commemorate the beast in a fresco, then laid Hanno to rest beneath the Vatican, and composed an epitaph in his honour, speaking in his voice.

And in my brutish breast they perceived human feelings.

Leo and his beasts and his boys, a queer sort of a circus. The pope—whose own name was megafaunal and who, as a Medici, was famous for saying, God has given us the papacy, let us enjoy it—was eager to greet his new pet. Ganda, wearing his harness of green-velvet-covered iron decorated in gilt roses and carnations

Philip Hoare

like some sacred cow, was chained to a ship bound for Rome. There was a stopover on an island in the Bay of Marseilles, where he received another royal deputation: the French king, Francis I, rival to Charles V, keen to be seen with this wonderful beast called a rhynoceron. It must have been mighty wearying, entertaining all these monarchs for a handful of hay. They couldn't even get his name right. Ganda continued on his way.

On 25 January 1516, in the Gulf of La Spezia, where Percy Shelley would drown, the ship sank, all but under the weight of its cargo. Some said the rhino flew into a rage and caused the vessel to capsize. Others that he tried to swim for the shore. Shackled on deck like a slave, he went down before Dürer could see him. All the artist had to rely on was a merchant's letter from Lisbon. The beast was well-armed and very frolicsome and nimble, it said. I have had to sketch it and send it to you for wonder's sake. It was slender evidence for an immortal image. Yet what Dürer drew was more rhinoceros than the rhinoceros. Armed with stories from Aristotle and Albertus, the artist set out his own account. It ran across the sheet, in his elegant, spidery, boyish hand. On the 1st of May in the year 1513 AD, the powerful King of Portugal, Manuel of Lisbon, brought such a living animal from India, called the rhinoceros.

| Plate I |

This is an accurate representation (he lied). It is the colour of a speckled tortoise, and almost entirely covered with thick scales. It is the size of an elephant but has shorter legs and is almost invulnerable. It has a strong pointed horn on the tip of its nose, which it sharpens on stones. It is the mortal enemy of the elephant. The elephant is afraid of the rhinoceros, for, when they meet, the rhinoceros charges with its head between its front legs and rips open the elephant's stomach, against which the elephant is unable to defend itself. The rhinoceros is so well-armed that the elephant cannot harm it. It is said that the rhinoceros is fast, impetuous and cunning.

A horn honed on stones, speckled hide in shades of grey. In Dürer's divine harmony, animals took on an emblematical role. He saw them the way a monk read the scriptures, or an astronomer peered into the sky. His rhino is interplanetary, pitted with lunar craters; erupting with coral reefs; jewel-laden as any tortoise, carved as any Venetian grotto chair. And as Dürer cut him into wood, Ganda became even more crenellated and encrusted, the way little oysters grow on bigger ones. In his days at sea, Ganda had acquired new markings, a kind of fungus, the way algae appears on the backs of whales and seals.

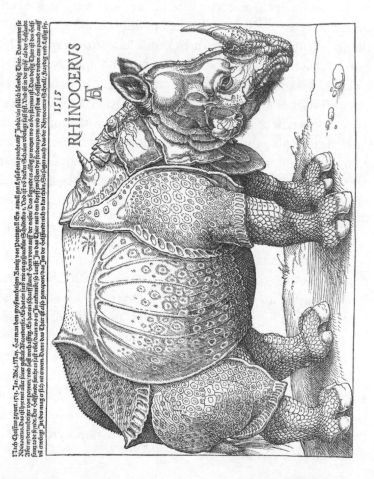

Dürer conflated all animals in one. He added a second spike to the chine of the rhino, not a horn at all but the helical tusk of a narwhal, as if this beast had a real unicorn within him and was only waiting to cast off that onerous, clunky hide. Whales, walruses, mammoths, rhinos: a strange fraternity, lingering after-images in our heads. The dark brilliance of this print, which explains its place in the pantheon of animals as imagined by us, comes down to its triumphal full stop: that spiral on Ganda's dorsal ridge, pointing to his noble name.

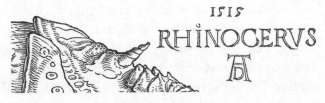

More hardware than flesh and fused hair, plated and riveted, beaten from ploughshares, surfing a battlefield as a land-ship; all gold-dusty with the stars, carved as a giant ivory netsuke at the end of a silken cord. Butt-headed, too big for his boots. A dinoceros. Enigmatic, keratinous, magnetic, all leathery in the sun, he drew loose metal to himself as he squeaked along; this part-animal, part-machine, drawn by Albrecht the great. That same year Francis I commissioned Leonardo, who'd already designed an automaton in armour, to make him a mechanical lion to present to Leo; a robo-leo who walked a few steps then opened his breast to produce a bouquet of lilies. Not to be outdone, Alessandro, a Medici duke of African descent, had Dürer's rhino engraved on his breastplate, branding himself with its heft and heave. Meanwhile, Dürer added sea unicorns to the armour he designed for Maximilian, since their horns were known for their ability to pierce metal, and thus articulated, the emperor became a rhino-lobster, ready to face the last battle.

Ganda exhibited greater grace than all this swagger. He bore his beauty patiently. It's not surprising he sank. He was weighed down

by the disservice we had shown him. He should have been left to sway slowly to the deep, along with the offspring of the enslaved and drowned. Instead, he was washed ashore near Villefranche, where, according to some accounts, he was stuffed and sent on his way to Rome. Others claimed he wasn't even on the boat, and was seen years later in Portugal, a displaced person trying to find their way home.

As Dürer's woodcut went through eight editions—seven subsequent to the artist's demise—his rhino was turned round and around: spouting water from a Palermo fountain, a mural in a sixteenth-century Colombian villa, remodelled from baroque corals in Bavaria, remade in eighteenth-century Dresden china, and recast in brass over an ormolu clock in the Winter Palace, waiting for the soviet to arrive. Strangest of all, Blake spun the rhino into a walrus into an elephant, as Behemoth battled Leviathan in fearful symmetry.

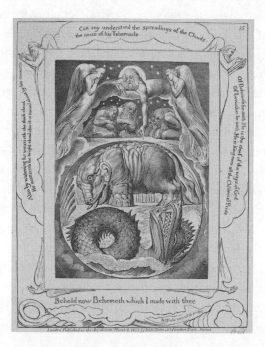

Philip Hoare

What if the whale had become a Dürer, alerting us to his plight? Would he have been the saving of his species, or just another victim, the way Warhol screen-printed a day-glo rhino ready for the dance-floor at Studio 54? Ganda clings magnetically to fridge doors, is printed on my T-shirt, decorates the label of a bottle of wine I just drank. We advertise our ignorance, it's not Dürer's fault. Something so fantastic could not survive being seen. The rhino and the walrus stare back at the people crawling around. All that pushing and shoving. As I write, the last rhino of his kind dies in a compound, becoming a myth of his own.

GENIUS

Dürer was broke when he got home. He'd been away for a year and three days. He'd lost money, giving so many prints away. He had to borrow a hundred florins to pay the apothecary and the blood-letter, but he had secured his pension and was assured of his fame. It was summer, 1521. He was fifty years old.

Albrecht Dürer, the son of Albrecht Dürer and his wife, Barbara, was born in Nuremberg on 21 May 1471, the third of eighteen children, of whom only four would survive to adulthood. His father was Hungarian; the original family name, Türer, came from their village, Ajtas, connected with the word meaning door. As a young man, he too had travelled to the Netherlands to learn from its great painters. Back in Nuremberg, he became goldsmith to the emperor, Frederick III, but he remained an artisan, always aware of his status. A migrant. They lived in the shadow of the castle on the hill.

Wolves prowled the city walls. Skeletons of executed robbers hung in bony avenues to discourage other offenders. The same roads brought rats carrying fleas bearing the plague. In the forests, darkness held sway. But the first factories also appeared, mills on the river that ran through the city. Life lay in layers: princes, merchants, artisans. The peasants danced like bears.

Philip Hoare

Nuremberg was both isolated and connected, an inland port. Before the discovery of the ocean passage to India—my 1933 *British Encyclopedia* tells me—it was the great mart of the produce of the East coming from Italy and going to the North. An independent city at the heart of Europe, a centre from which the imperial crown jewels extended their rays. Columbus's and Cortés's accounts of America were published here; with its printing presses, scientific instruments and financiers, the city took in the rest of the world. From its narrow streets, over its rooftops and spires, it gave Dürer a global view.

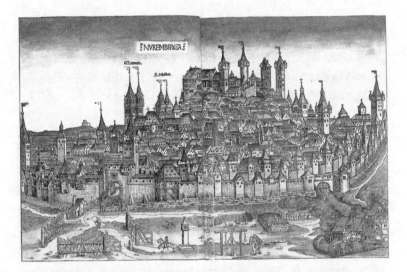

As he ran down to school, all those towers must have terrified him. One day he'd own one of those houses on the hill. Apprenticed to his father, his life was mapped out for him. But at the age of thirteen, after four years' study, and already able to draw with preternatural facility, he joined the studio of the city's most celebrated artist, Michael Wolgemut. For three years he learned the art of printing and getting to know the right people. One of his future patrons, Jakob Fugger, is still one of the richest men who ever lived. Albrecht's closest friend was Willibald Pirckheimer, from

another wealthy family; the Dürers lived in a house tucked into the Pirckheimers' courtyard. Willibald, educated in Italy, was obese, with a broken nose. He introduced Dürer to a classical world.

In 1490, Albrecht followed in his father's footsteps, leaving home to learn from other masters. We can see where he went in his art, in the traces of Netherlandish painters: Jan van Eyck, Rogier van der Weyden, Dieric Bouts and Hugo van der Goes; art in a cold climate. They mixed flax oil with their pigments, unlike the Italians, whose warm weather didn't produce such a medium. People thought it was alchemical, this mixture. Its cool sheen held the pale northern light.

Panels unfolded to reveal bodies in pain and angels tumbling like ravens; everything was illuminated, with nothing to hide: windows open to heaven, revolutionary in their restraint and glory, their skin and bone. Dürer absorbed them into his own visions of the dark, the beautiful, and the strange.

After working in Basel and Strasbourg, painting and printing, Dürer returned to Nuremberg in 1494. His father had arranged for his son to be married to Agnes Frey, daughter of a Medici agent. The dowry was significant; it doesn't appear to have been a passionate match. Love was different then. A month after the wedding, Dürer left for Italy to escape a new wave of the plague which took nine thousand lives in Nuremberg. Away from death, in Venice, his life was transformed by Mantegna, Bellini, Raphael and Leonardo. Back in Nuremberg in 1495, he set up his own studio, bringing the south to the north.

When it happened, it happened quickly, almost without his knowing it. In 1498 his woodcuts of the Apocalypse were greeted with astonishment and success. They sold in their thousands. He drew himself again and again, to satisfy his own curiosity, and, far from perceiving earthly disaster, believed in a golden age yet to come. Ah! how often in my sleep do I behold great works of art and beautiful things, he said, the like whereof never appear to me awake, but so soon as I awake even the remembrance of them leaveth me.

Only another artist would understand. Blake, speaking for Dürer at another century's turn, said, Ages are all Equal. But Genius is Always Above the Age. Dürer had that same naïve arrogance, that self-belief. He painted pictures, designed jewellery, planned cities, composed music. He even wrote poetry—so badly friends begged him to stick to art. His studio collective produced goldcraft, stained glass, prints and books: he was the first artist to publish himself; no one else could do it better. Devising theories of art and mathematics, he was his own renaissance, a gesamtskunstwerk. Like the Bauhaus—itself modelled on a medieval guild—his aesthetic embraced everything. He even designed his own letters, an invocation more lyrical than any bad verse.

Now let the arc of a circle, applied to the top inside edge of the heavier limb, project outside the square. Then cut off the top of the letter with a serpentine curve. . . Do this with the curve of a circle whose radius is one-seventh the side of the square.

Jn difer fchrift macht man die verfal in gleycher maß vnd geftalt / aber eyns dritteyls groffer dañ die gemeyn zeyl der fchrpft.

Squaring the width of a circle, his art was built to last. Dürer's oneness was so compulsive that four hundred years later John Ruskin, the artist and critic, would become obsessed by him. Where the medieval artist had his visions of the Apocalypse and the factories of Nuremberg, the Victorian Ruskin had his storm cloud of the nineteenth century, sweeping up from Manchester and Bradford (while in his public lectures he showed giant images of flowers and flapped his cape like a bird).

Ruskin declared Dürer the modestest German he knew, called him Albert, and marked his death date as surely as any saint's day. (One year it coincided with the development of submarine telegraph lines when, as Ruskin noted, a copper wire ran all the way to Bombay.) Ruskin's own microcosmic watercolours of lichens and bits of brick like asteroids hurtling through space were an echo of Dürer's futurity. He told the class at his Working Men's College that he intended to make Dürers of them all. To fill us with despair of colour, said a student, he bought a case of West Indian birds unstuffed, as the collector had stored them, all rubies and emeralds. Then he produced a splendid Albert Dürer woodcut.

Dürer was a spirit of manufacture; a man of the people, Ruskin declared, wielding his engraving tool like a knight's lance. But what beauty is, said the modest German, that I do not know.

It was a question of faith. Dürer's belief was shaken by false relics, Ruskin's by fossils disproving Genesis; both still held to the natural history of saints. St Francis, St George, Sts Anthony and Paul, Sts John the Baptist and Onuphrius; Sts Stephen, Sixtus and Lawrence, Sts Nicholas, Ulrich and Erasmus; a litany now observed only in candlelit rites in a darkened church. Once, their attributes were everything: St Sebastian's arrows protected against the plague, St Margaret's dragon saved women from the dangers of childbirth, St Christopher had a dog's head. We have no time for that now. We feel more for Dürer's beasts. Saints clamour for our adoration; animals couldn't care less; they seem saintly to

us because of what we have done to them. The story of Eustace, patron saint of hunters, dogs and anyone in adversity, was a good commercial subject for Dürer. Everyone loves animals, after all. Especially when they turn out to be God.

Eustace is out hunting with his dogs. Suddenly he gets off his horse and falls to his knees, throwing open his arms at the vision before him. A stag strolls out of the woods. There's a crucifix

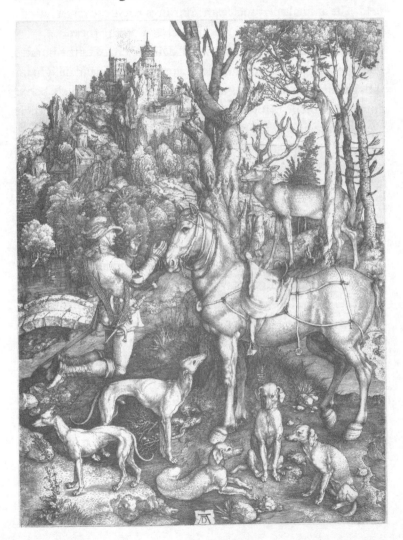

growing from his head. It pushes through the fur. He is his own altar. He addresses Eustace in the voice of Christ,

Why do you pursue me?

This antlered angel—you can almost see his lips move—became the emblem of Eustace, although it's unlikely the saint ever existed. That's why he floats in mid-air. His steed looks more real, standing the way horses do, stock-still in the middle of a field. The animals play their part. Starlings circle the tower, swans glide on the river, the deer's hooves clatter on the rocks.

Dürer depicts another reality: the delicate chain of the horse's rein, the gnarled roots of the tree; a world a child would delight in, the creatures his father engraved, the stories in Albertus's book, animals as dispensations of grace. We can't see through their eyes. We are unable to compare their world to ours.

When Erwin Panofsky was writing his book on Dürer in nineteen-forties America, he compared the artist's landscapes to aerial photographs. He was thinking of the aircraft flying over the country he had left behind, not least because he had prepared maps of his homeland and lists of its cultural monuments for the US Army, not knowing if they would survive the onslaught.

Born in Hanover in 1892, Panofsky had studied in Berlin. In 1916 he married Dorothea Mosse—known as Dora, also an art historian. Her shirt and tie and severe haircut had the air of the Bauhaus; he wore a long moustache in the style of Nietzsche. Like Ruskin, he was passionate about Dürer. He taught art history in Hamburg, but was forced to quit when anti-Jewish laws were introduced in 1933. Even in our university, he reported, they had some trouble with those tendencies, not only among the students but also among the professors.

Seeking refuge in America, Panofsky gave talks in New York, but felt he was performing for chinchilla ladies who arrived in their twelve-cylinder Cadillacs and seasoned Rolls-Royces. He was relieved to be given a post at Princeton, a kind of utopia to him, its leafy streets and large houses reminiscent of the old

Europe he had known; he taught alongside fellow exiles, Thomas Mann and Albert Einstein. His son Wolfgang recalled driving his father and Einstein round while they discussed whether there was any correspondence between ancient mysticism and modern science. Panofsky was a sceptical man, but he wept openly at the ceremony when he became an American citizen. He also lent his big black poodle to a sergeant to guard a military objective; the dog attacked all comers on sight. All the while, Panofsky was continuing to write, defiantly, his life of Dürer. But by the time his book was published, in 1943, it was already an epitaph.

In his preface, he warned readers that the quality of his illustrations was severely compromised because the war had forced him to work from unsatisfactory photographs. They bore witness to disaster from a distance. In a new edition in 1948, Panofsky would note that the losses caused by the war were still unknown, although he indicated their scale by itemising sixty-four drawings lost when the Landesbibliothek was destroyed in Dresden's apocalypse. They stood for fifty thousand people who were incinerated, leaving fields of rubble with wooden crosses over mass graves.

According to his colleagues, Panofsky had an almost puritanical insistence on integrity and truthfulness. He could be temperamental, with a quick wit and a sharp tongue, they said, and appeared unmoved by natural phenomena. Once, walking home on a clear Princeton night, when a friend remarked, Looking at the stars, I feel my own futility, Panofsky replied. All I feel is the futility of the stars.

Perhaps he didn't want to give himself away. He heard words and entire sentences in his dreams and had what he called visions in a half-waking state. In one he saw a hermit outside his cave, beating his breast with a stone, while out of the mouth of the cave came a scroll inscribed, Long distance for you, Sir. At a cocktail party, Dora was told off for talking about concentration camps. Their hostess ushered them away, saying, Out you go! I will not allow you revengeful Jews to spoil a perfectly decent party.

In 1943, as his father published his book on Dürer, Wolfgang Panofsky was recruited to the Manhattan Project by Robert Oppenheimer, who was impressed by the young man's research on the shockwaves of supersonic bullets.

Two years later, at 5.29 a.m. on 16 July, Atom Year One, Wolfgang watched from a Boeing 29 as the bomb, its plutonium core created from uranium stolen from the Belgian Congo, was detonated in the New Mexican desert. Oppenheimer, who sat reading Baudelaire with his big wide eyes in his smart tailored suit as he waited for his work to turn night into day, had a code name for the exercise: the Trinity Test, inspired by John Donne:

Batter my heart, three person'd God.

It was a test of faith. Wolfgang's attempt to measure the explosion was defeated by bad weather and he had to resort to art. All we were able to do, he said, was to make sketches of the mushroom cloud. And immediately after that he fell asleep. He had no time to be scared, said his father.

Five hundred years earlier, on the night of 8 June, after Pentecost—when tongues of fire had descended on Christ's apostles in a darkened room—Dürer woke from a dream in which he saw great deluges fall from the sky.

Philip Hoare

The first hit the ground about four miles from me with frightening force and terrifying noise and it broke up and swallowed up the whole country. At this I was so frightened that I woke up before the others reached the ground.

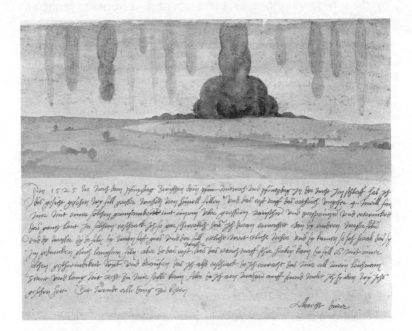

It fell with such swiftness, wind and roaring, that I was so frightened when I awoke that my whole body trembled and for a long while I could not come to myself. So when I arose in the morning I painted above here as I had seen it. God turn all things to the best.

As the whirlpools hit the earth, they made a vast column against the sky. The nightmare seemed to continue even when he was conscious. He fixed the scene in watercolour, its own element. The low country opens onto a broad bay on whose shores stands a town. The air is as electric as the moments before a storm, when a weird light saturates colours and the sky seems to fall down. Dürer might blame it all on his fever. But in the

distance a monstrous black mass bursts in the air, as if something gigantic had dropped into the sea.

The quick and the dead. Dürer's dream came in the wake of rumours of a new Flood so definite that people reserved lodgings on the top floors of houses and seats of government planned to evacuate to the mountains. The sense of an ending: the tempest witnessed by Turner as he was tied to a mast; the black cloud the ancient mariner saw massing on a rotting sea; the torrents shooting from the sky in Wordsworth's prelude; Wolfgang Panofsky in a plane over the desert while a hooded figure stumbles down a scree; Leonardo's last drawings of deluges felling humans and trees, obsessively rendered in black, billowing chalk.

Once, out on the moor with my brother-in-law in rain so hard it hurt our eyes, we watched as the water washed *up the hill* ahead of us. The sea was only a line on the distant horizon, but the tide was coming in. Down in the valley, the river raced under the bridge, spreading beyond its bounds, reclaiming the wonder world. And even as I got in it, I knew that anything could float past: dogs or trees or cars or sheep or angels with broken wings, all washed downriver as if works were under way to widen the waterway, directed by a dirty brown god.

On 17 October 1913, as the train he was travelling on from Zurich to Schaffhausen entered a mountain tunnel, Carl Jung was plunged into a waking dream which lasted for two hours. In it all Europe was flooded, he said; the inundation covered the northern and low-lying lands between the North Sea and the Alps, and reached from England up to Russia. I saw yellow waves, swimming rubble, and the death of countless thousands.

Over the next few months, the dream occurred again and again, each time more violent than before: a sea of blood over the northern lands, the slaying of Siegfried, his soul coming up from the depths, himself in a remote English land, trying to get home by

fast ship; the descent of the icy cold, a blood-red glow out of his window like the flicker of the sea seen from afar. Now lecturing in Scotland, Jung sailed back that summer as war broke out. He reached the coast of the Netherlands with relief, not least because he knew he wasn't going mad.

Jung, who disagreed with Freud on the meaning of dreams, thought he knew the German character deeply; he believed his father to have been the bastard son of Goethe. At the heart of Jung's investigations was his *Red Book*, a journal illuminated like a medieval manuscript, filled with his paintings of strange archetypes that haunted him. We contain nature, and are part of it, he said; animals are not only in textbooks, but living things with which we are in contact. He drew whales beneath the sea, knowing all our dreams lay down there.

There was no reason to dismiss things just because science had yet to explain them, he said. If we possess the image of a thing, we possess half the thing. He saw himself as a dog, and did not know if he believed in God. If I know a thing, then I don't need to believe it, he said in a nineteen-fifties television interview conducted in his villa on the shores of Lake Zurich. He even seemed to suggest that it was the dreamer who lived in reality, rather than the other way round. In one particularly precise nightmare, he dreamt he was in a southern town when an old Austrian customs guard passed by, lost in thought. That is someone who cannot die, he was told. He died already 30–40 years ago, but has not yet managed to decompose. Then a striking figure came, a knight of powerful build, clad in yellowish armour. He looks solid and inscrutable and nothing impresses him. He has continued to exist from the 12th century and daily between 12 and 1 o'clock he takes the same route.

It was an image direct from Dürer. No one marvels at these apparitions, said Jung, but I was extremely surprised. Dürer said his mind was full of inward figures. He was leaping through the forest, antlers falling to the ground and growing again; mercurial

as a lion, as alchemical as a raven, a sea-deer crowned with corals and conches, an attribute of his own.

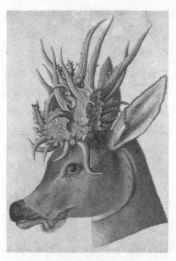

Cycling out of the woods and onto the heath, Peter and I stop by a mound at the top of the hill. It bears signs of Victorian excavation. A circle of holly trees guards whatever still lies beneath. The largest tree is bound with ivy like sinews, its base skirted with moss and sprouts of its own tiny leaves. If I was alone, I'd kneel down and look for faeries. (He that lay in a golden urn, eminently above the earth, said Thomas Browne, was not like to find the quiet of his bones.)

The heath is deserted. A straight road runs across it, but cars are few and far between; they only make the place more lonely. Peter kicks about in the dirt. Often flints emerge from such sites, he says, along with bits of human bone.

I look closely at the trees and realise they're gouged with regular marks, deep and wide. Some have healed over the years, others might have been made last night. They're all of a height, above my shoulders. It's only because Peter pointed out similar signs on our other rides that I know who left them.

Philip Hoare

This is a gathering place. They come here at dusk or in the dawn, pacing over the heath to conduct their ritual: bending heads, snuffling snouts, rubbing their crests on hard-soft wood. They've been doing this for generations. The trees are a century old at least, roots reaching down into the southern soil.

Fraying velvet, glove-thin suede, supple with blood vessels and nerves; a layer of luxury laid over fast-growing bone. Hot breath, the smell of each other, their togetherness, their glassy eyes. Bucks leave wounds which heal like wombs.

The prickly leaves, the antlers' tines; the grey bark, the grey velvet, the green moss; the bone beneath the skin and the bone beneath the soil, one for the other, deer to trees to leaves to horns. These marks mean something more than an itch; they're culture, the way elephants trace shapes in the sand. Scrimshawed, hiero-glyphic, carved like lovers' names by makers coming back again and again to this plain, to its evergreen trees and its empty mound. Everything returning to the ground. If I lay here long enough, my bones would soon root and rot.

Dürer's trees entwine wherever they root, turning into animals and people. For Willibald he even turned a deer into a chandelier. It was another trick. Such Lüsterweibchen were not uncommon, but I can't help thinking their spikes and the bare-breasted siren are a play on Pirckheimer's name and lustful nature. Animals become furniture, like wood: Willibald drank from a cup in the shape of deer's head, with coral antlers, and had another fash-ioned from a narwhal tusk.

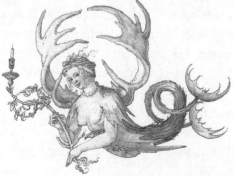

Dürer fixed antlers to the mermaid's back and teased her tail into feathery scales. He liked transitions like Leonardo, who, when in Rome during Leo's pontificate, created a living chimera by fixing wings made of scales to the back of a lizard, adding eyes, horns and a beard. The wings quivered as the creature walked about, prompting the artist's friends to flee in fear. Dürer wrote with quills which were themselves eruptions of skin, the way newly shed gannet feathers ooze diesel-ish oil. We're all part of the same repellent process, growing feathers or antlers or baleen or nails or teeth; our bodies are potent with the hard stuff that emerges from them.

Even humans sprout horns now and then. I wonder if my shoulder blades, which I've been told are unnaturally wide apart, might become wing-buds, pushing through my skin. We scratch at the surface of our strangeness, our components. We only have words to describe other species, as if the words, like us, like them, were rationed out from the beginning. From roots and bones Dürer endures in the Urwald, the way John Fowles saw the woods as the sea, places too vast and immense, he said, for anything but their surfaces or glimpses to be captured. You might become anything in there. Sewn up in a rabbitskin, with a robin to cover you with leaves, lost in the game of Waldschattenspiel, which my friend Clare brought back, its tiny trees of slotted card and nightlights casting shadows in which little wooden dwarves could hide.

In Dürerworld™ the forest and the sea are desolate places, crawling with strange creatures. Who could resist their beauty and fear? Even when he draws a Meerwunder abducting a bathing virgin, her legs elegantly thrown over his tail, Dürer's half-man, half-fish has stubby antlers, a turtle-shell shield and a jawbone club. According to the poet Hans Sachs, melancholia was a grave sea-monster; Maximilian believed his dynasty begotten by just such a creature. Dürer's nineteen-thirties biographer, Wilhelm Waetzoldt, saw a typically German combination of fidelity to

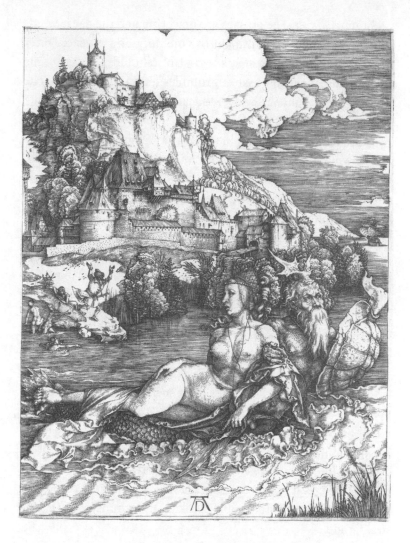

nature and fantasy, two mysterious beings on their journey to the open sea, having come from another world.

Dürer's woodblocks survive him, like myths, like the trees they came from. Do not imagine that you can improve on what nature, created by God, can produce, he says, sternly. So he made a forest of his own.

Summer, 1503. The grasses are flowering and the day is windless, but the bent stems retain the memory of a breeze. Dürer marches out in his boots, spade over his shoulder, to select his specimen. His servant-sexton grumbles along behind him. The right patch is found. They lug it back in a bucket.

| Plate II |

There it is. In his studio, his laboratory. Raised to eye level, as I lay down on the lawn as a boy in the hot afternoon, peering into blades of grass and weeds. There's no difference between this turf and the alps Dürer painted. These images have no subject, says Panofsky, only the breathing movement of the earth. The dandelions are about to turn into clocks. It's a microscope slide, a large glass, even, eerie ghost roots traced in an absence of paint. No one painted dirt before Dürer. It's a drawing in Darwin's journal, a Pre-Raphaelite sketch, so accurate a modern botanist could diagnose its species, the way you can age a hedgerow from how many different plants it sustains. It is an arbitrary cross section, chosen and framed in the most extreme manner. A portrait of violence visited upon a summer's day.

Under the bell jar the air has been sucked out, along with the spiders and mice. It's not what you think. It's a violent uprooting, a still life-in-death. There's a tension in the stalks as they reach for the light. Did Dürer hang a backdrop behind them, to present them like prize tulips in a vase? The horizon is awry, another trick of the eye. It tips up to make the scene seem more real, like a medieval architect purposefully breaking the symmetry of a cathedral façade.

We imagine the world around it: the field, a country, a continent, a planet; your name on your schoolbook. Life springs again. War and plague pass by. The land endures. Dürer looks so we can see. He elevates weeds in a pavement, buddleia in a wrecked apartment, the ocean in a pond. Our aptly named critic Norbert Wolf sets this wild square foot of soil on a pedestal. Examining it through a glass, he says its unity of perception, art, science and

natural philosophy could be seen as the central theme of the artist's entire creative output.

Art can't reproduce grass or a tree, or release seeds, blowing them away in a breath. So Dürer paints nothingness—the wavy air, as some call the wind, Turner said. Nay, he even depicts that which cannot be depicted, said Erasmus: fire, rays of light, thunder, sheet lightning, lightning, or the clouds on a wall—that is, something most similar to a dream, or nothing at all.

The artist shrugs. I just did it. The world doesn't begin and end with us. The grass comes to life as a twitching nose pushes through. She is longing to bound back into that field. Her fur is rendered with a single hair to underline the illusion. Like the turf, like her eye, she's the world.

| Plate II |

The hare was sacred to the Germans, believed to reproduce parthenogenetically, and so was associated with the Virgin Mary. But the hare quivers as she crouches, un-annunciated. Her ears are smooth and soft-resisting; like her vibrating whiskers, they're visible sentience, sensing a world beyond our own. She's wild, ready to be picked up and turned over, to lie entranced in your arms, the way Joseph Beuys explained the history of art, as I saw him do. The meaning of Dürer escapes us; he's too far away. But this—surely this, this hare so there in front of our faces, so like something we have seen: surely this is exactly what he says it is?

He repeats his feat, to compound the outrage of his genius.

| Plate III |

The blue roller, named after their acrobatics, the size of a jackdaw with the shouldn't-go-together shades of a jay. The wing, alone, outstretched, stands for the whole of the outrageous bird. Turquoise and sky-blue and russet-orange throat; the fiery colours of a winter home in Africa imported to European grey. In 1663, on his way to Nuremberg, the English ornithologist Francis Willughby shot one of these migrants out of the sky.

It was strange, as his biographer, Tim Birkhead, points out, that Willughby completely failed in his record to remark upon the astounding colours of the bird. Perhaps he didn't believe in them. Ruskin's watercolours of kingfishers and peacocks got near to this transcendent vision of a bird, or part of one, but even then, he despaired of such exquisite blueness, without having heaven to dip his brush into. Birds, mountains, hares: the strange fraternity. As fated as any human portrait, as weightless as air, Dürer's roller wing was rendered in elemental colour, like an advertisement. An animal-vegetable-mineral shopping list of pigments sourced from the pharmacy and stored in painter's mussels, *Unio pictorum*, long thin shells sealed with egg white for transportation, and used as little dishes in which to mix the paint with water or oil or gum arabic.

Naturally, this process involved animals themselves. Botanical pigments were dissolved in warm water, then hung in pigs' bladders to evaporate, leaving behind their powdery residue. Goat or cow horns were used as containers for colour and gold and silver leaf. To paint the world, the artist had to recycle it. Red lake was boiled down from madder root, which turned birds' beaks rosy when they fed on it, as if they were painters themselves; Dürer prized the variety he found in Antwerp, in neat, newly cooked blocks. Red also came as mythic dragon's blood from monsters or elephants killed in combat (it was actually plant resin). Bone black was made from charred bones, and ivory black came from burned ivory, often from mammoth tusks dug out of the permafrost.

Lead and tin combined to create yellow; Dürer spent three pounds on a grey-blue the colour of lead from Antwerp. Its port supplied artists who supplied art. Its docks imported verdigris from Montpellier and cochineal from the New World made from crushed scale insects, at three pfennigs a gram the most expensive of all reds. There was woad and brazilwood, and the colour that makes all the flesh parts glow, as Karel van Mander recorded, made from sulphur and mercury mined in Germany. Azurite came

from mountains hollowed out to recreate new heavens above. Little wonder that Renaissance art glowed so well, in these new fields and lakes of colour. The world was dug up, burned out and boiled down; it was a matter of demand and supply. Dürer's patrons—the Paumgärtners of Nuremberg, the Fuggers of Augsburg—were industrial barons whose international companies excavated the pigments and ores he used. They provided the copper plate he would engrave, the silverpoint with which he drew. Dürer bought their products to make pictures to make money so that he could buy more of their products to make more pictures.

Like pushers, they won, either way. His clients expected blue robes and gold and silver crowns, as if the paintings themselves were intrinsic investments, their dirty business refined for their walls, bought by the square inch, like gold and silver leaves, a dollar a wrap. In this addiction, animals and plants supplied the means of their own reproduction and demise: pens from goose quills dipped in ink from oak galls or squid (an ink stand was a calamarium); glue to fix canvas from rabbits' skin; paintbrushes from the tails of ermine. In Antwerp, Dürer bought thirteen porpoise bristle brushes. The bristle was baleen; he was painting with whales, standing over the blender, forcing a narwhal in, tusk first, to be chopped up with the other stuff. (Turner would mix his paint with spermaceti wax). The artist was paid to do it, this Judas, over and over again.

Most exquisite of all was semi-precious lapis lazuli that cost more per weight than gold and produced ultramarine, the ultimate colour, squeezed from stone, although it might have been mined from the ocean bed or ground down from the sky. No other German artist used this narcotic colour; they didn't dare. No wonder artists were accused of unholy pacts. In the port's backstreets Dürer traded twelve ducats' worth of prints for just one ounce, his fix. He'd been introduced to the stuff in Venice, where it flooded into the Virgin's luminous gown, the essence of the sea of which she was the Star.

In ports and quays and other queer places, these magical residues arrived, exotic hues he used to commemorate his blue roller. Hanging there like an angel shot down by a stray arrow from a passing scientist, the picture sang of the late animal, a bird of paradise, or any array of gods. To lend the bird a semblance of living glory, Dürer heightened his painting with gold leaf, a technique more usually employed to denote divinity. He deified the dead creature in blue and gold, the colours of Christianity itself, turning sacred something that might have been the aftermath of a hunt, torn off by a dog's jaws. He set feathers and dandelions on a par with emperors and saints. He painted God in dirt and blood.

The bird hangs from a nail on the wall, a piece of game, beak parted in pain, stone dead, still deeply strange. All the pity of the world lies in that claw, the other, tucked in defeat behind its wing. A talisman, said Marianne Moore, like a gull on the beach,

> Curling its coral feet,
> Parting its beak to greet | Plate III |
> Men long dead.

All life wrung out. In Dürer's hands, this once-warm body, this pathetic thing, was even more dead and alive. No one can tell me why these pictures were painted. Some say the hare was a study to show off the artist's ability; others that the wing was intended as an accessory to an angel, as if something so miraculous could only be meant for something that was not real.

Would not you fain to know what this angel looked like? asks Ruskin. I have always grievously wanted, from childhood upwards, to know that; and gleaned diligently every word written by people who said they had seen angels: but none of them ever tell me what their eyes are like, or hair, or even what dress they have on, he said. And, worse still, when I see a picture of an angel, I know positively where he got his wings from.

Dürer knew angels had their heavenly hierarchy, a taxonomy

of seraphim and cherubim, angels and archangels, created from pure bright gems, according to the Koran. But the bird came first: the angels only confirmed that beauty.

As he walked in the woods, wary of wolves and bears, Dürer always had a dog or two matching his stride. No one had drawn dogs like him. In The Seven Joys of the Virgin by Hans Memling, a real angel appears to the shepherds; their dog, in a spiked collar, barks out of fear and his own inexactitude. Dürer's dogs decline to be so disturbed. They stand next to serfs and saints, naked and unabashed, displaying all their charms; they don't howl at the moon or strain at the end of a rope. Dürer gives them such personhood that dogs become our witnesses, not slaves. In 1512 he illustrated a Greek text which declared that the dog, more gifted and sensitive than other beasts, has a very serious nature and can fall a victim to madness, and like deep thinkers is inclined to be always on the hunt, smelling things out, and sticking to them. Of all others, dogs are most subject to this malady, Robert Burton added in his *Anatomy of Melancholy* in 1621, in which he mentions dogs fifty times. Some hold they dream as men do, and through violence of melancholy run mad, he said. I could relate many stories of dogs that have died for grief, and pined away for loss of their masters.

A dog attends Christ's scourging. Five dogs gather around Eustace, the same one with different faces: solemn, alert, inquisitive, contemplative, fateful. In the corners of his paintings and prints, dogs go about their doggy lives. Perhaps it's because Dürer was childless, Colin Eisler suggests, that he showed in animals the care he would have given to a daughter or son. His dogs are ready and willing models, they don't shift and squirm or ask if they can see it yet. They'd rather break their hearts than betray ours, running till theirs give out. That's why they appear in his greatest engravings, bearing testimony to things you can't explain.

Melancholic
Slumbering with the angel, on a chilly spot by the sea.

Contemplative
By the paws of the monk's lion, sitting in his sunny cell.

Heroic
With the noble rider, waylaid by death and the devil.

The knight, a wolf's tail lashed to his lance to show contempt for his enemies, rides through a ravine hung with winter trees. Rider, horse and dog are accosted by the stinking pair: a snake-twisted head of death holding a mocking hourglass, and a grotesque, goat- and seashell-horned devil with torn wings. The intrepid trio do not deign to give this rotting couple a second glance.

Philip Hoare

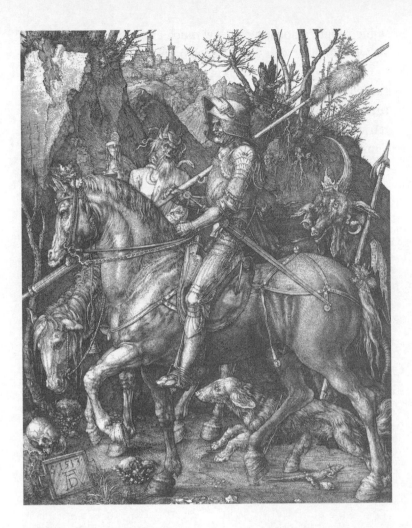

He's the original freelancer, this loner, left over from the Crusades, out of Jung's dreams. His steed is stalwart, sturdy, unfazed, ears pricked, looking straight ahead, a bunch of oak leaves tied to his forelock and tail for fortitude (I tie a sprig to my handlebars). Running to keep up is the third of the party, an eager and quick-scented dog, says Panofsky, shows untiring zeal, learning and truthful reasoning. He's ready to deny death and the devil. He has no sympathy for them. He's a seeker of truth, as his

noble snout demonstrates. How much easier things would be if we were all dogs, able to sniff each other out.

One moonless night, making my way back from the moor, I started to feel afraid. The trees in the thousand-year hedgerows seemed higher than the sky. But as I walked, Tangle, our black retriever, trotted beside me, taking me down the hill and back to familiar ground, even though at that moment he lay fast asleep on the warm kitchen floor on the other side of the town.

Dogs are timeless, perpetually reborn. They're only passing through, consoling us in our mortal state. The wild dog rescued from the streets, running free in the dunes. Animals are our future. You see it in their eyes: the bird in the air, the hare in the grass. They smell it, lying there.

A whale, on the beach.

Philip Hoare

STRANDED

They were always there, just out of reach. In the years after Dürer left the Low Countries, a series of strange deputations arrived. From 1521 to the end of the seventeenth century, there were forty recorded instances of sperm whales beached on these shores, as if summoned from their lairs. Dürer spent so much time with other animals, angels and saints, when all the while, there they were: sublime, fantastical, at the limits of the human realm. They were real, and they were in earnest.

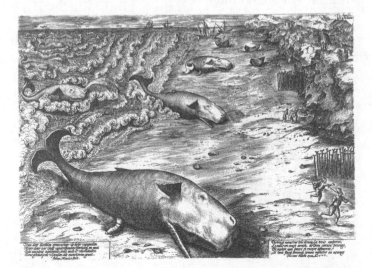

On 22 November 1577, due south of The Hague, thirteen whales spilled out of the waves. An etching by Jan Wierix of Antwerp shows three animals on the sand and ten ready in the surf. The locals flee in panic, fearful of those fierce jaws and extruded members. They run for the dunes. Later, Wierix would copy Dürer's Melencolia. That's what he's rehearsing here.

Arriving on the scene, a fisherman named Adriaen Coenen examined the trio. They were lying about a broadside from one another on the beach, he said. The largest was fifty-five feet, the second forty-nine feet, the third forty-eight feet. They were always males, this far north; females remained further south, in safer latitudes. Coenen drew them in his journal like a spy, along with sunfish and sharks and sea serpents. He labelled one of the whales across his tailstock,

EEN· pots
WAL.

noting another had a plaice in his mouth. He knew these were not bug-eyed versions of something awful on a fishmonger's stall, but individual, wondrous things.

Everyone waited for what would happen next.

On 2 February 1598, at Katwijk, north of The Hague, another whale appeared. These shifting sands were outlawed sites: the

Philip Hoare

inhabitants of the nearby fishing village of Berckhey were so wicked that neighbouring villagers were forbidden to talk to them and the sea swallowed up the place. The whale had someone to speak for him: Hendrick Goltzius, a German-born engraver, now a resident of Haarlem and a prolific artist, despite the fact that his right hand had been deformed in a fire when he was a boy. Goltzius owed his art to his reforged fingers, which forced him to hold his engraving tool all the more deftly; it was said his command of the burin surpassed even Dürer's. He drew his hand as the instrument of his imagination, like the shadow-play of a whale on the wall.

That was the trouble with artists. Like poets, they compared everything to something else. Goltzius did for the whale what Dürer would have done. His stepson, Jacob Matham, turned the potvis into a print, to be reproduced on Delft pottery, his body deftly glazed in tiles the deep blue of the sea. There was an audience gazing on this silent tragedy; spectators at the scene, which resembled a circus or frost fair, decked out with tents

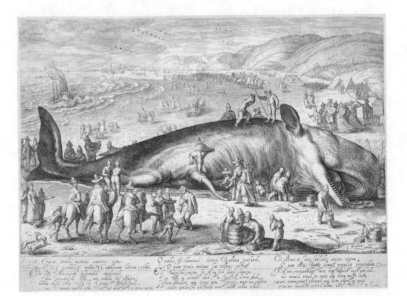

and entertainments. Their looking was dangerous; they too succumbed. As it lay there, the whale's bowels burst open—Goltzius said—which so infected the air thereabouts that many of those who went to see it were cast into Diseases by the stench of it, and some died.

Unlike Dürer's slow decline from an intermittent malady, theirs was a swift demise from the miasma. I was warned of zoonotic disease, too, in the same stink that still clings to me: a beheaded minke on a North Sea shore, slowly turning green; a humpback splayed on Herring Cove, collapsing under her own blubber; a huge detached flipper, waving beneath me as I swam in a lagoon.

All these I smell in my head, like dead-flower water in a vase.

A large whale, thrown up out of the blue sea, gods, let it not be a bad omen! What a terror of the deep Ocean is a whale, when it is driven by the wind and its own power on to the shore of the land and lies captive on the dry sand. We commit this creature to paper and we make it famous, so that the people can talk about it.

Animals did different voices. The whale commented on invasions and armadas, with specific warnings against irresponsible truces and sinful compromises with the Antichrist. Sir Dudley Carleton, British consul at The Hague, felt obliged to issue a briefing. In the very places and instant time of these tumults— the diplomat said—they cause the most surprise; the rather because it is remembered that at the first breaking out of these countrey wars there were two of the like bigness driven on shore in the river of the Schelde below Antwerp.

The philosophers looked askance at such bureaucratic superstition. Discontent with Goltzius's efforts and their attempts to make themselves understood, the cetaceans sent a third deputation on 20 December 1601. Their delegate arrived at Beverwijk, north-west of Amsterdam, in time to be drawn in ambassadorial detail by Goltzius's pupil, Jan Saenredam. He was their Holbein.

Saenredam's son would paint the whale bone on Amsterdam's town hall; his father had already taken that rib and recreated, not Eve nor even Aphrodite rising from a shell, but a seminal animal tipped on his side. The gaping mouth, the semaphore fin, the generative organ; all these exposed in the enigma of his arrival. A century earlier and they'd have summoned a priest to hear his sins. This whale has accrued the power of earlier, failed portraits; he is invested with the full panoply of unsayable splendour. Attendants pay court to an emperor whose realm reached far beyond any Hapsburg domain. Count Ernst Casimir of Nassau-Dietz, a war hero, arrives in his plumed hat, with his rapier, and a handkerchief to mask against infection. The whale is unsheathed. Saenredam learned from Dürer: his visitor is wreathed in the requisite symbols. This was his coming, and these were his signs.

Father Time with doomy scythe and hourglass; bits of whale lying about, auguries of butchery to come. The omens come thick

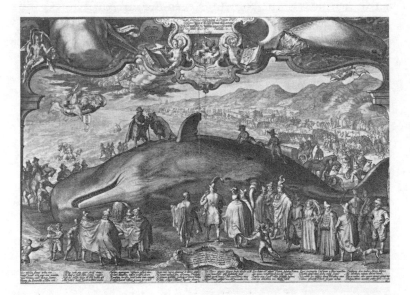

and fast. The timing, for a start. On Christmas Eve, four days after the whale stranded, there was a solar eclipse; that summer there had been an eclipse of the moon: both were represented in the picture, as if the animal that dwelt in darkness had blotted out the light. The words terra motus in a cartouche refer to an earthquake that had coincided with the darkening sun. (We now know that such tremors may indeed be associated with the phases of the moon, and can cause cetaceans to strand.)

Danger came from on high, from the deep, in the air. An angel aims arrows at Amsterdam, infecting the city with the plague. Death has winged a seraph like a roller, tumbling into the mouth of the beast. The artist rises on a cherry-picker, directing the scene; Eustace's dog wanders into the corner, sniffing at the wind. The horses bow their heads in grief. The dunes echo the leviathan; his fearsome teeth remain hidden from view. They might be medieval jaws of hell. You'd think there was a whiff of sulphur, not rotten flesh, about this visitation. Yet Luther lauded the marvellous monster, whose strength and confidence was such, he said, that he contemns even the force of arrows, and who encourages us to believe the more easily and firmly that God is able to preserve us also, who are so indescribably less in magnitude and strength. The archetypal whale.

By chance, we visited that same shore, on the same day, 20 December. We had no idea it was the anniversary of the whale's stranding in 1601. It was dawn, and the beach was empty of carts and nobles. The circus had long gone. The sky was grey and the sea reached in.

We walked over the wide brown sand. Behind us stood a steel plant pumping out fluffy white clouds, and a refinery burned its bright orange flame. Ahead a stone jetty ran like a road to nowhere. Cormorants perched on its boulders, drying their wings. We got to the end and had to turn round at the red-and-white-striped lighthouse. Everything pivoted there, at the turning of the year.

Out of the mist, an oil tanker came in, so close we might have reached out and touched it. It was about to be pumped dry. A fishing boat sailed past the harbour's red and green lights, into the North Sea. Within minutes it had disappeared into the murk.

As we turned back, the surface of the water broke as a lone porpoise arched its back in the pale sun. We saw a flash of white at the flanks, then it was gone. Dogs and their walkers arrived on the beach. I took off my clothes and swam. Afterwards we argued, but not about what it all meant.

Over four long centuries the Low Countries continued to receive shuddering beasts. They never seemed to stop. Roused from their sea beds, slumped on the sand, they bore no resemblance to the beautiful creatures you and I know them to be: elephant grey or ebony black or the colour of cocoa, spinning with the sun's rays on their backs. I've seen the underbelly of the whale. She fairly floated herself for her portrait, but I came to no conclusion as she hung there beneath me. No one suspected whales had been sent to spy on us, with their big brains and black eyes.

Had Dürer seen even one whale, his art would have pre-empted Melville's mutterings about how you can't tell the true nature of the whale from its bones alone, and how no one ever painted a less monstrous picture of a whale, despite the fact that the writer was born, half Dutch, in New Amsterdam, and claimed his eyes were tender as young sperms. The pale usher of *Moby-Dick* tells us the word whale came from the Dutch wallen, to roll, to wallow. We wallow in our ignorance. Whales heralded their own disaster, witnesses in the meaning of the word martyr; auguries of their own extinction, despite or because of their size, crushed by their own weight. Art might rouse them, but it could also make them vanish of their own accord.

When an unremarkable maritime scene painted in 1641 by Hendrick van Anthonissen was cleaned, the restoration revealed the shape of a whale. Lying unsuspected in the museum, no one had known he was there. No one seemed to wonder what all the people were looking at, or what was going on. He'd been there all along, this hider in the water, his fin in the wrong place and a man on his back. At some point he'd offended the human eye: unlucky, like a bird in your house, a non-person in a Stalinist photograph, a sinner from the village, banished from sight.

Philip Hoare

The Germans had a word for anonymous artists who left only their art behind: Notname. A name for nothing. The whales were nameless too, but they kept coming all the same. In the seventeenth century twenty-seven strandings were recorded on these shores, ungolden years for whales. The more real they seemed, the more ways we devised to dispose of them. Still they came, hoping one day we would have had enough. In February 1937, two sperm whales that stranded on the Zeeland shore where Dürer had nearly been wrecked were taken into Rotterdam. Raised by cranes and pulleys out of the barge that had brought them to berth, for an overhaul or the last rites, they were offloaded onto the quay, weighed and measured, the first time that this species had been so thoroughly assessed.

Afterwards the whales lay patiently, waiting to be processed into the kind of little white waxy blocks of spermaceti I'd find in a museum's stores, neatly stacked in a cardboard box like bars of soap, so silky I didn't want to let them go; like the cold cream my mother rubbed into her face at bedtime, its chill whiteness taken out of the black ocean; a layer of emulsified whale between her cheek and mine as I kissed her goodnight. Such a clearer! such a sweetener! such a delicious mollifier! says Ishmael. Squeezing

the raw fat through his hands, his fingers felt like eels and began, as it were, to serpentine and spiralise, wriggling like little sperm in this feminine task, his hands touching those of his mates. He squeezed them, too, until at last he saw long rows of angels in paradise, each with his hands in a jar of spermaceti.

We all do our duty. What anarchy would prevail if we did not. On 10 May 1948, ten years before I was born, the 15,000-ton *Balaena*, the world's largest whale factory ship, arrived from the Antarctic at Southampton Docks. There it was divested of its harvest, derived from three thousand whales. 4,500 tons of meat to be tinned or served as steaks; 163,000 barrels of edible oil to make margarine, as the local paper announced; and 10,000 tons of sperm oil destined for soap, cosmetics and lipsticks. Statistics. Whales fed, soaped and made up a bombed nation; the ship's departure four months earlier had been an event as well covered as any military expedition. Rewinding the solemnly voiced newsreel like a cable, I watch *Balaena* leaving the docks at the start of her voyage.

My family are safe in their beds, though they hear the foghorns in their dreams. The ship's lights glow in the murk; it looks like a London smog, the sort in which a killer might lurk. Untethered by tiny figures from her moorings—I apologise for investing such a vessel with femininity—*Balaena* belches black smoke from her funnel as she sails from her berth, eased out by a tugboat midwife. She rides high in the water, unladen, her tunnel-like ramp clean. They call her a mother ship; soon she will be making orphans.

A report published that year noted that a worldwide famine in edible fats caused by the war made such voyages urgently necessary. To carry out its harvest, *Balaena*, this post-war *Pequod*, carried three Walrus amphibious military reconnaissance biplanes, designed and built by the Supermarine Company in Southampton. They were named Snark, Boojum and Moby Dick: a superhero squad, part-animal, part-machine, racing to unsave the whales.

According to the *Geographical Journal*, each flying boat was launched from the deck by a giant catapult powered by a cordite charge. They lumbered into the air like albatrosses, seeking the grace of the updraught over the wide, wide sea. Up there, alone in the polar sky, the crew and scientists looked down and saw a shoal of at least fifty sperm whales; they found that even when the aircraft dived low over the water the whales took no notice of the noise.

Were I a whale, I should not show myself so.

The sperm were easily identified—said John Grierson, a celebrated pilot, denying their plural individuality—and calves could be distinctly seen swimming alongside their mothers. It is the gunner's business always to pick the largest animal, which calls for considerable experience. We were helped considerably with our photography by Doctor Bob Chase, chief of the Cambridge scientists.

The sperm were being removed from the remote oceans at a great pace, far from the scrutiny of human civilisation. Three hundred years after van Anthonissen's whale had vanished, *Balaena* and her cohorts were enabling the disappearance of three million whales. Their fate was also ours, since their faeces would have fed plankton which absorbed the carbon we had released into the air; the dead sperm would have fertilised the same food chain. What would fill all that space? Pliny explained, not long after the death of Christ, that whales were found in the sea because it was huge and open to receive from heaven the genitall seeds and causes of generative life itself. The seminal whales snapped at these mosquitoes. Trapped with only his boots sticking out as those jaws came together, one whaler escaped with a moderately crushed chest and emphysema from the neck to the waist, but he was back on his job in six weeks.

Side by side with cold-war scientists, as Wolfgang Panofsky sat in his plane, the catchers dealt death by explosive harpoon. In an account published in the *Illustrated London News* many years

earlier, publicising the War in the Air exhibition in the Grafton Galleries in Mayfair in 1919 (admission one shilling, and the band played daily), readers had seen, for the first time, aerial photographs of fin whales, taken from a British airship as it flew over the sea between England and the Netherlands.

A Neutral of the seas often mistaken for a U-boat, said the caption, adding that in the half-light, these huge monsters bore a strong resemblance to a submerged U-boat, and, as the rule in war was, when in doubt, bomb, a good many of them were killed by our aircraft.

Brutality knows no boundaries, said Jack Forbes, a Native American; greed no limits, arrogance no frontiers. This is the disease, then, he wrote, the disease of aggression against other living things and, more precisely, the disease of the consuming of other creatures' lives and possessions.

Between 1914 and 1917, 175,000 whales died to produce nitroglycerine for British bombs and oil to stop soldiers' feet rotting. In 1917 the minister of munitions, Winston Churchill, accelerated the call for what was known as train oil, from the Dutch traen, meaning tear, or drop. A pieta. One species was a particular target for the hunters, as Frank Morley, T.S. Eliot's friend, would note, after his own experiences on a whaling ship. It was a wholesale slaughter of the humpback whale, who is a reasonably cheery and very entertaining party with us on this planet, Morley wrote. He was all but exterminated in his own haunts, ten thousand miles away, for the purpose of exterminating the fellow across the way in his dugout.

In 1924, H.G. Wells declared we needed to protect whales from ourselves. In an article entitled The Impudence of Flags: Our Power Resources and My Elephants, Whales, and Gorillas, the author of The War of the Worlds said that these marvels of life, these strange and wonderful beings of whose vitality and impulses we know so little, were being killed because they were insufficiently protected. Species of whales were being exterminated

because the ocean is no man's land, he observed, and birds and beasts that live under a careless flag are dying and no one had the right to protest.

This was a new medieval hell. A school of turlehide whales stranded in hot noon, spouting, hobbling in the shallows, Joyce wrote in *Ulysses* in 1922. Then from the starving cagework city a horde of jerkined dwarfs, my people, with flayers' knives, running, scaling, hacking in green blubbery whalemeat. Famine, plague and slaughters. Their blood is in me, their lusts my waves.

The 1948 film tells us more humane methods of killing are now being tried out, much as they had been on humans a few years before. Encouraged by an onboard doctor, Harry Lillie, who had become disturbed by the fact it took five hours and nine grenade harpoons for a female whale to die—during which its still living body was pumped with air to keep it afloat, an example of unequalled cruelty, as he noted, since it left the whale to her greatest terror, of being eaten alive by sharks—there were new efforts to refine the process.

Sir Vyvyan Board, a hero of the First World War, had become the chairman of United Whalers, and had taken part in Grierson's expedition. He was interested in the invention of a new electric harpoon which used a conducting cable perfected by Pirelli General Cables of Southampton, where my father was employed—I have a sudden idea of him testing the resistance of a whale-killing cable rolled on a drum in that great dark brick building sprawling on reclaimed land—this stiff Sir Vyvyan Board, as I say, went directly to the Antarctic, to try out the invention himself. It was a success as far as he was concerned. Inspired by headlines announcing New Harpoon Electrocutes Whale in Two Minutes, W.H. Auden wrote a poem in which he gave ironic credit to Sir Vyvyan,

> thanks to whose life-long fuss the hunted whale now suffers
> a quicker death.

Grierson's report, which suggests the use of an armed helicopter as a refinement of the hunt, is accompanied by an aerial photograph of a humpback whale. Turning on her back, she offers up her body in surrender, her fins outstretched as a cross.

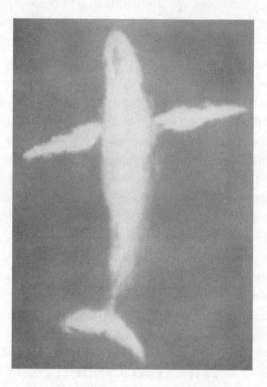

In the stormy winter of 2016, when I was on the other side of the Atlantic, a series of strandings occurred around the North Sea. As the reports came in, it became clear that they were part of one mass event, although they were miles and days apart. On 8 January, two animals appeared on the shore of Lower Saxony; on 12 January, two more washed up on Heligoland in the German Bight, the same day that five dying whales were found on the island of Texel, north of Amsterdam. On the 13th, 14th, 22nd, 24th, 25th and 31st of January, and on the 2nd and

3rd of February, whales stranded in Norfolk, Lincolnshire, Schleswig-Holstein, and Calais. It seemed they would never stop. The last carcase, decomposed, came ashore in Denmark on 25 February.

It was the largest such stranding since the eighteenth century. Thirty sperm whales, their strange, beautiful bodies littering the same wide beaches, the same shallow sea. At Skegness, someone sprayed graffiti on a pair of flukes—*MANS FAULT*—but this brutality only proved there was nothing to be done.

I followed the reports as the same storms battered the deck of the house I was staying in, the night the starman died. Friends sent eyewitness accounts. Jeroen made the journey to Texel. It was dark before he got there. The animals were still alive, trying to draw breath. They died during the night. When Jeroen went back at dawn, a rainbow hung in the sky. He returned to his hotel, hoping they wouldn't notice he was soaking wet.

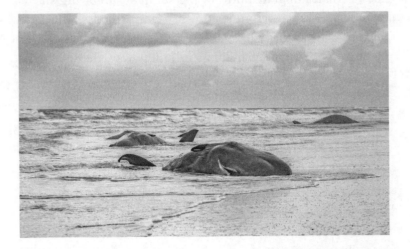

In a report published a year later, a quartet of scientists suggested a remarkable hypothesis to explain these events. They drew a correlation between the strandings and solar storms; proposing that the whales' electromagnetic sense, which they use

to follow geomagnetic lines laid down in the earth's crust, had been disrupted by electrical surges travelling millions of miles from the sun. Disorientated, the whales swam into the shallows. Up in the sky, the same solar storms sparked off a spectacular show of the Northern Lights, their shimmering curtains rising to reveal dying giants.

We once possessed this innate sense, too, the way birds and other animals use it to migrate, along with the changing constellations and the seasonal rise and fall of the light. Now we're lost for ever. (How did you get here? a guest asks me at dinner, when I say I have no phone.) Whales appear to possess tiny particles of iron in their bodies which act like minute compasses, alerting them to the right or wrong directions, though, mysteriously, no one has found them yet. The results of their misalignment, however, are plain. We can explain them in charts and statistics. Leaving their families in warmer waters, male sperm whales migrate north in the summer, following shoals of squids. On their return south, they face two possibilities: to go back the way they came, or to enter the North Sea. Deceived by heavenly disruptions millions of miles away, they make the wrong choice.

Silty waters hold no sustenance for such deep divers. They swim on, in increasing desperation, and as they cross south of Dogger Bank, they pass the point of no return. Dr Christiaan Smeenk, of Leiden's natural history museum, called the North Sea one big whale trap, and compared the strandings to exhausted humans who find themselves lost in a strange and hostile environment, where one wrong decision may be fatal. Deep is safe, shallow perilous; shelving shores blur land and sea, introducing a deadly ambiguity.

For centuries the ambiguous Low Countries had been in retreat, never quite sure of themselves. The sea built up great dunes and chased people into the interior. They drained the land, dug ditches, built dams and dykes. As it dried out, the land fell

Philip Hoare

below sea level, inviting the water back. The cycle never ended. In October 1944, the people of Walcheren watched through uncurtained windows as the dykes were bombed; the liberators were trying to flush out the enemy, but also took many civilian lives. The island drowned and redrowned in the watertijd, the water time. When it finally reappeared, like Atlantis, islanders discovered mussels growing on the walls of their houses, on fences and even on trees.

Then, on the night of 31 January 1953, the sea broke through again. The tide came in that afternoon and kept on coming. The same deluge that killed three hundred people on the east coast of England drowned eighteen hundred Zeelanders in the watersnoodramp, the flood disaster. Edgar, who inherits his parents' memories of that time, tells me people were simply taken away by the waves. Hundreds of thousands of cows and sheep, dogs and cats and rats and goats, along with millions of worms, floated off too, with no ark to save them.

Climbing a dyke, we find a perfect expanse of water stretched out before us, contained by the land and the sky. There's nothing to hide. A hare runs up the slope. A wooden jetty leads out from the shore. I launch myself into the inland sea. It is still and warm.

As I get out, a trio of teenagers arrive over the brow of the dyke. We startle, expecting something. But they just stand there, staring. One tells Ellen they sometimes see zeehonden out there, looking back with their big black eyes.

It makes you want to cry, he says.

In a nearby restaurant, the aproned waiter brings out a platter to show the diners; laid upon it is a fresh schol. The plaice glistens with the sea: the orange spots on the brown body, the fingerprints of a saint. Dürer would have drawn them on his napkin.

The young man holds the plate for our delectation, an offering. The scene is lit, artistically, in the flat northern light. We congratulate him; he accepts our praise.

But the fish's half-open mouth dribbles snot-like drool, and the light in their eyes has long since gone out.

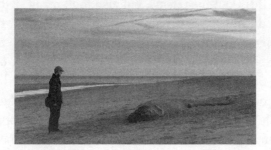

Philip Hoare

REVELATION

1493 Twenty-two years old. Pale, with red-gold locks and scrappy whiskers; they'd hardly add up to a beard, no matter how hard he tried. He's callow, knowing, and shy. We feel close to him because he's face-to-face with himself. Boys like him are always aware, wary of the way people stare.

<div align="center">

𝔐y fortunes will go as
it is written in the ſtarſ
</div>

| Plate IV |

He doesn't care. This is not a comfortable picture. It's not meant to be. It's not meditative or cool-headed but wired and unsettling; a picture for a lover, only the lover is him. His body is tense from knuckles to brow. He's all nerves, he almost pouts; it's outrageous, they said, spending so much time and money on yourself.

This is the first self-portrait of an artist painted for its own sake. A new man. A friend describes him as fragile. So vain. His tasselled hat like a jellyfish, a sprig of sea holly in his hand, a spiky, silvery ghost from the shore. It might be a love token. Goethe noted its German name, Männstreu, true man; it was known as an aphrodisiac, and Dürer was about to get married. But it also looks like a crown of thorns—the artist had begun to associate with the

Friends of God, a mysterious sect. His crooked finger points to the palm of his left hand, all but pierced by the bent stem.

He looks at us, so uncertain and persuasive, slipping through time. Three hundred years later young painters known as the Nazarenes will sport long hair and loose shirts and hold the same spiky flowers, the way Wilde's apostles will sport carnations suckled on green ink and goths will wear black lipstick and a scowl. In 1900, Bernard Shaw will hang this picture on his wall, the young superman, with his I-was-about-to-tidy-my-room look.

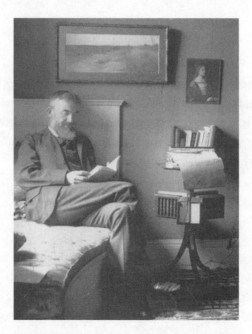

There's something odd about that stare. His right eye looks off to the side, as if it had seen something else in the darkness. To some it would seem disconcerting, this distracting squint; a malign alignment; an evil eye. In the nineteen-twenties, the dandy aesthete Stephen Tennant would boast of his regarde de Venus; in Sri Lanka, such a cast is seen as a blessing on a child. Art critics detect a stylistic trick: a symbol, as Wilhelm Waetzoldt wrote

in 1936, showing that diverging lines of sight occur in persons of thought. But there's another reason for this melancholy look. Any artist painting their face can only focus on one eye at a time. By not self-correcting the register of his gaze, Dürer asks what we do and do not perceive. It's his secret, to see askew.

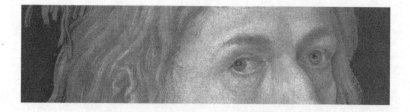

When a whale spins on her back, it's the only way she can see me in stereo: her eyes peering up at me peering down. How is it, then, with the whale, asks Ishmael, who can see one distinct picture on this side, and another on that? True, both eyes, in themselves, must simultaneously act, he says; but is his brain so much more comprehensive, combing, and subtle than man's, that he can at the same moment attentively examine two distinct prospects? Perspective, the secret art Dürer was to learn in Italy; to perceive, or deceive, depending where you stand. It sets us at the centre of things. It turns art into a science, says Leonardo.

1498 Five years later, Dürer is a prince of art. He's been to Venice and learned to dance. He's a performer, a courtly figure in black and white, the passeggiata on a summer night. These aren't practical, these clothes: he's no artisan. Down there he was appreciated; back home he meets only disdain. A freak, a parasite. A stranger on a train, the country rolling past. He's all plunging lines, fine pleats, thin skin. He's grown his beard, another disguise. His hands are sheathed in grey leather; they're the most alluring things in this picture.

| Plate V |

I made this, they say. In Venice the art of quicksilvering glass has been perfected; to mirror and to gild in mirroring, as Marianne Moore would say. He's a magician, a conjurer, a thief, stealing from the European canon. Leonardo, Bellini, and Mantegna, van Eyck, van der Weyden. The artist must portray extreme suffering and extreme wealth: the fancies of kings, Christ's wasted flesh. Imagine painting that, says my friend Mary. Hugo van der Goes, who did, was haunted by the notion he would never complete all the works he wanted to paint. Plunged into melancholy, he entered a monastery but couldn't be cured, no matter what music the monks played for him. Dürer would fear the hand reaching down from the sky.

His name is an empire. *Albrecht*, with its guttural reach; *Dürer*, enduring, forcing me to find his umlaut on the keys. Lord Clark, in his castle, says he's a very strange man, this Dürer, not at all German. Wilde, in his villa, says to succeed you must have only five letters to your name. Dürer has another trick up his tight little sleeve: the eye in the door, the D in his A, his DNA.

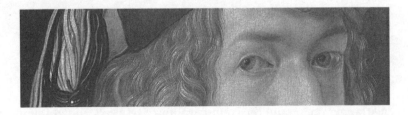

He's on the Nuremberg–Venice express, off to meet his heroes. When he crossed the Alps, Waetzoldt says, he came like a rustling wind from the forests of the North, an eagle soaring over the

world. He pulls himself together, giving nothing and everything away. His eyebrows are more arched, his cast more pronounced. There's a new detail in his eyes: an epicanthic fold, common in people from Hungary. The third eyelid of a bird or a shark; the eyes of a predator, a Venetian mask. Art is the magic mirror you make to reflect your invisible dreams in visible pictures, said Bernard Shaw. You use a glass mirror to see your face, he said. You use works of art to see your soul. But you can't see in the dark.

1500 He turns his face to face us. There's only blackness behind. The glitter comes from his eyes. My beauty is both mine and not my own, he says.

<div align="center">

𝕿𝖍𝖚𝖘 𝕴, 𝕬𝖑𝖇𝖗𝖊𝖈𝖍𝖙 𝕯ü𝖗𝖊𝖗 𝖔𝖋 𝕹𝖚𝖗𝖊𝖒𝖇𝖊𝖗𝖌,
𝖍𝖆𝖛𝖊 𝖕𝖆𝖎𝖓𝖙𝖊𝖉 𝖒𝖞𝖘𝖊𝖑𝖋 𝖎𝖓 𝖋𝖆𝖘𝖙 𝖕𝖆𝖎𝖓𝖙 | Plate VI |
𝖆𝖙 𝖙𝖍𝖊 𝖆𝖌𝖊 𝖔𝖋 𝖙𝖜𝖊𝖓𝖙𝖞-𝖊𝖎𝖌𝖍𝖙 𝖞𝖊𝖆𝖗𝖘.

</div>

He is where the modern world begins. That stare, that self, that star. This is where and what I am, he says: at the easel, in the mirror, on the canvas. From now on, he will never not be famous; the caption says the paint is immortal. Alpha, omega, atomic; half his life in one age, half in the other. Twenty-eight was the peak for a man of his time. A dizzying equinox, his midnight-noon. Like Janus, the two-faced god of doors and transitions, he's looking to the future and the past, the sun and the moon.

Such regular features ought to be reassuring, the kind our genes favour, but there's nothing so strange as someone trying to look straight. His eyes dilate, as if dropt with belladonna. They're why his dog, recognising his master, licked this picture, and why, in 1900, someone tried to scratch out his eyes with a pin, afraid of what the future would bring. You don't want to look too long, you can't look away. This isn't a look thrown together for a night out. He destroyed all the drawings so it would stand

unique. He may resemble a well-groomed spaniel or pony, but under his collar he's feral, this Dürer in furs; the werewolf who ate your mother, the dog beneath your skin.

We don't know what they made of it; it never went on public display while he lived. We see him through a veil of varnish, not the man who stepped away to wipe his brush and take a piss. He looks at us through his looking-glass. We never see our own faces, only their reversed adverts in the mirror. Dürer is sentimental, dandyish and charismatic, says a book I find in a charity shop; a mixture of coldness and sensuality, toughness and goodness.

The writer, Simon Monneret, thinks the beard stresses the Viking, conquering side of this prince. An Arabian merchant, Ahmad ibn Fadlān, trading in Europe in the tenth century, never saw such perfect bodies. The Vikings were tall as trees, fair and reddish, tattooed all over with fine dark green designs, their eyes made up to intensify their gaze, lined in black; he was amazed that they combed their hair every day. Dürer's friends described him as a thoroughbred. His head was intelligent, his eyes flashing, his nose nobly formed and square. His neck was rather long, his chest broad, his body not too stout, his thighs muscular, his legs firm and steady. But his fingers—you would vow you had never seen anything more elegant.

That tiny white triangle in the v of his mantle, like a T-shirt, isn't there by accident. It invites us to watch as he disrobes to find nothing underneath. Those elegant fingers draw you down to the dark fur, lustrously torn from a marten, a musky creature of the forest, also known as sable. An eleventh-century abbot, Adam of Bremen, said people wished for marten fur as much as supreme happiness. Kings and queens slung whole sable pelts round their necks, with gold or crystal simulacra of the animals' heads and feet attached. The marten conceived through her ears and gave birth through her mouth. His fingers mimic the origin of the world.

We all want what we can't have. Dumb objects of desire to disguise our naked lust. In 1543, Henry VIII spent £166 on eighty sables to fashion a gown for himself; robes could take more than three hundred skins to make. In England, where tailors were rated over artists, you could buy a Holbein for fifty pounds, but a royal outfit would cost you five hundred quid; the clothes were more expensive than the paintings of them. When sixteen-year-old Charles sailed from Walcheren to become king of Spain in 1516, he wore a marten mantle. (It was an adventurous voyage: one of his sailors killed a porpoise, which they ate; another swam from one ship to another, for a bet.) Dürer's mantle, comfortingly heavy, signified fertility as clearly as a codpiece; but it also meant death. Marten fur was harvested in winter when it was at its thickest, when the creature needed it most. With the advent of the Little Ice Age, as seas and rivers froze, martens were taken in such numbers they were already scarce by the time Dürer painted this picture. If animals are mysterious, it is only because we made them so. In *Austerlitz*, Sebald describes a visit to the Nocturama in Antwerp. In the artificial dusk he sees opossums and pine martens whose strikingly large eyes, adapted to the absence of light, are a reminder, he says, of the fixed, inquiring gaze found in certain painters and philosophers who seek to penetrate the darkness which surrounds us purely by means of looking and thinking.

There's something else quite curious about that sleek stolen stole. Dürer's finger points to a scrappy patch, as if moth-eaten or caught by a candle as he worked in the dark. (He was a night person, after all, though a true vampire would look in the glass and see nothing.) In this cycle of consumption, Dürer's brush was itself sable; only the animal's fur was fine enough to reproduce their own fur, to announce the artist's genius, like the seal and otter coat Wilde wore when he arrived in America, his hair centre-parted, a tribute to Dürer, whom he admired.

But the strangest thing about this painting is: it isn't him. This most German of German artists portrayed himself as a Jew.

Dürer transformed his features, elongating his nose and curling his hair. His imitation of Christ mimicked the Holy Face in his parish church, an image unmade by human hands.

He became an icon, a gesture against the marketing of God. In 1543 John Calvin would cite forty-three shrouds across Europe as an example of the trade in scraps of rags and bones. If we were to collect all the pieces of the True Cross, he said, they would form a whole ship's cargo. In Nuremberg the lance that pierced Christ's side was used to pierce paper hearts for sale as contact relics. Dürer's father made a gold monstrance to hold a holy thorn. Melville saw it all.

> For Durer, piteous good fellow—
> (His Agnes seldom let him mellow)
> His Sampson locks, dense curling brown,
> Sideways umbrageously fell down,
> Enshrining so the Calvary face.

This is why Dürer came to be a kind of saint. His eyes perceived the beauty of our melancholic state. He awaited his betrayal. Nothing human, nothing on earth, was certain; a portrait was Konterfei, from the Old French, contrefait. Dürer made up his own face. The twentieth century tried to uncover his secrets; Waetzoldt confirmed this portrait's date from a Röntgen photograph. But Heinrich Wölfflin had voiced his doubts. Can Dürer be extolled

by us as the great German painter? he asked, in 1905. Rather must it not finally be admitted that a great talent has erred and lost its instincts by imitating foreign characteristics? His work is interspersed with things which are alien to us, he complained.

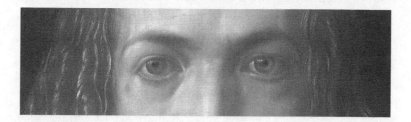

On 625 lines, on an old TV, Kenneth Clark talks with folded arms, holding himself together. He speaks from the Vatican gardens, Ely Cathedral, the old town of Würzberg. The sun shines, the trees sway, he stands still, straightening his stiffened back. The streets behind are empty. When someone walks round the corner and sees the camera, they quickly retreat. A long-dead dog runs past as the lens pans up and down Notre-Dame.

Civilisation is a broadcast for the future, the way that the Voyager probe was about to be launched into space loaded with whale song. In Episode Six, Protest and Communication, Lord Clark speaks confidentially about the artist, who was not the pious German craftsman he was once supposed to be. For one thing, says Clark, he was intensely self-conscious and inordinately vain, a man who wouldn't have married if convention hadn't demanded it. He was talking in code. He admits no one had ever described natural objects more minutely, but says that the Large Turf looks like a clump of weeds at the back of a glass case containing a stuffed animal. Yet, despite the fact that, as one critic said, Clark had the air of someone who happened to own the art of western Europe and was gracious enough to show it to us, his critique seems subversive, because it was so sure, so assured. We like to be told what we like.

From the revolutionary year of 1968, Clark describes, in his twitchy gestures, the 1498 portrait as a masterpiece of self-love, its ringlets framing a face that insists on its sensibility. His Dürer is a long-haired student on the Left Bank, pulling up paving stones to find the beach beneath. Clark calls him an intense young man whose art heralds a new scepticism: Shakespeare's faithless world, life as a tale told by a fool. He's Hamlet, on the brink. The German mind that produced Dürer and the Reformation, notes Clark, also produced psychoanalysis.

I was eleven years old. The man I saw on a monochrome set lived in a castle. I lived in suburbia, the strangest place there is. I knew only the art I saw in books.

Out of the books, another pair of eyes focus beyond me, looking over my shoulder at something else. Another floppy hat, a jewel dangling to one side, another low-cut jerkin and curls. A portrait painted in Venice, around 1506. In 1573, it was catalogued in Nuremberg as a woman with a red beret. By the time it got to Amsterdam in 1633, it was being traded as the portrait of a boy.

| Plate VIII |

We don't know who this was, this Orlando, with a candid and sallow face, as Woolf said of her slippery hero-heroine, with eyes so large that the water seemed to have brimmed in them and widened them. Venice was a floating palace filled with grave creatures. Byron's sea-Sodom, infused with marine melancholy. In the twenties, Daphne du Maurier talked of her Venetian tendencies. A travesty of a place, a looking-glass world: the piazza, patrolled by a kohl-eyed marchesa with a leopard on a leash, turns into the sea; an ageing aristocrat sitting on the beach, with his make-up running. Even Erwin Panofsky, not overly given to emotion, says that this is one of the most enigmatical paintings ever produced by Dürer. It was painted on vellum, not wood, and as such has an intimate air, something which may have been a gift or souvenir. The historian leans back in his chair. That dreamy

look unmans him. He knew the Weimar Republic; he detects a slight turn in the head, and peers at those wonky eyes. Not that he could see straight, either; one of his eyes was near-sighted, the other long. He called it a blessing, the best of two worlds. He could look either way.

From Amsterdam the girl-boy was passed on to a Viennese palace, was sold on the London market in 1899 and ended up in Berlin, where Panofsky sees them. He notes the deep décolleté, the small, soft mouth; his words caress up and down. The hair and the lack of ornament to the doublet, the flat chest and the mannish beret; they all suggest a pretty boy to him. Dürer was not unsusceptible to the charm of handsome youths, he adds, hinting that neither was he.

Leonardo liked young men with long curly hair, and was beautiful with his own, and a faraway look like the sea. They may or may not have met, but Leonardo was in Albrecht's head. His Mephistopheles, my friend Woodrow suggests. The two artists dream of deluges and storms and make the same connections. Dürer wears his beard in tribute to Leonardo's circle, a barbaric brotherhood. Amongst the Italians I have many good friends who warn me not to eat and drink with their painters, he says. Many of them are my enemies, and they copy my work. The nobles all wish me well, but few of the painters.

Canon Lorenz Beheim of Bamberg writes to their mutual friend, Willibald Pirckheimer. He wants a picture, and he wants it badly. It's a Firbankian exchange. I do not think that much begging is necessary if he is willing of his own accord, says the canon in Italian code. The obstacle is his barba bechina—his pointed beard—which doubtless has to be waved and curled every single day. Ma il gerzone suo abhorret, scio, la barba sua—But his boy, his gerzone, I know, loathes his beard: thus he had better be careful to shave. Dürer left his favourite student in charge of the studio: Hans Baldung, nicknamed Grien after the colour he liked to wear, an art-school boy in a fur hat.

Beauty is a currency we misspend in our youth. It's not a crime to look the way you do. Dürer's sketchbooks are full of boys, says Panofsky: the curiously effeminate countenance of a young man from Antwerp; handsome youths in the guise of Saints John or Sebastian. He paints the wealthy Paumgärtner twins, Stefan and Lukas, as George and Eustace in armour, in fancy dress. Dürer's in the middle, invisible. Someone says he's Stefan's lover.

They gossip in die Männerbad. Dürer plays the pipes like a faun, and is ogled over a drooping tap. The buff twins discuss business, Willibald swills beer. If only you were as nice and sleek as me, says Albert. There's some laddish banter about pricks up arses.

These cities in those days of doubt, wrote a Victorian historian, were like Paris in the mid-tide of the Revolution, full of lusty immorality. They go to dance halls in Nuremberg; Stefan

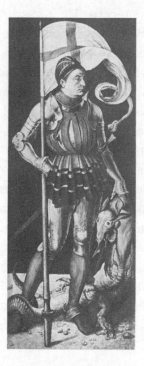 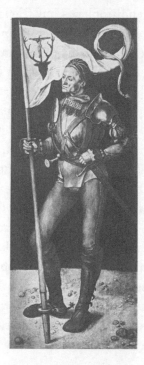

Philip Hoare

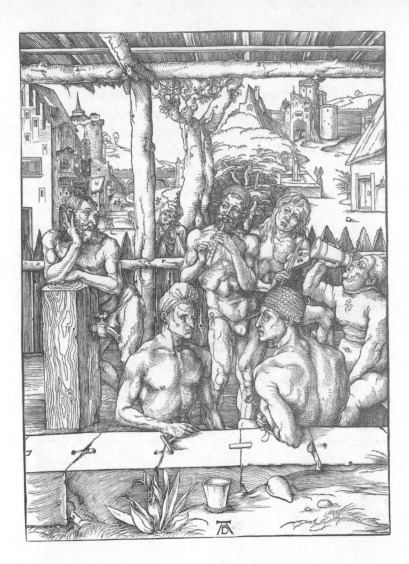

is arrested for dancing with a Jewish woman. Dürer's brother Hans is charged with brawling in a knife fight. Albrecht wears his artist's smock in the street, flaunting his talent, drinking with princes and forbidden people. The very behaviour his Apocalypse will warn against. Aristocrats love who they choose; for Dürer things are less assured.

Albert and the Whale

The Renaissance was born of the plague; art was fascinated with death. Dürer escaped to Venice in search of sensation, only to find another disease: syphilis, newly imported from the New World. I know nothing that I now more dread, he said. Many men are quite eaten up and die of it. His friend from Antwerp gives him a jar of Tiriax—a cure-all, known as Venice treacle, a concoction of opium and herbs to treat plague, rabies and melancholia. Theriac, from the Greek, theriake, relating to a wild beast; Galen said it was strong enough to calm the sea. James sends me an email from 1933.

Robert Byron, Venice, 20 August. We went to the Lido this morning, and the Doge's Palace looked more beautiful from a speed-boat than it ever did from a gondola. The bathing, on a calm day, must be the worst in Europe: water like hot saliva, cigar-ends floating into one's mouth, and shoals of jelly-fish. Lifar came to dinner. Bertie mentioned that all whales have syphilis.

Can Dürer be excluded from the records of dark impulses? asks Waetzoldt, in 1936. What had infection done to him? Art made him mortal as any god. He draws himself naked, a pawing tiger, a creature of the night; a star-crossed, sublunary lover, starkly lit in black and white. We have no idea whom he loved or even if love existed then.

Philip Hoare

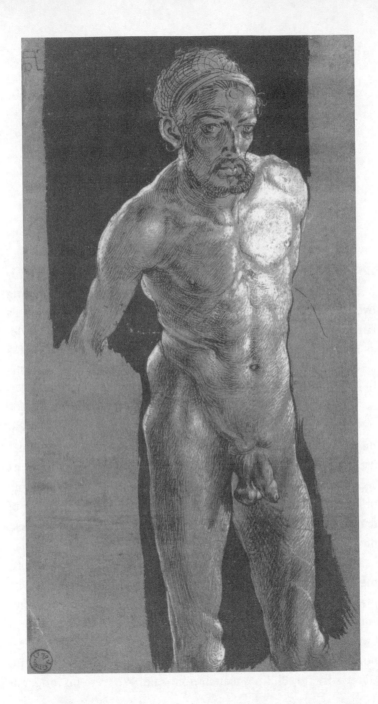

STAR

Boom! There it is, crashing through the ceiling. A heavenly body falling out of the sky. It could be anything: a shell bursting over the western front, a fiery dragon over the imperial palace, a corpusant born out of the ocean; an augury of a dissolving world, as someone said. Or the big bang itself, hastily sketched by the artist as he peered down the wrong end of a telescope into the beginning of time.

| Plate VII |

Hidden round the back of Dürer's St Jerome of 1494, one of his first paintings, barely bigger than this page you are reading, is this enormous star. You would have seen it only if you knew its secret: the galactic event going on, on the other side. Radiating orange-red rays, careering through the perpetual night. A thing of darkness created in light. The word comet came from the Greek, meaning long-haired, streaming away from the sun.

Dürer was living on the edge of new revelations, a world shifting nervously in space. Everything's happening too fast. The year before, Columbus had returned with America in his head, and Martin Behaim made the first modern globe in Nuremberg. Copernicus would publish his *De revolutionibus orbium coelestium* in the same city; he moved the earth and stopped the sun, Dürer's friend, Philip Melanchthon, said. We were no longer at

the centre of it all. Galileo, who pronounced the Milky Way a track of countless stars and gave the Northern Lights their Latin name, was overcome. He went blind as if from too much looking through his hand-ground lens. I feel an immense sadness and melancholy, together with extreme inappetite, he said, and felt his name was being wiped from history. We are caught, like John Donne, becalmed off the Azores:

But meteor-like, save that we move not, hover . . .
Dear friends, which meet dead in great fishes' jaws.

It's a cold and dark afternoon in the city. The starman died a year ago today. Propped up in the centre of the room, under a perspex box, is this relic. You'd walk past without a second glance, distracted by the saints and madonnas mortared to the wall. The label says it was probably used for private devotion. I take this as an instruction, and stand too long and too close for the comfort of the young guard. I've breached the respectable distance.

I can't help it. The picture pulls me in. It really is small, barely there at all. He had to fit everything in there. In its charred black frame, the star throbs like a nuclear core. A priest might hold it up to the eye of the storm. The guard's pacing is getting more urgent, his glances more suspicious. After his fifth pass, I slip round to the other side of the painting. He won't see me here. It's a relief to see something animal and human: a saint and his friends. The silent impact on the other side is mirrored here by the rock with which Jerome beats his chest. The two images might spin on a string, a twisted toy to placate a child, blurring the erupting star with the bursting heart.

| Plate VII |

Jerome in the wilderness, at dawn, prays to a cross in the stump of a silver birch. Pines stand on the crags. It might be Bavaria, if not for the appearance, quite casual and electric, of a golden lion. Dürer made his picture after Venice, where he saw the winged

beast perched in St Mark's Square. He wouldn't see a real lion till his trip to the Low Countries, when he drew one in Ghent; he gave the keeper three stivers for his trouble; the animal got nothing for his. Later, in the gardens in Brussels (where Leopold II would create a human zoo in 1897, exhibiting people from the Congo to whom visitors threw bananas), he sketched lions after slumber, roaring in exile, along with a lynx, a goat, and a blue baboon.

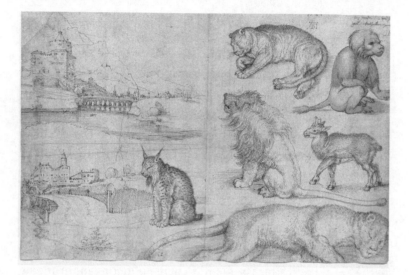

In Dürer's painting, Jerome's big cat, relieved of the thorn in his paw, wears a contented grin, ignoring the tiny goldfinch and bullfinch playing by a shallow stream. Their bright red patches speak of Christ's suffering. The attendant has moved to another room, satisfied my scribbling is benign. He doesn't realise this is what I've been waiting for. I lift up the box and ease the painting from its stand, and make off with it down the stairs.

Some thought Dürer's star depicted the days before the Last Judgement, as predicted by Jerome (I write this on the eve of his feast), of the days when all the stars will fall. Others saw it as an emblem of the limits of our knowledge: one of the *stellae*

Philip Hoare

errantes, the wanderers whose orbits could not be predicted. In fact, it was not a story at all.

On the night of 7 November 1492, a large meteorite fell to earth outside the village of Ensisheim, accompanied by crashing thunder and lightning as it hurtled through the clouds. It was visible and audible one hundred and fifty kilometres away. Only one witness, a young boy, saw it actually plunge into the field; but Dürer, abed nearby in Basel that night, could certainly have heard it. A huge rock tumbling out of the sky could only be an omen, a bad throw of the die. It was broadcast on a broadsheet by the poet Sebastian Brant (Dürer illustrated his bestselling *Ship of Fools*). It fell obliquely through the air, wrote Brant, as though hurled from a star like Saturn.

I don't know if Dürer visited it, but his emperor Maximilian did; he declared it a wonder of God and chipped off a piece for himself. The meteorite might have been the rock with which Jerome beat himself, or an emblem of the New World. But more than anything, it was a sign of Dürer's genius, as if that little panel he had painted was an announcement of his explosive talent.

As I write, a comet appears on the horizon as a little ghost, a disruption in the slow winding-down of time so low it might fall on my head. Light and darkness, sun and moon, stars and planets, trees, beasts, whales, fishes and birds of the air, all these things in the world around us once meant more to us than they meant in themselves, Thomas Merton wrote in 1953. That was why they entered so mysteriously into the substance of our poetry, of our visions, and of our dreams, the poet-monk said. I have also seen a Comet in the sky, said Dürer from his cell-observatory. But the most wonderful thing I ever saw occurred in the year 1503, when splashes came from the sky, auguries of the plague, infection falling as blood-red rain, spattering clothes the crosses or even an entire Crucifixion scene, which Dürer drew from the shawl of a serving girl. The maid was so troubled, he said, that she wept and cried aloud, for she feared she must die because of it.

Scientists would see this phenomenon as the result of micro-algae staining the rain red, an explanation Dürer may have preferred. But he also believed in signs and wonders. If a comet was an omen, what might his own genius prophesy? How wonderful it would be, he said, if, with the help of God, I could already see the works of the great masters of the future!

The Apocalypse. That's what that fiery stone foresaw. A vision so searing it seems impossible he didn't see it in Technicolor, a cinema trailer for what lay ahead. Its key image was truly horrifying: Death, Famine, War, Plague, riding roughshod over humanity; murderous, vindictive, inane, a hateful corps borne in on helicopters. Once seen, there was no escaping it, ever again.

A terrible new beauty. Pursued by plague, comets and floods, Dürer created his dark fantasy out of light, the spaces the ink let in. The economy of print freed him from patrons who wanted another madonna or a portrait of themselves. Painting was old; Dürer made art new. The woodcut was an instant hit; Ruskin called it the art of the scratch. The prints peeled off the press like posters, fifteen by eleven and a half inches. Like ships of a great merchant, said Panofsky, they carried Dürer's flag all over the world. They were the currency of his fame from Hungary to the Low Countries, from England to Italy. He became, as Laura Cumming observes, the first genuinely international artist.

At first he cut his images himself. As demand grew, he transferred the designs to blocks for professional cutters (like tailors, they earned more than him). He sent his reps to other cities, telling them to ask higher prices if they could. His mother sold her son's prints in a booth in the town square. Dürer took art out of the church; his prints were pasted onto cupboards and walls, mass-produced by his city studio like Warhol's Factory in six-ties New York; both artists were migrants' sons with origins in eastern Europe; both were obsessed with their self-portraits, recording glamour and disaster. Panofsky, in nineteen-forties America, the light squeezing through his venetian blinds,

Philip Hoare

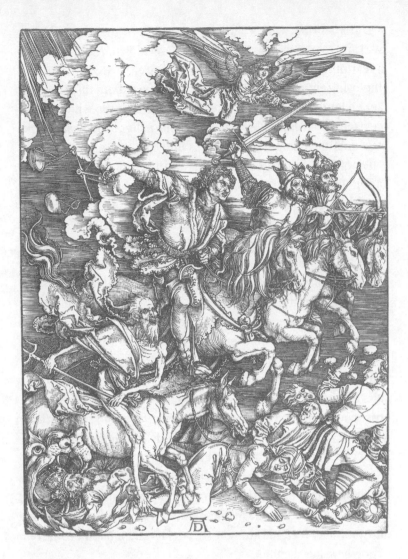

was awestruck. He saw Dürer's woodcuts as photographic, a new spatial concept, the scene in heaven brought so near the beholder that the celestial apparition seemed to descend upon the earth. Dürer defied the objective laws of nature, said Panofsky, and abolished the distinction between hallucination and reality.

Dürer's prints are revolutionary because of their speed. They swirl and roar. You want to turn the volume down. As Europe lived in fear of famine and plague and war, Dürer danced with death, employing emptiness to evoke things that were both there and not there: clouds and fire and water and air. It was the whiteness of the page which enthralled him. His white is light and heat, sparking saints and demons and civilians into sprawling, brawling life.

Panofsky—fascinated as he was by the work of Disney—saw Dürer's prints as a realm of the fantastic and the visionary into which the artist's imagination had been released by technology. The critic could have no idea, in his century, of that speed, any more than Dürer did. In 1500, an ordinary person could expect to see fewer human-made images in a lifetime than we see in a minute. Art was reserved, but it was understood. It had a specific role. In churches and monasteries, paintings and statues and windows were devotional, interactive, alive. Candles and prayers were offered to these portals between the real and the supernatural. Dürer opened up a wider world, just like Columbus and Copernicus. A visionary universe. It wasn't easy to behold. His suite of fifteen images rear up in our faces, in scenes so awful the artist could only use black ink; anything else would be too much to bear. We fill in the colour in our heads, these dreams held in black and white, in the northern light.

Is there anything he does not say in one colour? Erasmus asked; the philosopher believed Dürer could express language itself in his art. He had turned the medieval modern, as one century ticked into another. He stared straight ahead. His talent hadn't come out of nowhere like a comet.

Occasionally, God gives an artist the power to learn and create something valid, Dürer said; then, nobody is his equal among his contemporaries and perhaps not even among his predecessors and successors, at least for a time.

His prints are hard with the wood from which they are cut, inked from oak galls with the air of clouds. They may be filled

with muscles and wings, but they peer past pale flesh and into the infinite. In Adoration of the Trinity, Dürer depicts a broken Christ in His father's arms, mysteriously suspended, as Panofsky says, before a sombre sky lit up by milky clouds and by the electric flashes of the haloes. This Saviour is a floppy bird. He still bears the shape of His death.

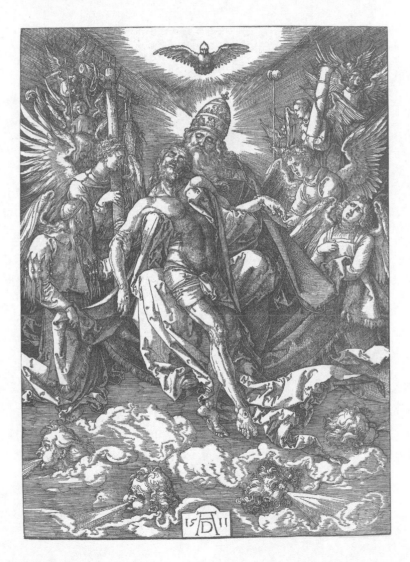

He sags like a dancer; Dürer takes up that weight and carves it away. His woodcuts are sculptures: they have depth; they resist and yield. They're the first industrial artworks. The forty Nuremberg presses run by Anton Koberger, Dürer's godfather, employed a hundred men. Panofsky saw Dürer's engraving tool as an extension of the artist's hand, as though he'd become an automaton

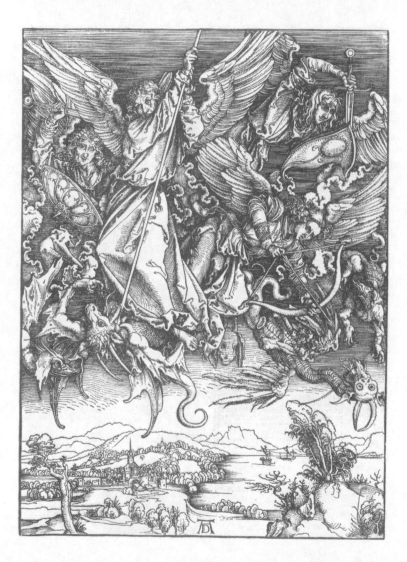

himself. The result was science fiction. Flames leap from God's head as meteors rain down like starfish; the Whore of Babylon is a courtesan from Venice. Castles explode and demons appear out of manholes, and the sky rolls back to reveal real seraphim battling dragons over European towns.

In Andrei Tarkovsky's film *Ivan's Childhood*, set behind wartime lines, a young officer shows a boy an art book.

It's captured material, he says.

The boy looks at the prints. Are they Fritzes? I know them.

Look at the skinny one. I saw one just like him on a motorcycle.

All this cutting and slicing was daemonic; Dürer gave you more ink per square inch. We still can't work out how. Peter Ursem, a Dutch artist, tells me that woodcuts differed from wood engravings. Cuts were made on blocks sliced laterally from trees, parallel to the grain. Working with this relatively soft surface, the artist had to make broad marks. Only in the eighteenth century, when Thomas Bewick used the dense end-grain of fruitwood, would great detail emerge. Yet Dürer achieved that effect with woodcuts. He was releasing images, like Ariel being set free from a tree. It was sorcery.

In the museum's print room, a wooden tray is brought out. Neatly arranged on it are eighteen pearwood blocks with a leaden sheen. They're fossils, or contour maps of the seabed. In their

gullies and crevices, agony collects. Dürer turned these blocks in his inky fingers, before the next run. Adam and Eve are chased from Eden; an archangel wields a sword; Christ dies, over and over again.

In 1515, Dürer created his Man of Sorrows, the first metal etching known to western history. The process allowed yet more extreme effects. If his woodcuts were astounding, his engravings seemed almost uncanny. When Ruskin told his apprentices to copy half an inch of Melencolia, he knew it was beyond their means. It could not be better done, he said. When a modern American engraver, Andrew Raftery, tried to replicate a Dürer, it took him forty hours to etch an image one inch wide. Even with magnification and the highest level of mental focus I could muster, he says, I was never able to fit quite as many lines in as the original. It was impossible to move beyond my own hand as an artist.

Dürer's mastery of this dark art struck fear in those who, like Luther, believed printing produced too much information; it would overload the minds of people, in the way that, centuries later, it was thought trains could cause women's wombs to fly out. It even changed the Word of God: Dürer's images of the Apocalypse were bigger than the biblical text of the book in which they were published, just as when Rockwell Kent's illustrated

Moby-Dick, a bible-like edition, was published in 1930, it had Kent's name on the cover, but not Melville's.

Kent had read Nietzsche in his teens and saw himself as an Übermensch. But then, as a fierce socialist in the nineteen-twenties, he declared that it was through art the essential superiority of the white race could be obliterated. He was as self-promotional as Dürer, to the extent that he incorporated his name on the New York stock exchange; but he also gave a large collection of his work to the Soviet Union. His white whale took over from Dürer's imagining: an apocalyptic creature spouting his frothed defiance to the skies from a newly drowned world.

Melville said scrimshaw—engraving on whale teeth and bones—was as full of the same barbaric spirit and suggestiveness as the prints of that fine old Dutch savage, Albert Dürer. It was impatient of the whale not to wait, to be accounted immortal by these authors and artists. Dürer's dragons were halfway to being whales; there's not much difference if you've only ever seen mysterious bones or pictures in books. The more lifelike and

individualised the details of the dragon, says Panofsky, the more monstrous the whole. So many heads rearing up, so many stars falling down. Then, when you least expect it, there it is.

The sea. The skin of infinity.

Ruskin couldn't fathom it. Dürer's continual and forced introduction of the sea in almost every scene, he said, much as it is to

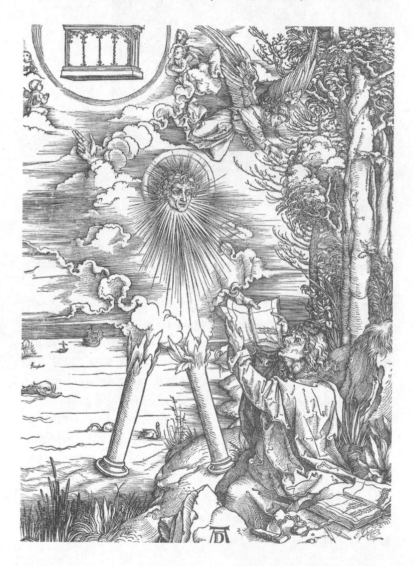

Philip Hoare

be regretted, is possibly owing to his happy recollections of the sea-city where, for once in his life, he was understood. From the Venetian lagoon Dürer drew a lobster; its fiendish eye and hungry claws seemed to lead a vicious life of their own, said Panofsky, who thought it looked like a devil by Bosch. But then an even odder creature appeared.

As an angel's head hovered and John ate his book, a ferocious beast slouched into view, all helmeted head and great jaws ready to eat the dead. Though universally denominated a dolphin, Melville said, I nevertheless call this book-binder's fish an attempt at a whale, since dolphins were popularly supposed by the old masters to be a species of the Leviathan.

In this mixed-up, cross-bred world, caught between old and new, animals and humans got confused. Dürer remembered the story of Arion, the poet thrown into the sea and saved by a dolphin. He carefully drew the scene for the private edification of his friends, a reflection in a golden eye. But leaning a little closer, Melville might have discerned familiar features in its muscled hero: the savage artist himself, riding the cetacean he never saw.

EXOTICA

There were other things to distract Dürer from dreams of dolphins and disasters. He'd been struck by something else, something spectacular that had landed in the Low Countries. Not a meteorite or a whale, but certainly a consignment from another world. A mass of gold and iridescence, in the heart of the city, stranded in its imperial palace.

In 1519, Hernán Cortés sent back a treasure ship from the New World. Charles v received the consignment in Brussels, where it was put on show to celebrate his coronation in 1520. Dürer came from a city of gold and silver, but he'd never seen anything like this. I saw things which had been brought to the King from the new land of gold, he said, a sun all of gold a whole fathom broad, and a moon all of silver of the same size.

They might have come from a crashed UFO. This booty was not only cast in the shape of animals that had never been seen, it was mixed up with their mortal remains. There were shields fledged with electric feathers of resplendent quetzals, and others stretched with the strange spotted jaguar skins. There were weapons stuck with obsidian blades sharper than steel, and black mirrors of the same infernal substance in which you could see the future reflected. And there were books that unfolded like painted screens, with images as apocalyptic and alien as any Dürer had ever drawn.

Philip Hoare

Cortés enumerated it all for his new emperor, to whom he owed a fifth of what he had found. He filled in his tax return under the Mexican sun—

First, a large gold wheel with a design of monsters on it and worked all over with foliage. *Item*, two necklaces of gold and stone mosaic with strings of red and green jewels, twenty-seven small gold bells and four figures studded with stones and hanging with pendants inlaid with gold. *Another item*, in a box, a large piece of featherwork, lined with animal skin which, in colour, seems like that of a marten, with a golden disc and blue and red stone mosaic.

The conquistadore had no words to describe this; he could only make a list.

Furthermore, a mirror set in featherwork and blue and red stones, a large gold head which seems to be that of an alligator. *Another item*, some fibres placed in some coloured feathers; the which fibres are white and look like locks of hair. *Another item*, a reed container with two large pieces of gold to be worn on the head; they are made like gold shells with ear ornaments of wood with gold plates; four pieces made after the manner of skates, their tails, gills, eyes and mouths of gold; four harpoons of white flint, fastened to four rods of featherwork. *Furthermore*, a sceptre of red stone mosaic, made to resemble a snake with head, teeth and eyes in what seems to be mother-of-pearl, the hilt adorned with the skin of a spotted animal.

Dürer ran out of words too. A goldsmith's son knew what it took to make such things. He recorded other rooms full of armour, and all manner of wondrous weapons of theirs, harnesses and darts, very strange clothing, beds, and all kinds of wonderful objects of human use. All the days of my life I have seen nothing that rejoiced my heart so much as these things, he confessed, for I saw amongst them wonderful works of art, and I marvelled at the subtle *Ingenia* of men in foreign lands. Indeed I cannot express all that I thought there.

Cortés claimed all this gold had been waiting for him to pick it up. As though his mission was preordained. He valued the sun disc, as big as a cartwheel, at 3,800 pesos; his officer, Bernal Díaz de Castillo, thought it worth more like ten thousand. The tally came to fifty items and included a feathered shield and a head-dress later claimed as Moctezuma's,

Another item, A fan of featherwork in the manner of a weather-cock. Above it has a crown of featherwork and finally many long green feathers—as if clipped from his wings.

Cortés told his hosts to fill a helmet with gold dust. The Aztecs couldn't believe the greed. They stood there, stunned. They lifted up the gold as if they were monkeys, with expressions of joy, wrote their chronicler, as if it put new life into them and lit up their hearts. As if it were something for which they yearn. Their bodies fatten on it and they hunger violently for it. They crave gold like hungry swine. The Aztecs offered them their dust, but the conquistadores followed it like a trail of breadcrumbs. As he reached the god-emperor, Cortés took off the necklace of pearls and cut glass he was wearing and gave it to Moctezuma. He received, in return, two strings of red shells hung with golden shrimps.

We see all this swagger through Dürer's journal; there are no other reviews of this show of stolen goods. Just as the whale bones in the nearby town hall bore witness to something Dürer never saw, so these gold shapes sliced like hearts from living men came from another culture he could not understand. The artist stumbled out, blinded by what he had seen: the last shining moment of all this useless beauty. In Mexico, the conquerors had saved the most exquisitely worked pieces from the melting pot to send back, but Charles consigned them to the furnace, in the same way that whales were boiled down for their oil.

They couldn't bear the shame: the ingots financed their new wars; Moctezuma's treasure funded his demise; the memory of his people perished under its weight. This was real alchemy =

stolen gold to pay for troops + rendered blubber to make munitions + plundered uranium to make a bomb.

Wolfgang and Albrecht stood in wonder.

That's awesome, said Albrecht.

Satan's greatest work of art, said Wolfgang.

As a boy, I too yearned for those things. I would have queued round the block to see them, when Charles brought them to London in 1522. I lusted over feathered shields and headdresses I saw in books I took out from the library. I became a teenage warrior in my bedroom mirror, a fledgling prince in an advertisement, trembling quetzal crown on my head, purple robe wrapped round my brown body. The word Aztec had an electric allure. I never knew the cost. But I was always an Indian, not a cowboy. Dürer was the same savage messiah, cloaked in this fabulous regalia, flying, a drugged bird-man-god in the air. He could not have known that his own visions of the Apocalypse would soon be shown to those same subdued people as prophecies of what would happen if they did not bow to the one true God.

Once, an hour west of Guadalajara, I nearly walked the wrong way round one of their turfed pyramids with a friend. I said we might draw the devil onto our backs if we did. How do you know he isn't already there? Iain replied. I saw raw obsidian for the first time, black glass that had bubbled out of the mountains, and I was given a pale green, polished lump of crystal the size of my hand, shaped like a lens. I left with it in my bag. I still have it, here. A dark green skein runs through it, like a strand of seaweed or a story.

Two years after Dürer saw such signs and wonders, and secretly longed to ship them back to Nuremberg as a challenge to all those imperial crowns and holy lances, Charles presented the feathered shield and headdress and the silver moon and the black mirror

to his aunt, the Archduchess Margaret of Austria, Governor of the Netherlands. He added sackfuls of pearls. In her palace at Mechelen, Margaret was busy filling her apartments with corals on clay bases and birds of paradise wrapped in taffeta, and works of art such as Van Eyck's exquisite Arnolfini portrait, its cover unlocked only for special visitors.

Margaret even collected her own husband—John, the son of Ferdinand and Isabella of Aragon—in the shape of his embalmed heart, which she had kept close by her side ever since his early death at the age of eighteen, supposedly of over-exertion in his lust for his young wife. Now she liked to wander round her palace and grounds in a black velvet gown with long wide sleeves trimmed with ermine, accompanied by her greyhound, her marmoset and her beloved green parrot, who perched on her shoulder, disconcerting guests. No one knew where to look: at the archduchess's examining eyes, or to engage the haughty, head-cocked stare of her avian companion and the other familiars who acted as her advisers.

Dürer's visit to the archduchess was not a success, to be honest. It all started so well. When he'd sought her intercession with her nephew—could she persuade Charles to look benevolently on the artist's pension?—Margaret had shown herself to be exceptionally kind. Dürer sent her his Passion engraved in copper and charcoal portraits of her staff, along with a set of all his printed works. He even drew her two new pictures on parchment with the greatest pains and care.

All this at a cost of thirty florins, he reckoned. But when he visited her in person, in her library where she received such esteemed visitors as Erasmus, and where many of her treasures were displayed, his offer of the portrait of her late father was met with such distaste he had to take it back. It was humiliating, the way Princess Margaret stared at me when I ordered a second helping of bread and butter pudding after the royal spoon and fork had been put down.

Philip Hoare

She gave me no recompense for everything that I gave and did for her, Dürer complained. He ended up exchanging the portrait for a length of white English cloth with one of her employees. He blamed the parrot and the monkey and their beady eyes. That little devil, down there at her feet.

We must forgive the archduchess and her animals, her sackful of pearls, her sex and her suburban palace with no curtains, even her manners, too. She could hardly be expected to consider the feelings of a mere artist, after all. She was an emperor's daughter, for goodness' sake, with a god for a father. Hadn't she ridden in Maximilian's Triumphal Procession, designed by Dürer and his peers, a giant billboard a hundred and eighty feet long, with the emperor in a baroque charabanc drawn by caparisoned horses, followed by a weary line of camels and bears and a trophy group of people from the Indies? This imaginary parade was just one of the fantastical projects Dürer had created for his patron. Known as the Last Knight, Maximilian claimed direct descent from Osiris, Hercules, Hector of Troy and Noah. His cv was equally impressive. Under Interests, he listed veterinary surgery, cooking, fashion design, mechanised warfare, mining, fishing, carpentry, poetry and art criticism; all excellent if somewhat breathless qualifications for a world leader.

And although many of Maximilian's fascinations remained on paper, even then they managed to be grandiose, not least his massive Triumphal Arch, also created by a team of artists led by Dürer. It was the largest such image ever made: a composite of one hundred and ninety-two woodcut blocks over an area eleven by nine feet wide, rising in arches, pillars and cupolas, stacked with jewels, relics, eagles, fettered monkeys, harpies and dragons and giant snails; a truly strange arrangement which Panofsky saw as an anticipation of modern surrealism. A future ruin, eyeless in the sand. And at the centre of it all sat the emperor, reading his personalised prayer book, also illustrated by Dürer, in which cranes and unicorns pranced and preened.

Animals strike curious poses in Dürer's world, most especially in his three master engravings, products of that technical advance. These impossibly detailed and wondrous images, which you could spend a lifetime looking at, are central to Dürer's art, according to the Victorian critic William Martin Conway, and admit us to the sanctuary of a noble soul. Two of these scenarios seem easy to understand: the knight's youthful resolution, the heroic past; the monk's erudition, a comfortable old age. It is the central state of the angel that presents the artist's dilemma: his present, which he could never resolve.

Philip Hoare

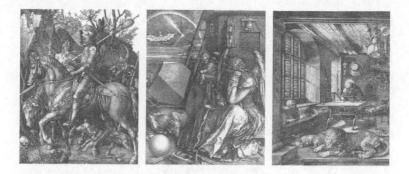

In his writing as in his art, Dürer turned to the ancient humours. They defined his world, from the animals he drew to the temperaments of the boys he selected for his studio. Of these four states or fluids—sanguine, of spring, of infancy and of air; choleric, of summer, of youth and of fire; melancholic, of autumn, of adulthood and of earth; and phlegmatic, of winter, of old age and of water—melancholia was the most pervasive, since it was the middle-aged state he was in.

The word came from the Greek, melan, meaning black, and cholc, bile. Its effects start to dominate at around fifty or sixty years old; symptoms included dryness, thinness, forgetfulness and misanthropy. But it could happen at any age, a shadow thrown across the face. If not arrested, it led to insanity, to be cured only by extreme measures: music, flogging or cauterisation, a process which Francis of Assisi underwent in his last years when he had a white-hot iron rod drawn from ear to eyebrow. It was a terrifying therapy, but the saint claimed to feel no pain.

Dürer had ever felt himself under the sway of Saturn, the melancholy star. In 1503 he had suffered a disease of the pancreas. He sent a picture to his doctor pointing to the source of his distress. Who knew their body better than an artist, attuned to its every vibration and disturbance? He didn't need to draw himself so beautifully. This is where it hurts, he said, like Christ.

Dürer, in his room, surrounded by fins and horns and furs, by books and cures and unanswered prayers, knew only this life or the next; human and God's time. Science had yet to explain who we were or what we might become. Everything was fixed like the future, like the stars. The angel peered up at his wound.

The only thing the critics agree on about Melencolia is that it is the most analysed object in the history of art. No other artist left behind such a cypher. It became his calling card—I gave a Melencolia to a young count at Cologne, he noted—but that was like confessing all your complexes on a first date. He's Byron, hand on chin, Wilde draped on a couch, the starman in a damask dress. It's one of those still misty nights when the sea opens up like an invitation. You can't sleep but can't stay awake. A lunar bow arcs over the bay, a comet bursts in the sky. The title is held in the claws of a bat-winged thing with a cowled head and a spermatozoa tail. Unlike the afternoon sun flooding Jerome's room, this eerie midnight light comes from the comet or the moon.

Philip Hoare

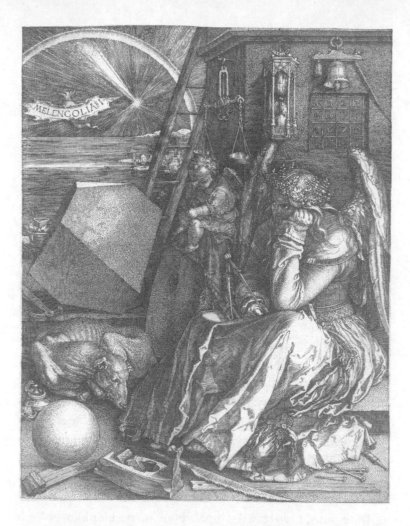

There must be a reason for all this gloom. Did Dürer remember Albertus's remark about a bat's weak sight shattered by sunlight? We think of things plain as night and day, but there's nothing black and white here. I peer at the sea with an eyeglass, expecting to see a rearing narwhal or a walrus, or a figure pursued across the ice. The instruments lie. The bell doesn't ring, the scales weigh nothing and the sand doesn't run out of the glass.

Is that a boy or a girl? It's difficult to tell these days.

Put the critics in a room and you might as well have shown them a mermaid. Elizabeth Garner sees the shapes of ships in the folds of the gown; Jonathan Jones thinks the angel echoes the artistic paralysis of Leonardo; Colin Eisler says boiled bats could alleviate stupor and numbness, as if that little demon advertised his own remedy; Caroline Joan Picart discerns eroticism, death, music and laughter in the four sides of the magic square. Others read grief into those numbers on the wall, the date of the death of Dürer's mother, 1514. Nothing has been proved, starting with the title. No one knows why it is numbered I and sectioned thus: §. Is it this regnal number of states yet to come. or the first in a series of promised visitations of ghosts from the future past? I search for clues the way a teenager studies an album cover. Panofsky, ever phlegmatic, says it simply refers to a scale of values which could be found in the works of Dürer's contemporary Cornelius Agrippa, the pre-eminent doctor of melancholy.

Agrippa, born near Cologne in 1486, was a physician, soldier and occultist, also in the service of Maximilian, and the archduchess Margaret (he flattered her with his treatise on the superiority of women). As a follower of Albertus, Agrippa was known for his defence of witches and was said to have a familiar in the shape of a dog who, when his master drew near death, threw himself in the river. It was to Agrippa's secret knowledge that young Victor Frankenstein had also turned; his tutor told him not to waste his time on such sad trash.

Dürer must have read Agrippa's book on occult philosophy; it reassured him, like all good hypochondriacs, of what he already knew. Agrippa said only the most metaphysically minded were susceptible to the influence of Saturn, the starry source of melancholy. There are three kinds of genius which act under its impulse, he said, the first of which were artists or craftsmen who, blessed with the gift of prophecy, would be able to predict storms, earthquakes or floods, epidemics, famines and other catastrophes.

Panofsky explains that as the artist represents the first state of

Philip Hoare

melancholy, so Dürer's picture becomes number one. And so he stakes his claim. Albrecht's friend Philip Melanchthon (his own name meant black earth) spoke of *melancholia generosissima Dureri*, Dürer's most noble melancholy, as if it were a binomial; a species or a virus. A glorious dis-ease of genius. Far from a depressive condition, this was a positive, creative state. An artistic ambition, an intellectual intent.

As I peer into the immaculate first impression Ruskin owned, like a black mirror (he had offered it to Elizabeth Siddal—whom he also regarded as a melancholy genius—to hang in her room), I see with a shock how astonishing the picture was, before repeated printing blunted the angel's bright face into a dark scowl. This mystery is Dürer's fame; his audience expected a game. By releasing such an ambivalent image, he created a new existential state. (Inspired by Dürer, Sartre's first novel, *Nausea*, was originally entitled *Melancholia*.)

This is how far we have come. This is how clever we are.

You can see why all this appealed to Panofsky, who liked to show silent films to his friends. In order to describe Dürer's art in words, the critic employed directorial terms, close-up and ordinary shot; he zoomed in and out, and panned up and down. His 1920s Melencolia became the blue angel sashaying on stage in satin and fur; the smudge eyed, steely somnambulist standing by his cabinet.

But that only begged more questions. Where did this world originate? In the infinite heavens or under the endless sea? How could something so full be so empty? Aristotle had said nothing could come of nothing; something had to be there first. Augustine (who was glad God did not hold him responsible for his dreams) thought the world was formed from formless matter. Albertus couldn't make up his mind (he'd found fossils challenging); his pupil, Thomas Aquinas, saw this inconstancy embodied (or not) in the shape of the angels, for whom he had to find a new definition.

The word angel meant messenger; they were not pure beings (only God could be that), but a third order: neither matter nor pure act, something in-between; Aquinas called it aevum. It was a state between time and eternity, Frank Kermode said in 1966, in his lectures on the sense of an ending. He called it the time-order of novels, but it was also the time-order of art.

Dürer's being is a fluid spirit, caught between heaven and earth. Among the many images the artist sent into the world—one hundred paintings, three hundred prints, a thousand drawings—it is this one that gathers force, becoming more obscure, and therefore more beautiful, the further away it is. Its exploding star is the source of its light, but it is haunted by the sea.

That's where its ambiguity lies. The profound deep. The angel astride the quay. The ladder going nowhere. The monolithic stone humming like an alien intelligence (there's a shadowy face on its side). Animals, pigments, gold, war, people, the plague; this unspecified portside might be cluttered with cargo and ideas. We can't work out where to look. We're flipping backwards through a book, scrolling down a screen, with no idea what to expect.

The distant town is about to be inundated. Saturn was the lord of the ocean; his children liked to live on or by the sea; he was associated with floods and spring tides. Since Babylonian times, said Panofsky (who liked to tell a story), it had been considered a fact that a comet with its head towards the earth pointed to abnormally high water. It brings the disorder, said Ruskin, who'd sit watching the sea for five hours on end. The sea is our collective unconsciousness, Jung wrote, a lonely and desolate place where weird ghostly shadows flit about in place of people. Any body of water evokes the eerie, the body beneath the skin, a body that isn't a body at all. Absence and presence. The *real* sea is cold and black, full of animals, Sartre said, it crawls underneath this thin green film which is designed to deceive people. When he sold off his collection of pictures to forestall poverty, Blake kept back one print: Melencolia, hanging in his lodgings overlooking

Philip Hoare

the Thames. He had already re-engraved its angel as Newton, naked at the bottom of the sea, trying to measure eternity.

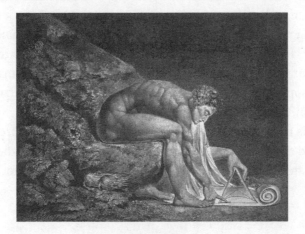

The whole thing was all a trick, of course. An hourglass appears in all three of these engravings, as time runs out. The numbers in each line of the magic square add up to thirty-four—an alchemical number supposed to unite the physical and spiritual. Freemasonry started with stonemasons' secret signs and passwords; it may explain the tools—the mallet, the compasses. But the little instrument tucked behind the angel's gown, next to the cruel nails, is a clyster, designed to deliver an enema. After his attempt to see the whale, Dürer had resort to the apothecary in Antwerp, paying fifteen stivers for a prescription and a further fourteen for the apothecary's wife to administer it. It can't have been a dignified scene. When the melancholic Coleridge became addicted to the binding force of opium, he was forced to ask the captain of the ship on which he was sailing to apply the same instrument. Unlike Leo's elephant, neither painter nor poet received gold-infused enemas. They did not turn precious metal into shit.

For all its exactitude, this picture is incomplete, abandoned in time, number one in a sequence never to be completed, from

Dürer to Blake, de Chirico, Magritte, Duchamp and Kiefer; from *The Waste Land* and *Endgame* and the blackness behind your device. We are not of today or yesterday, we are of an immense age, Jung tells the BBC in 1959. A figure stumbles down a scree. The angel watches an overloaded bank of screens. That fixed stare, said Panofsky, is one of intent though fruitless searching. All known cures—music, boiled bats, searing pokers, malaria, philosophy—proved ineffectual. And so he came to his final conclusion; he'd been writing about this image since 1923.

This is, he said, a spiritual self-portrait of Albrecht Dürer.

And this is where we enter the ravine and encounter the dark one. After all, we're all haunted by what we have, or have not done.

TEMPTATION

He stalks our dreams. That dark sexy shape. Could you turn him down? We have words for all sorts of things, but we don't like to guess at his name.

In February 1520, shortly before Dürer came to claim his passport from the prince-bishop of Bamberg, another wandering German arrived in the same castle on the hill. The astrologist and alchemist Johann Georg Faust was a shadowy figure, bearded and long-haired. A man with a reputation. The bishop asked him to cast his horoscope. They believed in the stars, these men. A few years before, Dürer's friend Lorenz Beheim, a member of the same court, had cast the artist's horoscope; he predicted travel and love. We don't know what Faust foresaw for the bishop.

Dürer came bearing gifts: a painting of the Madonna, and his Apocalypse prints. Did he meet Faust in some dark corner of the castle and see a mirror of himself? Later, when he tried to enter neighbouring Nuremberg, Faust was denied free passage on account of being a black magician and a sodomite. The town elders did not mention that he had the worst reputation of all: of having sold his soul to the devil in return for twenty-four years of secret knowledge. In other versions of this story, which has Jewish origins, he becomes Doctor Faustus, roaming the German lands with his black dog who is able to turn into his

human servant. After his allotted span of inspiration, Albertus lost his senses before being taken unto God; Faustus, practising his dark arts, is claimed by Mephistopheles and descends into hell.

Faustus's pact came to haunt artists and writers: the idea that you might exchange heaven for genius; of something forbidden for which you must pay. Man's ambitions were the devil's pandemonium; the myth reappears throughout history like a crack in the earth. In Christopher Marlowe's masque-like play of 1592, his Faustus is swollen with self-conceit: His waxen wings did mount above his reach, | And, melting, heavens conspir'd his overthrow; | For, falling to a devilish exercise, | And glutted now with learning's golden gifts, | He surfeits upon cursed necromancy.

Marlowe's extravagant drama is filled with angels and devils, with Agrippa and Albertus and Orion's drizzling look, and spirits that can dry the sea and fetch the treasure of all foreign wrecks and make the moon drop from her sphere. His Faustus is granted visions of the empyreal heavens, of the planets and their true movements; he is shown the pope and his cardinals in Rome and pesters them as a troublesome ghost; he haunts Charles, the emperor of Germany, and takes Helen of Troy as a lover. Realising too late the uselessness of all this, Faustus says he will burn his wicked books if only his soul can be saved; but at the last hour the devils tear him limb from limb, and carry him off to eternal torment.

Marlowe's drama is a recurring nightmare—it was said real devils appeared onstage during its performances and sent sane men mad—and in turn it inspired Shakespeare's dreamlike *Tempest*; although his magician, Prospero, would rather drown his books than allow his knowledge loosed on the world. A century later, Johann Wolfgang von Goethe, Germany's greatest writer, embarked on his *Faust*, which he began in 1775 and didn't finish for sixty years. It consumed him. Unlike Marlowe's

performance, short and sensational like his life, Goethe's epic is an interior play for an audience of one, in which you, the reader, are complicit in what unfolds: the intimate depiction of despair, as we find the doctor in his high-arched room: This is then | Thy world, O Faustus! this is called a world! | And dost thou ask, why thus tumultuously | Thy heart is throbbing in thy bosom, why | Some nameless feeling tortures ev'ry nerve, | And shakes thy soul within?

Goethe's scenes drew on Dürer's woodcuts, which affected the dramatist's work intensely. In this gothic chamber, which might be Dürer's studio, Faust's poodle turns into a hippopotamus with eyes of flame and enormous tusks, then swells to the size of an elephant before becoming Mephistopheles dressed as a travelling student, offering unearthly entertainment, presenting pictures like screens: a Leipzig drinking club; a witch's kitchen with familiars that are half-monkey, half-cat; and the bare mountain on Walpurgis Night, where he and Faust ride black steeds that snort along.

Humans, animals, spirits combine; all the devils really were there. Faust's torment is a psychological state. Samuel Taylor Coleridge, who was called a mad German poet for the wildness of his verse, was engaged to translate Goethe's play; he'd already lived it through the frightful fiend who stalked his ancient mariner for having shot the albatross. The same story gripped Byron and the Shelleys and their strangely constructed souls, as Mary Shelley wrote. Through Goethe, painters such as Caspar David Friedrich traced Faust's dilemma back to Dürer's craving for perfection. One of them, Carl Gustav Carus, even claimed the angel of Melencolia was Faustus himself.

These airy, obsessed young men saw their sense of isolation in Dürer's eyes, and their love of their country in his knights, his mountains and his trees. Dürer had gone beyond nature. His portrait, with his long curling hair and haunting stare, represented both saviour and magician. What was natural or unnatural? Did

we offend God with our efforts to remodel ourselves, our search for art and meaning in a painful, incomprehensible world?

The lie is in our understanding, said Dürer. Perhaps it would have been better to have left it alone.

Thomas Mann was born in 1875, the son of a wealthy grain merchant and his Brazilian wife. He grew up in Lübeck, a port which was still medieval, but by the nineteen-twenties he was living in Munich, a resplendent city, he said, where carefree young men devoted themselves to the arts, seeking moods of inspiration in the bright blue morning sky. Thomas, his wife, Katia, and their six children occupied a fine new villa on the banks of the river Isar, which roared past like the sea he'd known as a boy. Orderly, elegant and remote, like his books—a reviewer wrote of his first novel, his family saga *Buddenbrooks*, that its final perfection of clearness made it as satisfying as a Dürer drawing—Mann wore the finest clothes he could afford, often of English suiting. But he also liked to remind himself, secretly: I am partly of Latin-American blood.

He was devilishly good-looking, you might say. When Thomas, the consul in *Buddenbrooks*, leaves his dressing room, in tailored clothes, the fresh underwear on his body, the smell of brilliantine on his moustache, and the cool astringent taste of the mouthwash he used—all this gives him a feeling of satisfaction and adequacy, like that of an actor who has adjusted every detail of his costume and make-up and now steps out upon the stage.

Mann was born, by the sea, to be restless. His story of the Buddenbrook family drew on an international trade which would be familiar to Dürer. In 1846, for instance, the year in which one of his early chapters is set, a list of the principal articles imported into Hamburg from Norway included 4,758 lb of blue colours, 83,209 lb of rolled copper, 205 marten skins, 28 skins of hares and rabbits, 787 lb of walrus ivory and one million pots of train

oil, rendered down from whales and seals. Elemental and raw. Our native products, says Consul Buddenbrook: grain, rape-seed, hides and skin, wool, oil, oil-cake, bones, etc.

Mann left all that oil and grain behind. In Munich, art mattered more than trade. In its vast museum, the Pinakothek, Dürer's 1500 portrait hung like an icon; Nuremberg, where the artist's house was regarded as a relic, was only a short train ride away. From the city's statues, parks and galleries to the forests and castles beyond, Mann felt he was living at the end of that romanticism. And as he held three great figures of the last century close to his heart, so they held Dürer close to theirs.

Goethe saw the artist as the essence of the strong German soul; to him the artist's manliness and grace was the spirit of Germany, as if his woodcuts were carved from the Black Forest itself. Nietzsche cherished his print of The Rider, now known as Knight, Death and Devil, framing it in purple velvet—saying,

It stands very close to me, I can hardly say how—then gave a copy to Wagner, who displayed his veneration for the artist by wearing a floppy velvet beret. Between them, these three men summoned up the artist in a cotton-wool cloud. They were an unreliable triumvirate, falling in and out with each other; Mann would fall out with them in turn, when it suited him. Skittish and vain, he was a faithless young writer, he confessed, a chronicler and analyst of decadence, a lover of the pathological, a lover of death, with a proclivity towards the abyss.

The twentieth century had begun with the founding of the Dürerbund, a popular movement with three hundred thousand followers, extolling the artist as a symbol of healthy culture, the epitome of Germanness. In 1928, when the four hundredth anniversary of Dürer's death was celebrated throughout Germany, Mann wrote an essay extolling the artist's loving beauty. Nietzsche was the medium through which he learned to know Dürer's world. Through him I looked, I divined, I grasped my way through my emotions, Mann wrote. It was the myth itself that fascinated Mann. Where else were the philosopher's ideas of being beyond good and evil to be found, he asked, other than in Dürer's Knight, Death and the Devil? Mann held up that picture in front of his readers' faces. It was a symbol for an entire world, my world, he said. A spirit world of passion, the smell of the tomb, sympathy with suffering, and Faustian *melencolia*. A world of daydreams, daemonic and ribald, sick with infinity and self-torment.

But by the nineteen-thirties, Dürer was already becoming something else. Of one hundred and twenty-two works to be approved by the new regime for domestic decoration, one in four were by Dürer; and even as Mann declared Freud to be the new knight, caught between the devil and death, that picture passed into other hands. The leader was given it at a rally; the mayor told him he too was a knight, leading them to victory. He was painted in armour on horseback; only instead of a fox-tailed lance, he held a flag with a crooked cross. Dozens of Dürer's drawings would

be looted and delivered to him; he liked to have them on hand wherever he went. I turn the pages of the catalogue and his name appears beneath the pictures as their last known owner. Dürer holds his hand in front of his face.

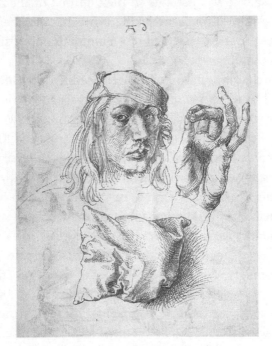

Everything Mann stood for was being perverted; but he knew he was part of the story, as if he had written it himself. His eldest children, Erika and Klaus, pleaded with him to speak out. He was afraid that if he did, he would be silenced, and never be heard again. He believed art could outpace politics. It was a dangerous game. I resist even saying the name of the bogeyman, he wrote in his diary. I refuse to apply the term 'historical' to this monstrous phenomenon.

His son saw the leader in a tearoom, stuffing himself with strawberry tarts. He was surprisingly ugly, and much more vulgar than I anticipated, Klaus said.

Erika stood up to read in public; a gang burst in, with guns and clubs. She joked, in deadly seriousness, that she never thought reading poetry could get her in such a mess. But if they wanted a fight, they could have one.

Klaus said it was perilous to pick up one of their father's books in a shop. Thomas declared in speeches that the ideology was false; privately, he called it a mammoth advertising campaign for nothingness.

In March 1933, having delivered lectures on Goethe and Wagner, Mann left for Amsterdam, Brussels and Paris. He and Katia—whose father was Jewish—were in Arosa, Switzerland, when, in a coded warning of bad weather, Erika and Klaus told their parents not to return. The Manns flew from place to place, Thomas said, while our homeland is barred to us by hostile, malevolent, threatening forces. He'd heard a camp had been established outside Munich for communists and socialists; their comrades were being tortured in Berlin. He and Katia took soporifics every night, Phanodorm, Adalin, Evipan, to suppress their dreams. He'd wake to find traces of the drugs still in his limbs.

Erika had planned to drive her parents to Madrid in their prized Buick Phaeton from Munich. But they had been betrayed by their chauffeur, Hans. In April the authorities had searched the house, supposedly for weapons, and illegally seized the Manns' property. As Hans drove Klaus to the hauptbahnhof one last time, he told him the car's new owner thought it was swell.

But Hans's treachery went even deeper. Thomas was desperate to retrieve his diaries from the house. The suitcase in which they were packed went missing, mysteriously. Everything now revolved around this threat to his life secrets, he said. He knew that whatever they knew or thought they knew about him could be confirmed by the contents of that case. Katia and I sat holding hands a great deal, he said. She understood his fears. He thought he was losing his mind.

In May they began to burn books. Works by Klaus and Thomas's brother Heinrich, who had written the novel on which *The Blue Angel* was based, were thrown on the bonfires. People cheered. The events were relayed live on the radio. Thomas's books only escaped because the regime was reluctant to attack a Nobel laureate. *Buddenbrooks* had sold a million copies; they would be difficult to burn, or drown, although ways might be found. Thomas did not know the orders had already been issued: as soon as he crossed back over the border, he was to be arrested. He was told that if he had stayed, he'd be in Dachau by now.

That autumn, they reached the resort of Bandol, between Toulon and Marseilles.

Thursday, September 7. The habit of a morning swim from the landing (where the water is still and clear) has become dear to me.

He knew what he represented. My very persona assumed a bright aura, he said, as a survivor from a nobler era.

The sea had become a vulnerable place. Seeking safety inland, they settled on the shores of Lake Zurich, in Küsnacht, the same town where Jung was living. Mann distrusted the psychoanalyst's irrational symbolism, and accused him, privately, of swimming with the current, of glorifying the neurosis of the regime. As winter came on, the Manns' coats and furs arrived from Munich, followed by Thomas's desk. He unlocked its drawers and found his keepsakes inside.

He laid them out in their order: a little blue vase, an Egyptian statue, a slice of agate, a magnifying glass; a page-turner carved from a walrus tusk, and a sperm whale tooth; talismans of his family's northern trade. They took him to other places: to warehouses named the Whale or the Walrus, and the sealskin satchel he had as a boy; to the ships he had sailed on loaded with living freight, a polar bear and a Bengal tiger sent from Hamburg to Denmark, roaring miserably below as the sea churned into a frenzy. The summers they had spent at Travemünde, where

strange roofed wicker chairs stood in rows on the sand, like shells for human hermit crabs. The house he had built in the dunes at Nidden, overlooking its lagoon. The flash of the lighthouse in the thickening dark; the sea that swallowed up his sorrows and sufferings.

His diaries arrived. Now he could make his statement to the press, denouncing the government, daring them to deny his Germanness for all the world to see. From that moment on, he became his country's most vocal critic in exile. In December 1936, they declared him a non-citizen, a non-man, and his riverside villa was given over to a foundation dedicated to breeding the racially pure.

27 August 1939. War will not come, he writes in his diary, at the Grand Hotel, Saltsjöbaden, on the cold, clear Baltic. There's a bathing island just off the shore. H.G. Wells has arrived from England.

3 September. Britain declares war on Germany. They fly from Copenhagen to Amsterdam to London. They don't even feel safe in the air; on previous flights, German fighters had swooped out of the sky, peering in at the passengers; on the next flight, one is shot dead, apparently mistaken for Mann. Thomas writes his diary on the train from Waterloo to Southampton, after a snatched station breakfast of tea and hot buttered toast. He expects America to be his home for the rest of his life.

The war would last ten years, they say, it will be the end of civilisation. It was just fifteen or sixteen capitalist arch-villains who were calling the tune. Mann placed his hope in the alliance between Britain and France and the beginnings of a free, federated Europe to oppose the forces that man had unleashed. Now they are calling him a madman, he says. Late, very late!

That afternoon they sail on the luxury liner SS *Washington*. Two months before, the same ship had brought 175 German Jewish children from Berlin to Southampton. A year later, the ship would take my friend Pat, ten years old, to America, sent there by her Jewish mother. On its next voyage, the ship will be held up by a u-boat. On their Atlantic passage, Thomas writes, *Washington* is filled with two thousand people who had to sleep in cots in the public rooms. He compares the scene to a concentration camp. Now he's installed in Princeton, a town of princes. Their house, on a tree-lined avenue, has ten bedrooms and five bathrooms. He's given a beautiful new poodle named Niko. From the start I attempted to make him believe he belongs especially to me. And as if by magic, his desk appears, with every item in its place, along with the painting that travels everywhere with him, of three naked bathing boys lounging on blue rocks.

He dreams alone in his big bedroom, in his big wide bed with its down comforter. He lectures on Faust and Freud, and meets his colleagues, Panofsky and Einstein. When Dora Panofsky falls ill, a three-man shift reads to her: her husband, Mann and Einstein. Free to speak his mind, he regains his voice. He broadcasts the

first reports of the death camps to Germany; Alfred Knopf tells him he is the regime leader's most formidable enemy; Roosevelt plans to appoint him head of a German government in exile. It's a forgone conclusion, he's told by a newspaper editor, that he will be president after the leader falls. He has become the antithesis of his opponent on the other side of the ocean. He has his talismans to hand, the way JFK will collect the same whale teeth on his desk.

He sees himself from afar. He declares his exile a grave stylistic mistake on the part of History, as if God had made a mistake. Niko is attacked by der von Panowskys bösem Pudel—their evil poodle—while out walking. It is not only possible that the two German exiles discuss Dürer and what he has become, it is certain, since Mann had read Panofsky's monograph on Melencolia during the Weimar, when that engraving seemed a mirror of the future, an angel in an overcoat on a parapet.

Now he moves again—as far away as he would ever get. He's tired of playing the professor or politician. He goes in search of the sun, and has a modernist house built on the outskirts of LA. His new neighbourhood, the Pacific Palisades, began as a commune of cabins, but is now a scatter of million-dollar homes. Schoenberg and Brecht live nearby; their favourite café sells Sachertorte. The *New Yorker* says Mann is Goethe in Hollywood. He's living in the city of angels.

You ought to see the landscape around our house, he tells Hermann Hesse, the view of the ocean, the garden with its trees —palm, olive, pepper, lemon and eucalyptus. Bright sensory impressions are no small matter in times like these, he says, and the sky is bright here almost throughout the year.

Up there in the hills, surrounded by bougainvillea and palms, he addresses his fate. He walks by the ocean every morning, but the Pacific has become a different place; the blue theatre of war, he says, a place of hate. He remembers an idea for a story about an artist's pact with the devil he'd sketched out in three lines in

Philip Hoare

1901. It was barely definable, he says, but its long roots reach far down into my life, as if it were a living organism.

23 May 1943. Two weeks before his sixty-eighth birthday, six thousand miles from home, Mann sat down at his desk, arranged his charms and began to write. *Doctor Faustus* is a disturbing book. It was written at a time when art and reality were never more incompatible, he says. Everything had been leading up to this.

In Mann's most celebrated novel, *The Magic Mountain*, published in 1924, Hans Castorp, a young man from Hamburg, arrives at a sanatorium for consumptives. Aged twenty-two, with red-blond-hair and blue eyes, he is an unheroic hero; he's training to be an engineer, but he wears dainty coloured shirts. He has come to visit his ailing cousin Joachim, a young soldier, who shows Hans to his room, telling him its last occupant died the day before. Hans finds it all very funny. Each inmate sleeps on their balcony, wrapped up like a papoose. As he contracts the disease—he almost invites it—he becomes one of them. We don't feel the cold, he says. Time means nothing there, only an overwhelming melancholy. Life is an infection, he says. In its isolation, the whole place becomes an allegory for Europe, caught up in madness and decay.

In the strangest scene in a strange book, a seance is held in the consulting room, where, underneath an engraving of Rembrandt's Anatomy Lesson and next to the x-ray machine that had revealed Hans's interior like folded tissue and his half-naked cousin's manly heart expanding and contracting like a jellyfish, the medium—a nineteen-year-old girl named Elly—channels the spirit of a poet called Holger. The patients listen to a spectral ode on the sea slumbering under a vanishing sky and a silvery, moonstone gleam, while the sand pours in an hourglass; a solemn, fragile toy that adorns a hermit's hut, along with an open book and a skull. Hans, supporting his cheek with his fist, asks the spirit to tell him how much longer he will remain there. Holger indicates

the number of his room, thirty-four. Anyone could recognise that number and those images. As Hans plays a song from Gounod's *Faust* on the gramophone, Joachim, who had died some weeks before, his beautiful eyes as great dark orbs bulging from the last stage of the disease, appears in the corner, sitting on a chair, wearing a helmet like a medieval soldier in a future war.

The record runs down to a scratch, needle tripping on empty grooves. Tears in his eyes, Hans begs his cousin to forgive him. Someone turns the lights back on.

The uncanny beauty and dark comedy of his book earned Mann the nickname with which he liked to sign himself: der Zauberer— the magician. He had begun *The Magic Mountain* after visiting his wife in a sanatorium in Davos in 1912; it was intended as a comic novella, a self-conscious skit on the deathliness of his story set in Venice, which he had written the year before. But it was only in the autumn of 1918 that his thoughts had returned to the mountain. It grew in his mind as he walked the riverbank at dusk with his dog, Bauschan, wary of the bats that fluttered out of the trees.

Mann was haunted by the collapse of the present. Alone in his study by day, he spent his nights at the opera, listening to *Parsifal* and *Palestrina*—aus der faustischen-dürerischen Sphäre—dining in the interval on vegetable soup, tomato sandwiches, and red wine while machine guns rattle in the distance. He confided in his diary that a deathly melancholy is his central subject, and wonders, what if he were to die now?

Thursday, June 19. Persistently lovely weather, warm enough for a silk suit.

There was no certainty in the human, so he wrote about someone he could control. Bauschan lived outside in a kennel hung with sackcloth curtains. Unlike their previous dog, Percy, a collie whose breeding had produced an aristocratic but mad animal, Bauschan, a German pointer, was subservient, as of the lower classes—I do not mean to exult the aristocracy, Mann was at pains to say.

Bauschan knew his master. His master knew him. When Mann emerged for his early morning walk, before the pressures of the day began, he'd give a whistle and out would bound Bauschan, so loyal he'd even follow his master when he set off for town, running after the tram. Extraordinary creature! said Mann. So close a friend and yet so remote. When they sat together in the park, Thomas with his back to a tree, he'd put down his book and call his dog's name repeatedly, to remind him: That he *was* Bauschan and that Bauschan *was* his name.

It was a kind of experiment. By continuing this for a while, Mann wrote, I can actually produce in him a state of ecstasy, a sort of intoxication with his own identity, so that he begins to whirl round on himself and send up loud exultant barks to heaven out of the weight of dignity that lies on his chest. One day, hunting in the park, Bauschan drove a hare into his master's arms. Mann stood there, cradling the fearful creature, for an instant, eye-to-eye.

For a second, or part of a second, I saw the hare with such extraordinary distinctness, its long ears, one of which stood up, the other hung down; its large, bright, short-sighted, prominent eyes, its cleft lip and the long hairs of its moustache, the white on its breast and little paws; I felt or thought I felt the throbbing of its hunted heart.

His haunted heart. He might have been holding Dürer's hare. He calls her the little genius of the place. That summer, as revolution raged, he escaped alone to the sea at Glücksburg, the northernmost tip of Germany. He swam three times a day, and received a letter from Katia's brother, who'd been interned in Australia as an enemy alien and whose return is made frightful by influenza; twenty dead thrown overboard without the ship even stopping. He went back in the water, out of love for the sea and its purity. But he shivered, and the churning water was full of seaweed and jellyfish. He spoke to a young man in white trousers on the train. It seems I am done with women, he tells his diary. In

Munich he gets a new outfit. He takes pleasure in the quality and elegance of his clothes. Every night he looks forward to his bath. He's forty-five years old.

Mann's themes swell as one, rising and falling with the tides. He can't write as if the past never happened, it wasn't within his gift. He goes to hospital to see the bones of his hands revealed in an x-ray. He goes to the animal hospital to see his dog, who puts out his paw, and is about to die. He walks his new dog. The river is swollen grey by rain.

Sunday, May 22. At midday I read in the woods, faithfully accompanied by Lux in his new collar. While I lay under a tree he stayed close beside me.

Twenty years later, Mann sat down to write what he thought might be his last book. All his work was written in the same study, wherever he was, whatever lay outside, whatever order he laboured under, writing between two candlesticks, the tooth and the tusk on his desk, stopping now and then to smoke a cigar

Dr Thomas Mann in his Study
1942
Pacific Palisades, California

Philip Hoare

and sip his peppermint tea. The view changed but the words and the routine were the same: the afternoon sleep on his bed, the morning walk with the dog, the society of the night before, the intrigues, the terrors, his notes. A glass of vermouth before lunch. He pulls down the blinds.

At the centre of *Doctor Faustus* is an avant-garde composer, Adrian Leverkühn, who comes from an ancient town, Kaisers-aschern. The name means emperor's ashes: it's Nuremberg, with a little Lübeck thrown in. The book is narrated by Serenus Zeitblom; he's loved Adrian since they were at school. But as he too sits down to write, on 23 May 1943, Zeitblom knows it is his duty to explain, to himself as much as anyone else, how the man he so admired achieved genius by dark means. From his desk in Bavaria, Zeitblom sees the glow of the firestorm on the horizon. The frightful bombardment of the city of Dürer and Willibald Pirckheimer is no remote event, he says.

Mann's view is rather different. He looks out from his room, down to the sea, to Venice Beach and its muscled angels. He meets Johnny Weissmuller. The neighbours complain that the Manns are always discussing homosexuality. Caught on cine film, he sits on the terrace, drink in hand, wearing a grey homburg and round metal-rimmed sunglasses, an alien who can't go home. His heart was alive in Lübeck, he says, but it was dead in Munich. He's never been at ease in his body; this heavy, faulty, hateful encumbrance, he calls it, which always prevented him from being something other and better.

Up there on the magic mountain, Hans was bewitched by a fellow patient; her almond eyes remind him of Hippe, the boy he loved at school. He had borrowed Hippe's pencil for precisely one hour, the one definably happy hour of his life. I've wondered for a long time what it is about eyes like that, Hans says. Wolf eyes or Tartar slits. The feral eyes of a beautiful predator. The eyes of a lost boy. In another story, set in Lübeck, the schoolboy Tonio Kröger falls in love with his friend, also named

Hans, who wears a short reefer jacket with the broad blue collar of his sailor's suit hanging out over his back, and a Danish sailor's cap with black ribbons and a shock of flaxen blond hair standing out from under it. He too will betray him, the way they all do.

Mann's one true love was Paul Ehrenberg, an artist. They met in Munich in 1899. My first and only human friend, he said, the central experience of my heart; his blue eyes almost burrow into your face. An ecstasy that happened only once in my life, which is as it should be. They'd cycle into the country in their knickerbocker suits. They were always dressing up. When he was still a young boy in Lübeck, Mann said, he awoke one morning with the resolution to be for the day an eighteen-year-old prince by the name of Karl. He clothed himself in a certain kindly majesty, and walked about proud and happy in the secret of his dignity. In another book, the wayward Felix Krull models naked as a Greek god for his artist godfather. He's sixteen years old, a fancy-dress boy: a Spanish bullfighter in a spangled jacket, a German mountaineer in leather breeches and, most fitting of all—thinks Felix—a Florentine dandy of the late Middle Ages.

As he began to write, that May 1943 (spring was always a good time to start), Mann was still in disguise. His Faust is reborn under Californian skies; he meets stars in fancy dress, and his imagination takes on the scale of a biopic; images on a screen. He draws deeply on medieval and modernist ideas; he wears his suit, as usual, but *Faustus* is anchored in his heart, he says. In elaborate scenes, page-long paragraphs and sentences that wind round and round (if he had his way, there'd be no paragraphs or section breaks), Zeitblom recalls the Bavarian upbringing of Adrian Leverkühn, who is educated like a young prince.

In one early episode, Adrian's father, Jonathan, shows the boys books with coloured illustrations of exotic lepidoptera and sea creatures. They're full of freaks and fascinations, tropical insects that natives believed were evil spirits that could bring

Philip Hoare

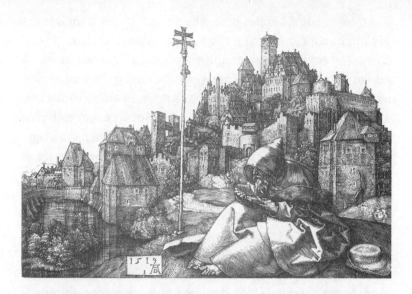

malaria, and the shells of certain salt-water mussels that appear to have hieroglyphics written on them. And when Jonathan grows crystals in a chemical sea of brown spires and green reefs seeded from sulphate of copper and potassium chromate—an experiment I also conducted as a boy, the slow-motion creation of a nebula in a jam jar—young Zeitblom thinks it is the most remarkable sight he ever saw; profoundly melancholy, even malignant.

The setting for all this is the town, a reef encrusted in time, a set piece, a character itself. You might pick it up and shake it, waiting for the snow to fall. The old churches, the faithfully preserved medieval dwelling-houses and warehouses, the buildings with exposed and jutting upper storeys, the round towers in the wall, with their peaked roofs: this is a place where you could see strange things. Zeitblom imagines a children's crusade, a St Vitus's dance, a wandering lunatic with communistic visions, and people still capable of seeing something daemonic in the little old woman with the evil eye. It was by no means impossible that such an old soul should have to burn again today, he says.

Anything could happen here. The devils left over from Dürer's day might appear, stalking the narrow streets, leaping in windows. The city is an incinerator of dreams. The house in which Adrian lives rises in three storeys, not including the roof, which was built out in bays, its foundation storey unwhitewashed and unadorned. It has been in the same family since the sixteenth century, but it is clear to whom it really belonged. Adrian has a magic square which he keeps above his piano—every line adds up to thirty-four.

To research his novel, Mann turned to Wilhelm Waetzoldt's book on Dürer. Published a decade before Panofsky's biography, it was a very different portrait of the artist. In 1933, Waetzoldt had been dismissed as director of a Berlin museum for employing Jews and displaying modern art. But his book, as it appeared in 1936, was carefully tailored to the times. Its orange-and-black jacket bore no portrait of the artist, nor even one of his animals; under its strident gothic type stood the martial image of Lukas Paumgärtner in armour, his lance flying a stag's-head flag. The third chapter was entitled Apokalypse, with a sombre sequence of woodcuts that took on a new terror in their starkly printed state, and inserts of stiff black paper stood proud from the pages, acting as frames for colour plates of true German faces.

What makes it such a delight to trace the course of this man's life, Waetzoldt writes, is the extraordinary way in which such a degree of solid respectability is combined with so much daring, how the demons rap on the panes of the quiet workshop by the Tiergärtnertor, and how Albrecht Dürer rises from the warmth of the guild to the chilly isolation of genius. Waetzoldt praised Dürer's Nordic spirit, claimed that his marked, but harmless, masculine vanity and his long hair were not owed to any 'strain' of Hungarian blood, and said Nuremberg was the meeting place of four of the best racial strains. To Mann, the city was one of the worst places in Germany, where they went in their thousands, in special trains, marching through the streets with their torches.

The fact that Waetzoldt ends his foreword with the words Deutschland, Vaterland!, and signed it off Sylt, Summer, 1935, was enough to disturb Mann. As he turned the pages of this entsetzlich nationalistischen Buch, this horribly nationalist book, he found a photograph of the artist's house taken in the sixteenth century, with a lone figure standing in the square.

Working in his room overlooking the ocean, Mann gathered his sources. He drew on medieval chapbooks, the avant-garde compositions of Schoenberg and the radical essays of Theodor Adorno. Both men were neighbours. He asked Adorno: How would you do it if you had a pact with the devil? He read Joyce's *Ulysses* for its use of myth, and he underlined lines from *The Tempest*. One book fascinated him so much he read it twice. Franz Werfel, the Austrian author, and husband of Alma Mahler, was another neighbour; his futuristic novel, *Star of the Unborn*, would be published just after his death in 1946.

The book was filled with the strangest, most bizarre features introduced into an infinitely remote age, Mann marvelled. There were advertising posters composed of moving stars, people no longer moved to a destination but used an instrument to bring it to them in some technical-spiritual way. The oddest detail of all was a note on the innocently incorrect speech of the dogs who always said nod instead of not. In this Astromental age, dogs had evolved to live as long as humans, but had lost the ability to spot a ghost a mile away.

Mann had always seen ghosts—in *Buddenbrooks*, the consul's brother regularly sees one sitting on his sofa. He scanned Waetzoldt's book for its spiritualistic illustrations, gravely laid out in photogravure. In schönes, sonniges Wetter, nice, sunny, Californian weather, he studied the section on the Apokalypse as the news arrived from the Nuremberg trials. He stopped to get Niko's black coat shaved. The world had become science fiction.

In our own days, said Waetzoldt, popular fantasy has been caught by the problems of radiation and the so-called death-rays, by the stories of diviners and the predictions of astrologers. The development of stratospheric flight and rockets, the attempts to scale the Himalayas, the discovery of remains dating from the earliest periods of history—these are all questions which interest the entire world. In turn, Mann turned Waetzoldt into a

character in his book: a Dürer scholar named Gilgen Holzschuher, one of a group of intellectuals whom Zeitblom finds unacceptable on account of their enthusiasm for blood and soil and their readiness to throw human rights overboard. That is the phrase he uses. (On the magic mountain, a Jesuit priest advocates terror as a tactic and says aviators take ravens on their planes as mascots.)

We know where this is leading. We'd be fools if we didn't.

Adrian becomes a superman. Mere dull unconscious being, ichthyosaurus-being, was no good, says a fellow student; one must assert one's specific form of life with an articulate feeling of self as soulful youth, as spontaneity, as faith, and Düreresque knighthood between Death and Devil. In his search for perfection, Adrian disdains the stupid and the everyday.

But someone is waiting; he introduces himself long before we see him. The great old Serpent, Timothy Tempter, Old Blackie, Adaddon, Belial, Master Dicis-et-non-facis, Black Kaspar, the Father of Lies; also known as the Destroyer, the Arch-Deceiver, the Wicked Fiend, the Great Adversary. He appears in many guises in the book: a shady figure throwing a bread roll from a corner, or causing the faithful to mutter abominable filthinesses at Mass.

And as Adrian escapes to Italy, he realises that he has been followed.

In his darkened room, Adrian sits in his summer suit, reading Kierkegaard. Suddenly the temperature is sucked out, and he is no longer alone. There's somebody sitting on the sofa in the corner with his legs crossed.

He wears a sports cap tilted over one ear; his reddish hair stands up from his temples; his eyes are pink and his shirt diagonally striped, its sleeves too short, his breeches too tight. His yellow shoes are worn down. He's a bully, a strizzi, a pimp you

might meet on a street corner. The coldness is coming directly from him; how else would he keep cool where he has come from? And in a voice as eloquent as an actor's, pleasing to the ear, he engages Adrian in conversation for forty pages. He speaks in German, here in Italy, this pagan, Catholic country. It's an opera, a performance; we wait in the wings.

German I am, the visitor tells Adrian, but that I should once in good Düreresque style freeze and shiver after the sun, that Your Excellency will not grant me.

Adrian laughs, as if amused by his own research.

Extraordinarily Dürerish, he says. You love it. First 'how will I shiver after the sun'; and then the houre-glaasse of the *Melancolia*. Is the magic square coming too? Do you know what you look like? Like some shameless scum.

He and his caller bandy dialogue as though in a Wildean play.

(Halfway through writing his novel, Mann receives his own visitor: a fourteen-year-old girl named Susan Sontag, who has plucked up the courage to call on him. He tells her, over tea and cakes, that the Devil himself is a character in his book, and he speaks in the German of the sixteenth century.)

How long must I needs sit and freeze and listen to your intolerable gibberish? Adrian complains. He feels the cold, despite the cloak he has just fetched.

Is this only a metaphor for a little normal Dürer melancolia? replies his visitor; then he changes shape, turning into a bow-tied critic in horn-rimmed glasses, promising Adrian he will become a hero to his generation. He offers him twenty-four years of genius—although it's hardly an offer, since it cannot be refused—then changes again, into a caricature of himself, with a forked beard and moustache, and reveals the plan they've had for Adrian from the beginning, citing signs such as miraculous crosses on men's garments, meteors and comets and the right planets coming together; an infection, borne from four centuries ago, he says.

As Master Dürer has eruditely drawn in the medical broadsheet, there came the tender little ones, the swarms of animated corkscrews, the loving guests from the West Indies into the German lands, metaphysical, metavenereal, meta-infectivus.

All this comes only as a confirmation. The germs are already in Adrian's spinal sac, working up to his cerebellum. We know that the composer has deliberately contracted syphilis, inviting the bacillus into his brain. (Mann believed Nietzsche caught syphilis in a brothel; a male one, according to Freud.)

Adrian is promised ecstasy and superhuman insight. There is only one condition: that he must not love for those twenty-four years.

Then his visitor changes one last time, back into the tight-trousered strizzi.

Adrian turns round, and he is alone.

Infection opens Adrian up to new sensations. In the next scene, which may or may not be a dream, Adrian descends to the bottom of the sea in a diving bell with Professor Akercocke, a marine biologist. The ball-shaped contraption is equipped somewhat like a stratosphere balloon, he says, provided with a supply of oxygen, a telephone, high-voltage searchlights, and quartz windows all round, and is lowered into the water by a crane. As Hans ascended the snowy mountain, so Adrian descends into the dark abyss. His dive is another experiment, like a Victorian aquarium installed in the sash window of a townhouse, stocked by mail-order monsters that prompt the housemaids to shriek.

So vivid are Mann's descriptions of the deep ocean that you'd be forgiven for thinking he had himself descended into some benthic trench. In fact, he'd read an account by William Beebe, a scientist fascinated by marine life since he was a student, when he had seen whales spouting and breeching off the New England coast: I cannot express the peculiar sense of weirdness

and freedom which it gave me, Beebe had written, to see these tremendous primeval monsters absolutely masterless, rioting in this vast expanse.

In order to explore this otherworld, Beebe collaborated with Otis Barton, a diver and actor, to devise a bathysphere capable of withstanding the immense pressure of its voyage to the bottom of the sea. Beebe and Barton, scientist and showman, deployed their invention in the waters off Bermuda—Prospero's island of strange noises where, a few years later, a cold-war sonic array searching for Soviet submarines would record, instead, the eerie sounds of whales singing like lost souls. Only dead men have sunk this deep, Beebe noted, as he and Barton fell through the dark blue to the black and creatures unknown to science appeared: some the colour of dead or water-soaked flesh, others glowing with pale yellow light.

Beebe wrote about his experiences for *National Geographic*— A Half Mile Down: Strange Creatures, Beautiful and Grotesque as Figments of Fancy, Reveal Themselves at Windows of the

Bathysphere—in 1934 (I imagine Mann finding a dog-eared copy in his dentist's waiting room). The article was accompanied by fantastical illustrations by the young artist Else Bostelmann, who had to rely on Beebe's verbal descriptions, relayed on a telephone line from thousands of feet down, in order to create detailed images of neon organisms glowing purple and pink as if painted on black velvet. Like Dürer, she drew the unseen. Indeed, some critics claimed that Beebe had imagined these monsters himself, or that he was deluded by condensation on the diving bell's window, or was hallucinating due to short oxygen supply. But others noted that, while his descriptions did not fit those of any known animal, this alien territory was still so unknown Beebe may have been the first and last human to have seen these creatures alive. Whatever he saw down there, through that giant eyeball dangling in the dark, Beebe's reports had a sensational effect. They were broadcast live on radio like a moon landing and turned into a film, *Titans of the Deep*, so over-dramatised that it played in some theatres as a horror movie and Beebe disowned it as a result.

In turn, Mann's version of Beebe's expedition became a dark fantasia, accompanied by a studio orchestra. Thirty-six hundred feet down, under five hundred thousand tons of pressure, in the soundless, frantic foreignness, Adrian sees the unlooked-at, the not-to-be and not-expecting-to-be looked-at, the monstrously extra-human, in den Ozean der Welten alle. (One of his first compositions is *Phosphorescence de la mer*.) Out of the blackness looms a nightmare vision of obscene jaws and telescope eyes, the paper nautilus, and silver- and gold-fish with goggling eyes on the tops of their heads; others dangle phosphorescent lanterns as lures. All are seized by spasms of twitching excitement: when one of the slimy things touches the capsule, it shatters into a thousand pieces.

Yet as soon as he reaches the greatest profound, unable to go any further, Adrian suddenly spins, in his infected imagination,

into interstellar space. He is Faust, being shown the empyreal heavens. As he sees galaxies forming the shape of flattened watches, he realises that the universe beyond is neither finite nor infinite: it is just what it is. High above the world, he sees that medieval theories of its starry fates are echoed in the latest scientific theories, which propose that germs, bacteria, organisms from other planets—Mars, Jupiter, or Venus—could produce an influenza epidemic on earth. (He might even have noted that the Spanish flu had arrived, not from Europe, but via American soldiers on the converted liner *Leviathan*.) Disease is a metaphysical state, and the oratorio that Adrian writes as a result of his encounter with Mephistopheles—*Apocalypsis cum figuris*—is inspired by the spirit of Dürer, himself infected.

The composer excitedly explains to Zeitblom the transformative effect that Dürer's engravings have had on his art: strident, raucous music in which the frightful chorus of humanity flees before the four horsemen, stumbling, fallen, overridden; John the Baptist boils in a cauldron of oil while the emperor's dog looks on; and the towers and gables and pointed oriels of Nuremberg become the Kaisersaschern skyline of Adrian's birth. This homage to Dürer is a modernist vision of a medieval hell, scored in jazz sequences that deploy drum machines and loudspeakers to cacophonic, infernal effect. A column of drone workers might march out of monstrous jaws. There is only one performance, in 1926: it is less a concert than a great and piercing prophecy of the end, says Zeitblom.

Hell has already happened. Art was taking an increasingly apocalyptical view of the world, as Sebald would write in his natural history of destruction. The demons rapped on the windows of the Pacific Palisades. Some wore aqualungs. Spinning on the cover of his book—the Dürer symbolism is really very fine, said Mann—the strange shape from Melencolia hurtles through a nuclear sky like Dürer's star, engraved with an hourglass, scales and musical notes.

Thirty years later, in the same city, in his room overlooking the ocean, the starman will draw circles on the floor and see a demon in his pool; he meets the devil in downtown LA, but manages to get away in a car. Mann witnessed the oncoming storm, the whitened stumps. Dürer's vision was being visited upon his own home. They made the bombs, they had to use them.

There is outcry over these crimes against culture, crimes we ourselves invoked, says Zeitblom. The old Germany hangs from a chandelier of bones and antlers. All that is German has become intolerable to the world. Those lazy western democracies, he says, they knew how to deploy their weapons, after all.

Like Panofsky, Mann had pre-knowledge of the atom bomb, through his brother-in-law, Peter Pringsheim (a physicist who collaborated with Einstein, and whose speciality was phosphorescence and new atomic theory). The secret has come to light, Mann writes in his diary for 6 August 1945, as if complicit in the end, like the wide-eyed Oppenheimer, reading *Les Fleurs*

du Mal on the night of the Trinity Test, or Nietzsche predicting that the world would know his name through something monstrous. One of the scientists at the test site compared its strangeness to *The Magic Mountain*. Art became fissile material, a retro-genesis.

As German cities fall and surrender, Zeitblom hears of bands of raving-mad lads, known as werewolves, hiding in the woods, ready to murder the invaders. Adrian changes again. He grows a beard, with the addition of a drooping little strip of moustache. It was this beard, says Zeitblom, that gave his countenance something spiritualised and suffering, even Christ-like. His eyes flicker open wide in a fixed stare.

He has become Dürer.

He summons his friends to his abbot's room based on Waetzoldt's photograph of Dürer's study, wainscotted with a wooden floor and stamped leather on the wall. Hanging from the ceiling is a huge chandelier with horns, shovel-antlers, and other fantastic shapes. It is a pressurised chamber with bottle-glass windows, a haunted laboratory recreated on a film set. Fishes swim past with devil's eyes, their jaws ready to gnaw at dead men.

Here, in this cell and its shadows, Adrian delivers a bizarre speech in which he reveals appalling visions, of the loss of the child he loved, and of the price he has paid.

As his words grow ever wilder, he declares he was born for hell. The guests start to leave, distressed and confused. One laments that an alienist is not available. Surrounded by his few remaining friends, Adrian begins to play, for the first and last time, his *Lamentation of Dr Faustus*. The dissonant notes resound with his madness, and he falls, paralysed, to the floor.

It's all over. He is taken home, to be cared for by his elderly mother, bearing witness to the Icarus-flight of her hero son. All his memories have gone. One afternoon, he is discovered standing up to his neck in the pond. As he is about to go under, a farmhand plunges in and brings him out. As they take him back

to the house, he speaks repeatedly of the coldness of the water and adds it was very hard to drown oneself in a pond one had bathed and swum in often as a boy.

Halfway through writing his book, Mann took his diaries from 1921 to 1933 out to his backyard and burned them. It was a long-held resolve, he said. It was 21 May 1945, Dürer's birthday.

It wasn't as if he had ignored the signs. They were there, back at the beginning of it all, in the treacherous beauty of the sea.

19—. The Continent lay under threatening weather. Overstimulated by his writing, which has reached a difficult and dangerous point, Gustav von Aschenbach, forgetting that he was fifty, left Munich for the watery city where he would fall in love. Venice, the Grand Hotel des Bains, stretched along the beach.

It's late May, and as Aschenbach sits in his deckchair on the Lido, he watches a young teenager playing on the sand. The boy wears an English sailor suit with lanyards and bows. Despite rumours of the disease which has spread from the East, and is now raging through the city, Aschenbach stays on, risking infection. His decision not to warn fellow guests about the epidemic, least of all the boy's family, is born of a horrified curiosity about what is to come, says Mann; it is the lascivious delirium of annihilation. Breeding dark art out of death. Aschenbach is fatally bewitched. In sultry weather, his hair dyed and face made up in a mortuary parody of youth, his decayed Dorian Gray story ends on a litter-strewn strand. The boy-angel seems to beckon to him, Mann writes, pointing out to sea, an immensity rich with unutterable expectation. And as so often, he set out to follow him.

It was a story of the voluptuousness of doom. He wanted to show the tragedy of supreme achievement, he said. He remembered that visit, the unparalleled melancholy—he wrote to Erika, when she was staying there in that same hotel—living between the warm sea in the morning, and the ambiguous city in the

afternoon. He loved it without limits, like Byron, like Nietzsche, he said. The beginning and the ending connecting as *Doctor Faustus* drew the life out of him. I can feel myself waning, he said, adding, I use the word in the mythic lunar sense. The x-rays showed the shadow on his lungs. Having written so much about disease, disease had caught up with him. At seventy, he said, he had written his wildest book. Now they cut the cancer out of him, the first surgery his body had undergone.

I can recall every item of those first hours, how I made the acquaintance of the pendulum clock suspended on the wall, how the nurses floated back and forth, taking temperatures, giving injections, dispensing soothing tablets; how the doctors who were to treat me came *in corpore* to pay me a welcoming visit, at their head the surgeon himself.

He came round from the operation, saying, It was much worse than I thought, I suffered too much!—when in fact he felt none of it, at all. His stitches were removed by the handsome young Carlson in his rubber apron (good looks are a pleasure, whether in men or women, he said), and Alfred Knopf sent him caviare. Discharged with a huge scar running from his chest to his back, to the astonishment of his doctors, he rushed home to finish his book, returning to the city of angels by train, in a drawing room with private meals, to be greeted with joy by his poodle. Niko had sensed the grave meaning of his master's departure, and that morning had laid his paw on Thomas's knee as they waited for the ambulance to arrive. Now he ran around in dances and wild dashes in circles.

Mann wrote the last lines of *Faustus* on the morning of 29 January 1947, then went for his walk on the beach. On 11 May, he and Katia sailed on the *Queen Elizabeth* to Southampton. By June, he was back in Zurich, waiting for his proofs.

The sea, from beginning to end. The sea he knew as a boy, the deluge and decay: the stranded jellyfishes and shallow tides of Travemünde, the pale northern sea and its remembered roar;

an unborn, unembodied world that demanded to be ordered and shaped. The sound made by the little waves, one single sound of which would make him immune to all the terrors that faced him. The great seaboard city of Hamburg, where cranes lifted crates from the bowels of seagoing ships like quiet elephants at work.

The past reeled in on a drum. The island of Sylt, enraptured by the great soft wind and waves like beasts of prey, and the fearful pleasure of toying with forces so great that to approach them nearly was destruction. He was lost and found. Even in his walks by the river, as Bauschan dipped in the water with a look of virtue on his face, Mann worried that his dog might be carried away, all the way to the Danube and beyond. For man is water's child, he noted; nine-tenths of our body consists of it, and at a certain stage the foetus possesses gills.

He liked best to write by the sea, he said; only in his contemplation of it did he achieve true self-forgetfulness. Hans skiing on snowfields that remind him of the broad ocean dunes, of time drowning in space and a sense of deep content; Adrian offered the little mermaid, her tail sleeker than the forked human kind, her eyes as blue as the depths, soothing the composer by the knowing, as she tenderly drowned him, that he would end up as foam on the sea. Tadzio beckoning on the Lido. The boy he met on Sylt. The note he left in the hotel guest book for the future to find.

11 September 1927. On this tremulous ocean I lived intensely.

The handsome sailor, the melancholy angel, the dangerous gaze. After the boy came to Munich to stay for two weeks, Mann asked the family, Are you happy the young fool has gone? He was quoting from Goethe's *Faust.*

That was the last time I loved, he said. Black eyes filled with tears over me. Lips which I kissed. I will be able to say that, when I die. He even admitted to desiring his own son. What had his art done to him? He can't even look at us.

Aschenbach had a
feeling that something
not quite usual was
beginning to happen,
that the world was
undergoing a dreamlike
alienation, becoming
increasingly deranged
and bizarre,
and that perhaps this
process might be
arrested if he were to
cover his face for a little
and then take a fresh
look at things.

BETRAYAL

How could I not love such a man? He walks the sand before me, his heart like an anemone. The sea, cold enough to fool anyone, to numb any pain. All that loving beauty had been besmirched. The sky over the city wasn't so blue.

His children rebel. Erika in her cabaret in Hamburg and Berlin, wearing a man's tight jacket and a ruffled shirt; Klaus, interchangeable with his sister, the same swept-back hair. They see themselves as twins, pretend to have one another's birthdays, and conduct outrageous conversations on the tram.

The twenties, those desolate, distracted times. Thomas wrote them into a story, Disorder and Early Sorrow, published by Marianne Moore in *The Dial*. In it he sees his own son and their manservant, both wearing their heavy hair very long on top, with a cursory parting in the middle, giving their heads the same characteristic toss to throw it off their forehead. He wanted to be them.

They even fought over the same boy. (Thomas writes to Erika and Klaus saying he found him first and why should they alone sin?) Klaus imitates his actor friend, an artist of the modern school who stands on the stage in strange and, to Thomas's mind, utterly affected dancing attitudes, shrieking lamentably. Both boys blacken the lower rim of their eyelids. Klaus says that even if he ends up as a waiter in a club, he will walk precisely thus.

Philip Hoare

I wanted to be them, too. The green nail varnish, the dark eyes. Erika and Klaus in each other's lover's arms, the glow of the sun, shadows falling like leaves. Klaus found words for how they felt. We tried to be urbane and seditious, sacerdotal and flippant, progressive and romantic, he said. We were mystical and cynical. We wanted everybody to be happy. Nothing seemed definite or impossible. You are like bewitched princes, someone told them. We could not make up our minds, Klaus said. Anything not to be ordinary. I knew people like that. Angels at the ending of things. A society of lost souls.

Erika plays a schoolteacher in *Mädchen in Uniform*, encouraging her cross-dressed girls in a play. Don't think, obey, she tells them. On your knees! Open your arms! Her eyes fire with passion. The film is banned. Her lover is the Swiss writer and photographer Annemarie Schwarzenbach, neither a man nor a woman, with the face of an inconsolable angel; she and Klaus are twinned in addiction. Morphine dulls their despair as they crawl from room to room. The sea in the windows, the empty beach.

May 1932, Grand Hotel des Bains, Venice.

They drift from Vienna to Prague and Paris; by 1935, they're living at Emmastraat 24, off Vondelpark, Amsterdam. Their fellow tenants are Christopher Isherwood and his boyfriend, Heinz, also on the run. Isherwood is writing *Goodbye to Berlin*. Perhaps in the Middle Ages people felt like this, he says, when they believed themselves to have sold their souls to the Devil. Klaus is editing his anti-Fascist magazine and working on a story about his hero, Ludwig, the mad king whom he compared to Wilde and who hadn't drowned in a lake but was still alive, imbued with eternal youth, like Lohengrin. Klaus sees himself as Caspar Hauser, the lost prince who wandered out of the forest and into Nuremberg. All seas wait for me, he said, the human body is beautiful in all its parts. He writes *Mephisto*, in which a vain performer succumbs to the regime in return for fame.

That summer they're joined by Morgan Forster, Stephen Spender and the notorious, brilliant Brian Howard, who, over tea in an hotel, produces a twist of paper and asks Isherwood, Do you know what *this* is, my dear?, before snorting its contents. Cocaine makes him feel he's in a wonderfully calm Venetian palace, and that he is Joan of Arc; heroin spreads like a stone flower from the stomach to the legs and the arms. As they walk back along the canal he jumps out from a corner, black furry coat over his head like a bear. You see how much he loves us? Christopher says. Even evil is a performance. In Munich, Klaus attends a rally with Brian, who turns to the woman cheering next to him and says, I beg your pardon, Madam. Did you ever consult a really good psychiatrist?

They didn't really believe what was coming. Klaus asked Christopher to marry Erika so she could claim a new nationality; he declined because his mother wouldn't approve, but Auden agreed, because he did. After all, he said, what are buggers for? Back in England, Forster goes to see Stephen Tennant in a Sussex hotel, with news from the Continent. It is all moving away. They discuss *Moby-Dick*. I know all this because I met the survivors of that time. I wanted to be them. I felt I had been. I felt I could act or

Philip Hoare

speak the way they did, in their herringbone coats and floppy hair. My sister and I dressed in clothes reincarnated from suburban jumble sales on dark winter nights. One of them signed their book for me. He dated the inscription August, 1930.

Klaus and Erika escape from Spain; their father is told they've been rescued by submarine. Klaus follows his family across the Atlantic. He sails from Southampton on a new luxury liner, *Champlain*. It was nothing he wasn't used to. Three months later, in their tweed coats, Auden and Isherwood take the train to Southampton and sail on the same ship. They run into a blizzard off Newfoundland; the ship arrives in New York looking like a wedding cake. Sailing on the quarantine launch to meet them, like swan knights out of the snow, are Klaus and Erika.

In Manhattan, which Panofsky describes as a gigantic radio set capable of receiving and transmitting to a great number of stations unable to reach each other, the Manns become the unofficial reception party for artists and writers fleeing Europe. Their house is a rescue bureau for people in danger, says Thomas, people crying out for help, people going under. In Princeton,

they're photographed for *Time*, in their sitting room, sitting round. They smile conspiratorially in their masks. You can't tell who belongs to whom, what demands they will make. Thomas stands hand-on-hip; they laugh because he's just quipped that Christopher is the family pimp. They're back in their villa on the river, the Buick purring outside. The ornate fireplace, the rococo chairs, a black-and-white still from a movie set, still and bright, lit from underneath. The flash casts shadows on the wall. They don't look foreign at all.

October, 1940. Another family assembles on Brooklyn Heights, overlooking the sea. At 7 Middagh Street, a tall, gabled house, a ship that's slipped its moorings, friends take rooms: Jane and Paul Bowles, who lent his name to Sally in Isherwood's story; Benjamin Britten and Peter Pears, who will make operas out of *Death in Venice* and *Billy Budd* (Mann wanted them to do *Faustus* too); the smart magazine editor George Davis and Gypsy Rose Lee, the intellectual burlesque queen; and Annemarie, the inconsolable angel, with whom Carson McCullers is inconsolably in love. Nor is the household only human: Joe the chimpanzee moves in with his friends, a pack of circus-trained dogs.

Auden orchestrates it all, this two-year cabaret; a defiant performance ruled over by a poet who collects the rent and runs the place like a public school: We've got a roast and two veg, salad and savoury, and there will be no political discussion. In the evenings they decamp to the waterfront bars, with their sailors and friends. Everyone is beautiful and never boring. It is a tumult of alcohol and incest. Klaus starts a new magazine, decisively called *Decision*; Marianne Moore contributes to the first edition. Thomas accepts the post of advisor, on condition that Marianne agrees to be Klaus's associate editor. Klaus and Erika say art must take sides and resist, or culture itself would perish; anything else is a charade.

Wystan and Christopher aren't so sure. Auden says it's the artist's duty to tell truth first, even if that means pointing out

uncomfortable facts; otherwise you risk becoming like your enemies. He shuffles about in his carpet slippers, wearing expensive clothes as if they didn't fit. Fastidious and filthy—he once had to throw away one of his caps when he was sick into it in a cinema—he's sustained by Benzedrine at breakfast and sedated by Seconal at supper, after which he retreated upstairs, saying he wanted to be alone like Garbo.

Like a monk, Auden gave up ordinary life for art. His life was a painting. Looking out of his window, he saw Whitman boarding the ferry at flood tide and Melville sailing into mildness, his occupation another island. Marianne Moore, Auden's favourite American poet, lives nearby. He says her work is dolphin-graceful (he was quoting from it). She says his work has the effortless continuity of the whale or porpoise in motion, and that she and Wystan are bound by hoops of steel.

Her life was determined by steely bonds. Born in St Louis in 1887, and brought up by her mother, Mary, she never knew her father, who, admitted to an asylum, obeyed Matthew's gospel and cut off his right hand. Marianne received a feminist education at the women's college, Bryn Mawr, where she spent most of her time in the biology lab and learned to swim in a slimy pool with a rope tied around her waist. The intensity of her mother's hold meant that Mary and Marianne would share the same bed for forty years, even when Mary's lover, also named Mary, moved in. Her mother was her other, her voice of correction.

It was difficult to know who was who or what. Marianne and Warner, her brother, saw themselves as twins; he and her mother referred to Marianne as he, as did she. All three took on non-human identities: Mary, a mole or a rabbit, Warner a dog or a badger; Marianne a rat or a basilisk. The whole family was an animal analogy. Marianne was already writing poetry that seemed to come out of nowhere, startlingly modernistic, drawn from her immersion in books and art. I do not appear, my work jerks and rears, she told Ezra Pound.

She is determined to live in New York; she called her first solo visit there in 1915 her Sojourn in the Whale. The city was Nineveh and she was Jonah by the Aquarium in Battery Park, where Ishmael had bemoaned his landlocked state with the other water-gazers there. Inside the former fort, in a circular pool thirty-seven feet wide and seven feet deep which once housed beluga whales, dolphins now swam. They had been stolen from Cape Hatteras the year before. What disgusts you? Marianne asked, looking across to the Statue of Liberty.

In 1918, she and her mother moved into a two-room basement apartment at 14 St Luke's Place, Greenwich Village. It was three blocks from the river; they could see the tops of the masts there. Mary had to cook in the bathroom, and they ate sitting on the side of the tub. Marianne's study was a corner of the sofa, a nest of books and notes where she embroidered her samplers of words. They tumbled out in strange arrangements, just so, ordered impressions and cut-up quotes. People only called them poems because there was no other category in which to put them: they were observations, she said, written to be looked at.

She'd wanted to be an artist, or to write fiction. It sounds rather bizarre, she would say. No one expects a poet to be consistent. I do not like artists, she says, I like laboratory scientists & tennis players and boys of the kind that go in flocks and say little when isolated. But she liked Marsden Hartley's magnificent little thing of the sea she had seen at Alfred Stieglitz's gallery, and Man Ray made a deep impression on her. She raves to Bryher, her wealthy young patron, about *The Cabinet of Dr. Caligari*, the way every angle tipped and tilted; she will love *Mädchen in Uniform*. Everyone she knew in London was leaving for Berlin. (Stieglitz tells Rockwell Kent that Germany stood at the head of civilisation; Hartley invents a cross-bred Amerika, combining abstract portraits of Berlin officers in their medals and Native American swimmers in their trunks.) In Greenwich Village, Marianne and her mother live like anchorites. She spends months writing a

single poem. Out there, in the anomalous streets, dark and woozy on a midsummer night, she goes to the Provincetown Playhouse, whose actors arrive by ferry from the Cape. She meets radical poets whose work she was already superseding beyond years. She sunbathes on the roof and calls herself a pterodactyl, with a craving for peacock blue. She stands in the street, a pony's reins in her hand; her Titian hair, her pale face, her Irish descent, deceptively reserved. Some sort of handy mask ought to be invented or hindoo veil for the city social event, she says. Lunching on onions and prunes, her weight falls to seventy-five pounds. She loves the circus; she has a trapeze to stretch her scoliotic spine. I could pick her up with one hand like a bird.

She wasn't eccentric; it is we who are odd. She sees animals as her ancestors: in the library, in the museum, in the zoo, where sea lions swam round and round, and still do. It was the sea that held her, the one thing she wanted to put into her work. Her brother was a sailor, after all. She escaped, with her mother, to Monhegan, an island off the coast of Maine with rocky, tree-hung shores. It was a place for wild writers and artists, she told H.D.; Hartley's friend Rockwell Kent worked there. Climbing a headland one hundred and fifty feet high, she saw things slip from animal to mineral to human in the clear water. Her titles became the first line of her poems, so that

> An Octopus
> of ice. Deceptively reserved and flat,

becomes a glacier becomes glass that can bend, then turns back into an octopus picking periwinkles from the rocks while larch branches filter sunlight (like whales), and antelopes stand on cliffs the colour of clouds. She is the watcher, in shifting animal weather. She sees a jellyfish as an amber-tinctured amethyst, quivering with intent, a fish wading through black jade, the recurring phosphorescence of antiquity; the sea as a chasm in which she

was contained. My writing is, if not a cabinet of fossils, a kind of collection of flies in amber, she says; she liked Thoreau's line about being curiosity from top to toe. Quoting from Ruskin and *The Tempest*, from magazines and maps, she gathered up her curiosities, became them: her hands, her eyes, her feet, her incandescent hair. A lost prince, an ice maiden, a queen. I fairly sparkle now and then, she said.

26 May 1927. This apparently shy woman who is absolutely modern and the editor of *The Dial*, an influential literary magazine (Thomas Mann is their elusive foreign correspondent; Marianne sees his reports as a commentary on his fiction), sets off on a two-month trip to England. She and her mother sail on *Caronia* from New York to Southampton; the great highway between the New

Philip Hoare

World and the Old World, the advertisements say. She'd left the latest edition in good shape. They were late sending Roger Fry the Brueghel to review, she was accepting Hart Crane's poem even though it was not well reefed, could they be sued for protesting the piracy of *Ulysses*, should they publish the Mann pamphlet with a review of *The Magic Mountain*? In London they stay in Bedford Place, round the corner from Faber and Faber, but she declines to call on T.S. Eliot, though he's only a few doors away. They'd never met, but were born in the same city, within a year of each other, and had been corresponding since 1921.

Marianne and Mary explore the bookshops, museums and ruins of England, as they had done in 1911, their first trip there. Then she'd marvelled at the boys of Oxford, whom she described as though they were exotic birds. A deluxe lot, she said, disporting white flannels & loud ties and socks. Such a combination of taste and seasickness she had never seen. Green socks with orange clocks, lavender socks and flannel coats with wide rainbow stripes of orange, light blue and dark blue. Any zoo, aquarium, library, garden, or volume of letters, was an anthology, a portrait of the curator's mind, she said. They all folded into her poetry, in evolving portraits of the leaping jerboa, the machine-like form of the pangolin, and the anteater, which she would sketch for her young nephew. She wrote about animals because, like athletes, they look their best when caring least.

As their 1927 trip draws to a close, they stay with Alyse Gregory and Llewelyn Powys in a coastguard cottage on a chalk headland in Dorset known as the White Nose. It is the end of England.

From cliffs nearly five hundred-feet high she looked down as if from a mast. Powys, who was there for his tuberculosis, takes her to the edge.

We were right above the sea, Marianne said, which stretched in a kind of primeval panorama for miles as far as you could see, down to the arch of Durdle Door. Powys shows her, as if he were God, foolish guillemots & puffins & young seagulls, ravens possibly & possibly a fox, as well as a young kestrel hawk on the path. Inside the cottage, a pair of lion skulls stand guard on the bookcase and a beautiful engraving hung on the wall. It showed Lulworth Cove, whose geological ridges looked like a whale's gill to Marianne.

The next day they took the train from Dorchester to Southampton and sailed back to New York; Mary wanted the ship to go the other way. I wish you could have seen the yachts at the Isle of Wight, Marianne told Warner, her brother, now a navy chaplain. Back in Greenwich Village, *The Dial*, which had stopped her publishing her own poems for seven years, has come to an end. Posted to the Navy Yard in Brooklyn, Warner insists on moving his mother and sister there, installing them in an apartment on Cumberland Street. It has a dumb waiter, a kitchen and two bedrooms, but the two women still sleep in the same bed.

Stranded on the third floor of the anonymous yellow-brick block, Marianne came to terms with her new home. Brooklyn is not bohemian, but she likes its sea air, the streets named Ocean, Surf, Mermaid and Half-Moon, and others called Orange, Cranberry and Pineapple, after merchandise brought from Cape Cod and the West Indies. Their street ended at the Navy Yard, its harbour fingering in from the bay. She noted that at the local stationers, your dog may wait inside but not among the merchandise. (She had no dog.)

And here she started to write again: a quiet, outrageous sequence, merging New England with a newspaper report from Brooklyn Harbour as

PART OF A NOVEL, PART OF A POEM,
PART OF A PLAY.

THE STEEPLE-JACK

Dürer would have seen a reason for living
 in a town like this, with eight stranded whales
to look at; with the sweet sea air coming into your house
on a fine day, from water etched
 with waves as formal as the scales
on a fish.

There was a shore in Brooklyn called Whale Kill; but she couldn't remember where she'd read about the whales. She should have married Dürer. She loved him: she had said so publicly in *The Dial* in 1928, on his anniversary, after seeing an exhibition of his prints in the New York Public Library. It was a modest show, the curator admitted, compared with Nuremberg's torchlight parade in the artist's honour that year; but it included Melencolia, and Saints Eustace and Jerome. Marianne wrote a page and a half on it, a love poem in prose. She loved Dürer's newness in oldness, she said, an apparitional yet normal miraculousness like a heraldic flame or separate fire in the air, and the fact that his secrets were not easily invaded.

She was talking about herself. For years she had sought out Dürer, stalking him like the library cormorant she was. In the summer of 1911 she and Mary had seen his prints in the Hunterian in Glasgow and his Turner-like watercolour of the Tyrol in the Ashmolean in Oxford. Then they sailed overnight from Southampton and looked with piggy eyes at the Dürers in the Louvre, where the portrait of the artist as a young man hung, with his jellyfish hat and long red-gold locks. She compared him to Edward de Vere, the Earl of Oxford, whose little hat was couched fast to his pate like an oyster and who was said to have written

Shakespeare's plays. She loved Dürer's sensitiveness to magnificence in apparel. Paris was also full of poodles, she noted, with dusty ears, patches, and plain legs.

Back in New York, at the Met, she had met two of his woodblocks, Samson Rending the Lion and The Martyrdom of Saint Catherine, along with the tools that cut them. An almost complete set of Dürer's prints had been given to the museum by the banker Junius Morgan. Nuremberg, on her doorstep, a subway ride away. She professed to distrust the blocks and their reliquary magic—as if someone were to venerate her typewriter—but confessed that a living energy resided in them. Her appreciation was truly votive, she said.

Now, in the library's room 321, she came face-to-face with his rhinoceros. He'd imagined it just for her. A conjunction of fantasy and calculation, she said. She liked the subtle way the D of his monogram hid beneath the medievally prominent A. His mere journeyings were fervent, she noted, observing that he had gone to the Dutch coast to look at a stranded whale that was washed to sea before he was able to arrive. Dürer's hardness drew her in. The Steeple-Jack slipped from Maine to Oxford and back again,

> a sea the purple of the peacock's neck is
> paled to greenish azure as Dürer changed
> the pine green of the Tyrol to peacock blue and guinea
> grey. You can see a twenty-five
> pound lobster; and fishnets arranged
> to dry.

She was re-enacting Dürer, like a circus, like a zoo; like the china animals on her mantelshelf, or her little velvet bear in a cricket cage. Seeing was an act of faith, from Jerome's domesticated lion who appears in her Sea Unicorns and Land Unicorns of 1924, to her Then the Ermine: of 1952,

with the power of implosion;
like violets by Dürer;
even darker.

She acquires a dull silver book embedded with gothic lettering, 𝔄𝔩𝔟𝔯𝔢𝔠𝔥𝔱 𝔇ü𝔯𝔢𝔯 / 𝔅𝔩𝔲𝔪𝔢𝔫 𝔲𝔫𝔡 𝔗𝔦𝔢𝔯𝔢, published in Berlin, 1936, with Dürer's stag beetle on the cover, all spikes and horns. Inside were his dark violets, like a bouquet. In 1937, she compares the exhibition of Dada and Surrealist art at MOMA to the Mariner's Museum in Virginia, in whose laboratory-like rooms she finds bleached wood garlands, figurehead fish-tailed monarchs of sea and land, a tattooer's apparatus, iridescent glass objects from the sea, the skeleton of an infant whale. The museum is a Shakespeare's or Dürer's paradise, she says, no more accidental than a work of art is accidental. A friend sends her a print of magnificent squirrels for Christmas. 'By probably the greatest painter of the German school', she quotes, I don't feel like quarreling with that! Such absent minded busy, wild-animal eyes.

For a poet who saw Elizabethan narwhals as ostentatiously indigenous of the new English coast, and who wondered what it might be like to be a dragon (immense, at times invisible), it was preordained that Dürer's vision should be hers. She imported a sixteenth-century German artist to twentieth-century New York, her own armoury show.

She became him.

Her Dürer was boxed up and strange, like a landed lobster. In her freighted words the whale became the America the artist never saw. From the medieval sea of Dürer to the modernist sea of Moore: the melancholy angel, the Aztec gold, the armoured animals, the exotic birds, the pale moonlight; all the sadness of the world in a whale's eye. Albert became Ahab; *Moby-Dick*, the *Faust* of the United States. The White Whale, as Charles Olson would write in 1947, was America, all of her space, and the *Pequod*, all races together, was not yet an accomplished dream.

The whiteness of the whale, the darkness of apocalypse. The absence and presence of the sea, from Southampton to Rotterdam, Hamburg, and Lübeck; Manhattan and its projects, Prospero raising the storm with his dark arts. That same year, 1947, Howard P. Vincent would observe that Moby Dick was ubiquitous in time and place. Yesterday he sank the *Pequod*, he said; within the past two years he has breached five times; from the New Mexico desert, over Hiroshima and Nagasaki, and most recently, at Bikini atoll.

Down in the Navy Yard where Warner worked, there really was a stranded cetacean: the first American submarine, made for the civil war in 1863, now standing high and dry. It was named Intelligent Whale, and was hand-cranked; it might have been designed by Dürer. When I first arrived in Brooklyn in 1929, Marianne wrote, it lay inside the Cumberland Street Gate, a shapely little cylinder of clamshell grey, like a pig (she added, in a note of rivalry, that the American Museum of Natural History had a blue whale that weighed sixty tons).

Lying in her sickbed, Marianne watched from her window as a steeple-jack worked on the church at the other end of Cumberland Street. His name was C.J. Poole; she knew that from the sign at the bottom of his ladder; another sign warned, in red, of danger, as he climbed up to gild the star at the top. The church had stood

Philip Hoare

proudly on Lafayette Avenue since 1860, a red sandstone corner of resistance built as a temple of abolition. Frederik Douglass and Harriet Tubman spoke there; fugitives from slavery on the Underground Railroad were hidden in the tunnels underneath. Although she saw the church as a fit haven for waifs, children, animals and prisoners, I doubt Marianne knew that; or that in 1833, the young Douglass, Tubman, and Abraham Lincoln, all witnessed the same stupendous storm of shooting stars which turned the sky electric and was seen as a great upheaval of things. But as she watched the workman in his scarlet overalls let his rope down like a spider, the steeple he was climbing had already been made unstable by the new subway tunnel which was being driven under the road.

An amazing street. A wobbly gothic church at one end; a beached iron whale at the other. A poet in the middle, high in her room. Soon the spire would fall, just as the storm disturbed the stars over Maine and summoned whales to the Brooklyn shore. Marianne could only look down from her window and write.

Bound by hoops of steel. Six years later, in 1938, visiting Brussels with Isherwood, Auden stood in front of Brueghel's painting and saw a boy falling into the sea. A man on the shore in a red hat carried on fishing, and a ship sailed calmly on.

Two years after The Steeple-Jack had appeared in print, T.S. Eliot sent his fellow director, Frank Morley, to see her in Brooklyn. Morley's nickname, the Whale, or Leviathan, was a mystery to those who thought it derived from his corpulent size. (In his letter, to let her know how to recognise him, Morley drew a sketch of himself from behind, telling her he was a yard wide.) But when he arrived for tea, Marianne decided she liked Mr Morley a lot: firstly on account of his plaid raglan coat made of wool from his own sheep; secondly for the amusing way he crossed his ankles like Tweedle-dee; and thirdly because he had written a book, *Whaling North and South*, detailing his adventures off Shetland and South Georgia in 1924. Far from being an ordinary, boy's own account (SINCE we all began reading 'Moby Dick' again, the epic grandeur of the whaler is no longer a secret to us, the *Radio Times* had noted in 1927, in this evening's talk Mr Frank Morley will describe how the biggest creature on the face of the earth is caught) Morley told Marianne he was revolted by the slaughter he saw.

There are two kinds of whales, he had written: the whales that are classified as cetaceans, and those that are enlarged into ideas. He'd seen the dead whale. Marble would not be good enough to lay this corpse upon, he said. This is the sordid remnant, yet the eye may even now replace what has been lost.

The big man warmed to his theme.

This monstrous form and painted shapeliness has burned its way through phosphorescent waves in summer, the black night lighted by luminous clouds of its own breathing; and sinking with an easy silence, it has spiralled to unseen depths, upon unknown desires. Akin to mine, his body was alone among the nations of the sea. Here he lies, the wanderer, received on earth, he said, more lovely and more startling than the Sphinx.

Philip Hoare

Marianne, the tiny woman, talks about the whale between them. There was little room for business in this New York conversation. A few weeks later, she tunes in to Radio WJZ, for the Thursday afternoon lecture at 5.30 p.m. on animals in art. This edition particularly fascinated her, she told Warner, since it dealt with whales. The name came from Aristophanes, who called the whale the loud-mouthed phalos? (or was it wide-mouthed?) —not from wallowing as has been supposed, the lecturer said. Michelangelo chose the whale as the symbol of restored life, and Alexander the Great hung great bells on his galley, fore and aft, to frighten off the whale. He was the most architectural of beasts. Marianne made notes, of course, as she had when composing An Octopus, carefully writing in pencil in her lined notebook: American Pacific Whaling Co tows in whales, humpback, finbacks, sulphur bottoms, & sperms—

Meanwhile, in London, Eliot was considering a request. A friend asked if he would read from *Moby-Dick* for a radio serial, playing a Nantucketer in the style of conversations he had heard between Eliot and Morley. The poet replied that he'd never been able to finish the book, finding it tumid, but admitted that his great-grandfather had run whaling ships out of New Bedford.

It was a wealthy business, he said.

Every port had a name for the sea, said Auden (it was a typo, port for poet, but he liked it anyway). There were three acts to your life, he knew from Kierkegaard. The first was the passing moment of sensation; the second, involvement and responsibility; the third, understanding that there is no inheritance and no matter what you do, good may not result. You could only abandon yourself to despair, or throw yourself on the mercy of God.

Klaus surprised everyone by joining the US Army. He stood on the front line with a megaphone, urging fellow Germans to surrender. He re-entered Munich and found his family home,

which had been used as a state brothel, reduced to a shell. He stood there, looking over the clear green river. Peace had brought nothing of the sort. The house on Middagh Street was demolished by the city planner, Robert Moses, who divided Brooklyn from its sea with an expressway, and demapped the end of Cumberland Street, replacing it with a housing project named after Walt Whitman, blocking off any poet's view of the bay.

Bitterly disillusioned by America and unable to accept what had happened to his homeland, Klaus had to face the fact that his dreams of a federated Europe had ended with the falling of the iron curtain. There is no hope, he said. We intellectuals, traitors or victims. We are lost! we are won! Annemarie had followed her lover to Nantucket, tried to commit suicide twice, but died after a bicycle accident in Switzerland, trying to ride hands free. She was thirty-four. Addicted and hopeless, Klaus, her soulmate, ended up on the shores of the Mediterranean, and took an overdose in Cannes on 21 May 1949, Dürer's birthday. According to Isherwood, it was also the date set by an international suicide club of intellectuals for their final protest; Klaus was the only one to carry it out. Thomas declined to attend his son's funeral. He didn't, or couldn't, explain why.

In his memoir, *The Turning Point*, published in New York in 1942, Klaus had written rhapsodically of his childhood. Dressed in eccentric, embroidered clothes, the siblings spent summers at their country house, where they loved to swim in a pond. Its water felt so heavy that you hardly sensed your own weight once you had dived into its gold-brown depth, Klaus said. But he also remembered the baker who had drowned in it and whom he had seen laid out in a chapel, his hands so brittle and transparent and so unspeakably noble, as if he had accomplished something utterly fine and unusual. The corpse's mouth was closed with a black band, covering the blue and swollen lips like a muzzle. It was, Klaus said, a new puzzle, a new beauty, a new myth.

Silenced, sewn up, like a protestor, he couldn't act up or speak of death.

In March 1949, at the University of Virginia, Auden delivered three lectures on the sea. He'd waited a long time for this. He began with a long quote from Wordsworth's Prelude—the echoing shell of imagination and the geometric stone of abstraction—and proceeded, with references from Coleridge, Baudelaire, Mallarmé and Rimbaud, to propose a double-natured hero, an amalgam of Melville and Dürer: part Ishmael the exile, part Knight of Faith who would restore the Age of Gold. Auden saw the sea as a state of barbaric vagueness and disorder, and thought classical authors would have agreed with Marianne Moore, who had said that it is human nature to stand in the middle of a thing, but you cannot stand in the middle of this.

Isherwood said Auden hated the sea because it was so formless. But you can't expect a poet to be consistent. Auden had been an inveterate swimmer since he was a boy, and had spent the past two summers with his friends, James and Tania Stern, in a shack they rented on Fire Island. Photographs show his pallid body made gainly by the waves. It was there that he wrote his epic poem The Sea and the Mirror reimagining *The Tempest*. I doubt he knew it was also where Melville began *Billy Budd* and where Wilde swam. What he did know was the evil he had seen in an Icelandic whaling station in 1936. As a boy, one of his favourite books was *The Cruise of the Cachalot*, Frank Bullen's story of his voyage from New Bedford and the crew's lust for Actual Warfare, Our First Whale. In Iceland, the poet was faced with the reality. He described the scene in a letter to his wife.

A whale is the most beautiful animal I have ever seen, he told Erika, it combines the fascination of something alive, enormous and gentle, the functional beauties of modern machinery. A seventy-ton one was lying on the slipway like a large and very

dignified duchess being got ready for the ball by beetles. To see it torn to pieces with steam winches and cranes is enough to make one a vegetarian for life.

Auden's empathy was mixed with guilt. He believed that he owed his own ancestry, his pale face and straw hair, to this land. People saw a certain cruelty in him, the way I saw my first whale in captivity and knew my own cruelty, too. The body remained alone in the sun, he said, the flesh still steaming a little. It gave one an extraordinary vision of the cold controlled ferocity of the human species.

Five dead whales lay out in the bay. All the while a wireless played an inane ditty, I want to be bad. Animals are our past and our future, Auden wrote later that year, as the news worsened. He captioned his photograph The Corpse. Let me pretend that I'm the impersonal eye of the camera, he said.

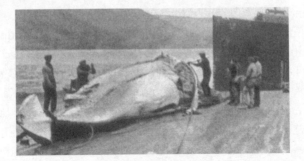

In his poem, Herman Melville, written in 1939, Auden stated two simple truths. Evil was unspectacular and always human, but goodness happened every day. Yet none of his words saved a single Jew, he would confess, and

No one is ever spared, except in dreams.

The ghost lifted out of the ocean, the saint in their niche, the fugitives under the church. In his Virginian lectures the poet

summoned up the damp drizzly November that led to Ishmael's suicidal thoughts, standing at the tip of Manhattan where Marianne had written of her sojourn in the whale. Auden told his audience that the grand explanatory image of this condition was of course Dürer's angel, unable to sleep, unable to work, surrounded by abandoned tools and the fragments of a city they have the knowledge but not the will to build, tormented by a batlike creature. All the while, behind them, was the dark water, the rainbow, and the comet. Most melancholy, Melville agreed. All noble things are touched with that.

In November 1945, Erika Mann had returned to Germany to report on the Nuremberg trials. She watched unrepentant war criminals acting as though the whole process were a kind of entertainment. When she visited them in their hotel-prison, they told her they would have done things differently. One wore nail varnish on fingers and toes. Back in Berlin, she was shocked at the nothingness: she saw the city as a sea of devastation, shoreless and infinite. Everything was poisoned. Her family had been driven out of America by the same perversion of power that had forced them from their homeland. A report published years later would reveal that the FBI had trailed her and Klaus, suspecting them of being communists and queers.

I have no desire to rest my bones in their soulless soil which I owe nothing, said Thomas, and which knows nothing of me. America had wasted him. The Manns returned to Switzerland, where Erika—who'd edited *Doctor Faustus*, surgically removing forty pages as the cancer had been removed from Thomas's lung—devoted herself to assisting her father. He had prophesied that 1945 would be his last year, as if that were his allotted span. Ten years later, in 1955, in a Zurich hotel, he fell in love with a young waiter with pretty eyes and teeth.

He might have been describing a dog. Erika chided him for his indiscretion. Pleasure at a poodle is nothing different, he told her. The boy lit his cigarette for him at the table; Thomas

waited for the match to burn in the hollow of the boy's hand. When we still suffered with love, he said. You still do at seventy-five. The dark angel, who unclasps hands and sends each of us into the solitude of nonexistence, he wrote to his wife, does he really, in each instance, have the commandment and power to do that? The questioning look in her father's grey-green eyes grew ever broader and bluer, said Erika. He no longer quoted Prospero—And my ending is despair—words that had pierced his heart.

They spent that summer at Noordwijk, on the same shores where whales stranded and villages vanished, and he saw time become sea time, another dimension, drowning in the immeasurable monotony of space. This was one of his favourite places, he told Hermann Hesse; they'd been there several times before. The hotel was as bad as it was expensive, but the grand terrace, the beach and the sea were glorious, the most magnificent he knew. It was there that he had waited for war in August 1939, swimming in the cold summer sea, writing in his beach shelter and reading Goethe's *Faust*.

August, 1955. The weather had been unusually fine, they all agreed. For writing I must have a roof over my head, he said, and since I enjoy working by the sea better than anywhere else, I need a tent or a wicker beach chair. So he sat in his sandy retreat, surrounded by playing children, facing the gently rolling ocean, in the stimulating air; he felt especially well, and loved it there, even in the fog. He was writing his last essay, for an anthology of the most beautiful stories in the world. He chose *Billy Budd*; Melville's last work, composed on a beach. Having reread its final scene, in which Billy's beautiful body is hanged from the yardarm before being lowered into the sea, Mann declared, Oh, would that I had written that! Love of the sea is nothing else than love of death, he said.

In Amsterdam, as his death awaited him, Mann stayed in the Hotel Amstel and gave his last press conference, nineteen years

before the starman stepped down the same staircase in high-heeled shoes, with flame-red hair and a patch over one eye, Thomas was planning a new gallery of characters from the Reformation. He'd received a gift: a black poodle named Niko, wearing a collar of Florentine gold leather with fringes of gold tinsel. He might have diamonds strung round his neck. A new dog or the same one, as loyal as all the others, as Bauschan, or Lux, the German shepherd. A life measured out in dogs, always by his side.

Two weeks later, having suffered a thrombosis, Mann was taken from the beach by ambulance to a Zurich hospital, from where he wrote to a friend that he hoped he would not be condemned to a long enchantment on the mountain. You cannot imagine how sorry I was to depart prematurely from Noordwijk, he said, there of all places this had to happen to me.

Two days later, his condition took a turn for the worse. Attended by the same doctor who had ministered to James Joyce in his final illness, Thomas Mann died on 12 August 1955. Black eyes had filled with tears. Lips he had kissed.

With her mother's death in 1947, Marianne Moore had been released. Secure in her brilliant mind, she started to dress like a character from her own world, wearing a black cape and velvet tricorne made by a Brooklyn milliner. She'd wanted one ever since she was at Bryn Mawr, when she'd longed for a three-cornered sailor's hat. Elizabeth Bishop said she looked like a luminescent Paul Revere, others that she was Washington crossing the Delaware. It was an advertisement, this archaic-modern look: a sign of genius and dedication to the sea, like Tennyson in his wide-awake hat and cape on the whale-backed Isle of Wight, or Dürer in his smock in the streets of Nuremberg.

At last she was the captain of her own fate, and her work was everywhere. She appeared in an airline commercial with Mickey Spillane and Andy Warhol, delivering her line—When you've

got it, flaunt it—then turning to fix us with her steely eye. For someone so shy, she was photographed, remarkably, all her adult life: by Sarony's studio, where Wilde's American image was fixed; by George Platt Lynes, Cecil Beaton, Carl Van Vechten, Henri Cartier-Bresson, Richard Avedon and Diane Arbus. Her hands folded, holding gloves. She attended Capote's Black and White Ball in a 39¢ mask, and wrote the liner notes for Muhammad Ali's LP, *I Am the Greatest!* (she compared him to Sir Philip Sidney). George Plimpton took her to Madison Square Garden for the big fight; Norman Mailer invited her to his table.

Her animals spoke for her: the elephant carrying the Buddha's tooth, the paper nautilus releasing her eggs, the unconversational giraffe. Her bracelet of elephant hair, rhinoceros-skin whip and walrus tusk from the Greely expedition became little museums in

Philip Hoare

words, like the boxes of Joseph Cornell, her friend. She wore two watches so that she would never be late and carried a pair of black plastic binoculars in her handbag, bought to watch a blue jay in her backyard. She liked to imitate him so that he answered her, looking sharply round, like Pluto the crow whom she imagined had adopted her in the park, furnishing her hat with feathers of a blue-green lustre and fetching her Webster's from the shelf. A visit to her apartment, wrote Bishop, was otherworldly—as if one were living in a diving bell from a different world, let down through the crass atmosphere of the twentieth century. Miss Moore would see anyone; I could have called at her door. She'd give me a dime for the subway back.

In October 1955, Marianne received a letter from Robert B. Young of the Ford Motor Company, Dearborn, Michigan. Would she devise a name for their new model, to reflect its elegance, fleetness and advanced features? Over the next few weeks she sent forty-three space-age, animal-mechanical submissions to Ford, an assembly-line of names such as the Aërundo, the Angelastro, the Astranaut, the Thunderblender and the Mongoose Civique. None found favour in the boardroom. Then, responding to the secret sketches they'd sent, in which she saw a sense of fish buoyancy, she wrote, I have always had a fancy for THE INTELLIGENT WHALE—the little first Navy submarine, shaped like a sweet potato; on view in our Brooklyn Yard (as if it were parked outside).

Having carefully studied the mechanics of the car, as fascinating to her as an armoured animal, she said she wanted to capture the principle of the swivel-axis, which she compared to the Captain's bed on the whale-ship *Charles Morgan* (late of New Bedford, now moored at Mystic, Connecticut), balanced so that it levelled, whatever the slant of the ship. If I stumble on a hit, you shall have it, she told Ford. But her final idea, UTOPIAN TURTLETOP, had a surreal, if not mischievous quality, and she hears nothing more. Ten months later, the company wrote to report Mr Young

had left to serve in the US Coast Guard and they'd decided to call the model Edsel, after their founder's son.

Ford's car of the future was a failure. It was discontinued within two years at a loss of $250 million, and the name Edsel became a byword for commercial disaster. This left Marianne free to embark on what had clearly been her mission all along: to commandeer the *Intelligent Whale*, with a new crew. Thomas cranking the propeller, Queequeg as first mate, Wystan peering through the periscope and Marianne as their piratical captain, Pluto perched on her shoulder crowing out the orders as they sailed for utopian shores.

After all, as she said, if you weren't willing to be reckless, what's the point of the whole thing?

In Zurich, Erika Mann continued to edit Thomas's work as if he were still at his desk. She died in 1969 and was buried beside him. The youngest of the Mann sisters, Elisabeth, lived into the twenty-first century, in Nova Scotia, where she devoted herself to the protection of the ocean and an organisation whose motto was *pacem in maribus*. Human beings are returning to the sea as the whales and penguins did, she told *People* magazine in 1980.

It used to be a hostile environment but now it was an important part of human life and economy, and she hoped that her cooperative society, Planet Ocean, would see man as part of nature, not an overlord (not a species that turned tusks into page-turners or teeth into paperweights). Elisabeth admitted her words might sound utopian and high-flown, but insisted pessimism was a self-fulfilling prophecy. It was necessary to muster optimism, or you can't act, she said.

Dürer sat in his chamber, in the light of his bottle-glass windows, thinking about the stars. In the year after Melencolia, he engraved a pair of prints for Johannes Stabius, astronomer to the

emperor, laying out the firmament like an astrobiologist studying life forms that may or may not exist. In 1509, Dürer had acquired his own observatory, along with his new house; it had belonged to his godfather, Bernhard Walther, who had worked with Regiomontanus, the great astronomer. There was a window built for star-gazing (a council injunction forebade the emptying of chamber pots onto next door's roof). Dürer's father made astrolabes; Nuremberg was famous for such instruments.

Set at the dark heart of Europe, with its dark skies, the city was the best place to see the stars, said Regiomontanus. Dürer's designs stilled the universe. In part the first, northern constellations jostle for air space. There's no inertia here. Everything sparks into life like a human zoo. Part two had a clearer view of the south, the Pacific he never saw.

The extent of the Earth, of the water, of the stars, is intelligible thanks to painting, said Dürer, and much more will be learned through pictorial representation. His animals roll around. The hunter with his dogs (O flashing Orion, said Marianne, when writing about baseball, your stars are muscled like the lion); scaly beasts swimming so low only a Netherlander could see them. Meanwhile, down in those southern oceans, whales navigated by the sun and the moon and the stars.

Nor when expandingly lifted by your subject, can you fail to trace out great whales in the starry heavens, says Ishmael, tucked up with his harpooneer. Thus at the North have I chased Leviathan round and round the Pole with the revolutions of the bright points that first defined him to me.

And beneath the effulgent Antarctic skies—he goes on, tattooed legs thrown over his—I have joined the chase against the starry Cetus far beyond the utmost stretch of Hydrus and the Flying Fish. Would I could mount that whale and leap the topmost skies!

He rolls over and goes back to sleep.

In 1976, a crater on Mercury was named after Dürer; they

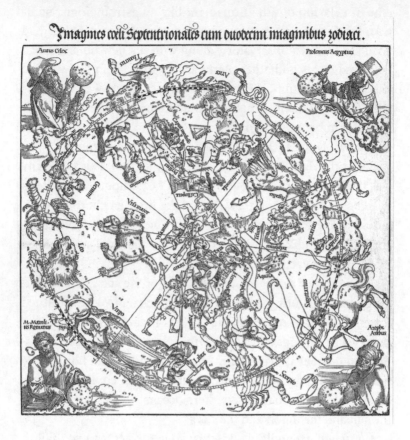

named another Melville the same year. I'm eighteen, watching the starman in a darkened hall, caged in black and white. I'm writing this on the other side of the world, where the whales dive in the deepest ocean I'll ever know, tempting me down with their clicks. But the sea is no consolation. It doesn't remember me, and no one is saved, except in the stars.

Philip Hoare

MELANCHOLY

The emperor lay shrivelled like a little bird, sins all shriven. He wore a red skull cap, eyes puckered, no longer seeing, his Hapsburg nose a beak.

A death foretold. When Maximilian died on 12 January 1519, his final portrait was painted by an anonymous A.A. The monarch had spent the last years of his life travelling with his own coffin (Nelson did the same). He'd pre-ordered his cenotaph in Innsbruck, complete with guardian statues designed by Dürer. It was a grand, empty gesture, since in the event, Maximilian was not inside. His body lay elsewhere; at least, what was left of it. He'd decreed his remains were to be destroyed. His hair was cut off and his teeth were smashed out, the shards buried with burning coals; his flesh was scourged and quicklimed to decompose more quickly and, strewn with ashes and wrapped in sackcloth, his corpse put on display to all eyes, as a reminder of the vanity of earthly glory!

Death dries us up. The water runs away, says the doctor on the magic mountain. We dissolve, leaving only a shell; all the cells that hold you together will break and decay. Death is the most dissolute power, said Mann. It bursts you open like a whale. The sea has nothing to give but a well excavated grave, said Marianne Moore. For a man who had ruled the world, death was an abdication,

yet even then he was still chastised. When Maximilian's coffin was opened in 1573, birch scourges were found by his side.

The departure of his demanding patron had a direct effect on Dürer. No more triumphal arches or processions, no more armour to engrave or prayer books to illustrate. He was released in middle age, a student again. Dürer's sketchbooks of 1519 look more like those of an artist from 1919, filled with figures reduced to their essence, anticipating Duchamp's nude descending a staircase or the robotic workers of *Metropolis*. These poses and gestures, said Panofsky, were governed by rectangularity which made them, now abrupt, now frozen, at times almost contorted, but always strangely expressive in their mechanised movement. In his relentless aesthetic—accelerating rather than slowing down as his own body aged—Dürer was redesigning the human for the final renaissance: of our selves.

Type faces squeezed into the same boxes as his alphabet; a parade of ectomorphs and endomorphs, measured and assessed

till they resemble the idealised figures etched, not on copper plates or armour, but on golden discs sent into outer space. A foolish attempt to show off.

Hi, here we are

We can't help ourselves, we're that important. Dürer distils the irregular curves of living organisms, said Panofsky, into polyhedral shapes. It was the end result of all those clumps of grass and twitching hares: spiral auguries, fractal shapes.

Hi, here I am

Everything is archetype, said Jung, if you only knew what depths of the future you carry inside you! The future waited for Dürer: designing masques for monarchs in riverside palaces, peering at sublime landscapes through a Claude glass, capturing people as floating ghosts on silvered screens.

Panofsky said Dürer did violence in some measure to nature; Ruskin thought he was polluted and paralysed by anatomy, and could never draw a beautiful female form or face. We have various kinds of men because of the four complexions, Dürer observed from his Nuremberg eyrie.

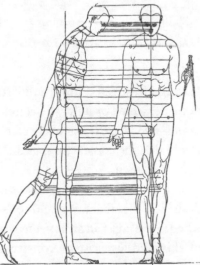

Besides, there are two races: white and black, he said. The difference between the two is remarkable. His opinions were certainly not enlightened. Yet he drew a young Black woman named Katharina, twenty years old, in service to his friend João Bradão, the Portuguese consul in Antwerp; and another young man, unnamed. These were the first serious portraits of people of colour in western art, drawn with subtlety and sensitivity, far in advance of the times.

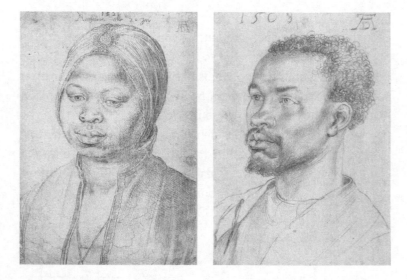

Having investigated three hundred living persons, Dürer found none deformed or ugly. His conclusion was that perfection was impossible. The Creator made men as they should be, he said, and I hold that the comely form and fairness are found in the multitude of all men.

In his precise, cool way, he was formulating the randomness of desire; the idea that we should consider our bodies beautiful at all, when all we are is an arrangement of bones, growing under layers of skin and fat, scraggy constructions made to sag and move and process, to consume and exude, full of blood, sweat, shit and

piss, ready with embraces and emotions, outrages and rejections, and intimate, mysterious alliances. We are asymmetrical, incapable of binary division. He sensed that our bodies vibrate invisibly with an unknown energy, like dynamos, twitching whiskers and flickering eyes. He wanted to understand, moving towards his end and back to his beginning, like Leonardo's drawings of a foetus in the inner space of the womb.

Time was running out. His greatest work was to be a sacra conversazione, begun in 1521 after his tour of the Low Countries. In it he would gather all those animals and angels in one monumental altarpiece, his best yet. Its preparatory drawings permit us, says Panofsky, to observe the growth of the invention as an entomologist might observe the development of a butterfly. It would inspire any poem by Marianne Moore. He drew the sketches on blue-green paper from Venice dyed with Turkish indigo, floating his world on its watery sheets like Hokusai, seeing everything till now as a preparation for everything to come. He even listed the colours he'd use, so that we could imagine the finished picture

feilet, rot, plo, rot | prawn, gel, feilett, rot, gel, weis, schilh

violet, red, blue, red | brown, yellow, violet, red, yellow, white, neutral

—which is what we must do, since his painting was never made, just as he never saw the whale. It remained a private conversation. When I was young, Dürer told his friend Philip Melanchthon, a melancholic automaton, I craved variety and novelty. Now, in my old age, I have begun to see the native countenance of nature and come to understand that this simplicity is the ultimate goal of art.

It was more urgent than ever, his urge to create. No wonder he was so interested in bones. He saw and felt his own, all jumbled up with the antlers and teeth and furs, his melancholy anatomy.

Once inside the gallery, leaving the queue of winter pilgrims behind, under the glass pyramid, I climb up the stairs and pace down endless corridors, past apartments where an emperor languished in his canopied bed; past portraits of well-fed merchants and extravagantly dressed dames whose skin never saw the sun; past multiple depictions of torture undergone by martyrs, as if the worse a fate could be imagined, the more faithful the witness; past the people peering through their phones at the half-smiling woman and refugees on a raft.

I came a long way to see him. I ought to have made an appointment. At the top of the building, the corridor stops. Boarded up. I knew what that meant. He was there on his own in a chilly room, bare-necked, all dressed up. Could I bribe a guard, sneak in like a thief? There's a hand in front of my face.

So I walk down the river. The water runs thick and grey. I can't even get in here, not because an arctic wind is blowing, but because I'd attract the attention of the police boat and its armed and helmeted crew. Instead, I find myself in the botanic gardens. Ignoring the stink of dung from the zoo where Sebald heard the roars of big cats going slowly mad, I climb another set of steps. I've no idea of what lies inside. It might be a railway station, for all I know.

Everything is still and bare. I'm in such a trance I walk straight past the young woman in the wooden kiosk and am turned round by a stern guard ordering me,

Achetez un billet, s'il vous plaît (nine euros).

The price of admission. I almost ask for a return. The sunlight falls in angles, not across trains waiting to take people away, but on row after row of bones. A terminus of another order.

Arranged before me, all facing in the same direction, is every kind of animal I can think of and many more I cannot. Camels and monkeys and pigeons, fishes and snakes and pterosaurs, all reduced to the same strange grey, boiled down to their constituent parts. Some plague must have raged outside, four horsemen

　　　　　　　　　　　　　　　　　　Philip Hoare

joy-riding down the embankment, leaving these hollow-eyed beasts behind. Or perhaps they're experimental victims of the animal camp next door, their organs decanted into jars that line the walls alongside their embryos with the putty-coloured flesh still on them.

The pale cavalcade is led by a flayed human holding his hand in the air, leading them to natural selection or the abattoir. I hate museums, says Thoreau, grumpily. They are catacombs of Nature. But Marianne Moore finds something more mellow than information in them. The parade could go on for forever, an endless thicket of ribs and femurs and backbones. Some stand shoulder-high, nuzzling the rope looped between us. (I feel in my pocket for a sugar lump.) Others scurry along a skirting board, out of the corner of my eye. They're all eyeless, looking at me. As we are in the womb, the same formula: vertebrae and sternums and craniums, all doing the same job underneath.

There's no end in sight. The bones start to dip into the water, slipping into sea-states, fingers fusing into fins, ribs ballooning to become seals and whales and dugongs; it's like seeing MRI scans of close friends. Lurking at the end is no mammal I know: half-way to a whale, far bigger than a walrus, with a long tail, broad flukes and a disconcertingly small head. The bones defy diagnosis.

It takes me two or three circuits and all my schoolboy French to work out from the yellowing label what they were. A Steller's sea cow—a rhytine, from the Greek for wrinkle—an enormous creature first discovered in 1741 and undiscovered twenty-five years later. Last seen, ten metres long, foraging in shallow waters and uttering snorts and sighs, as if bemoaning their fate. Slaughtered for their meat, by 1768 the species had been entirely wiped out.

Georg Wilhelm Steller, the German scientist in whose human name they came into being, recorded that these highly social, slow-moving animals were pursued and killed in the chill fog. A man in a boat, he said, or swimming naked, can move among them without danger (he did not explain how a sailor came to

be swimming naked among them). Steller, this starry scientist, stroked their backs, then stuck in his lance. They had an uncommon love for one another, he said: when a female was killed, her mate would revisit the beach where she had died, as if he would inform himself about her condition. This animal existed for the blink of a scientific eye, though there were sightings of sea cows off the Kamchatka peninsula in 1962; the *New Scientist* noted that if the report was found to be true, the Russians could be relied upon to take the necessary protective measures.

Then I turn round, and see them. Dozens, in a disorderly queue.

Looking at me. What took you so long?

Les rorquals, cachalots, dauphins, narvals, bélugas, orques.

An exotic array shouldering their way in, squashed together in their sub-order in a manner which would have made for an unmannerly bunch had they been alive. The killer whale snaps at the humpback's tail; the bottlenose dolphin beak-butts a harbour porpoise; a blue whale, la plus volumineuse créature océanique jamais apparue sur la planète, yawns lazily to swallow the whole lot up.

I couldn't help but see the owners of those bones not dead but alive, stretching and growing and replacing themselves in unrendered flesh. Specimens so big they'd burst their articulations, strain at the restraining screws; the oldest carefully provisioned with prostheses, senior cetaceans boasting wooden hip replacements. Their ribs echo in the ceiling, vaulted in iron; the railings and balconies bloom with iron bouquets painted pale green, turning into fleurs du mal like bunches of garage chrysanthemums left at a roadside verge. This hall was raised over the river to celebrate the fin de siècle; un bâtiment de verre, de fer et de lumière; a glamorous industrial ossuary of vertebrates. We'd made it that

far. But for all their glory, they're making me lonely, this panto-mime of lovely bones.

Suddenly, the spell is broken. At the far end, a school group has arrived. The animals stand to attention, preening long-gone fur and feathers as the pupils burst in, bringing their anarchy, chattering and pointing with their fingers and phones. A moment ago everything was silent and academic; now the bones have come to life. This is the audience they've been waiting for. As the children mill round the animals at feeding time, I climb upstairs. On the next level of the game, there are as many specimens again, stacked up in this department store.

Deuxième étage: grands carnivores quaternaires.

The mammals downstairs have been supersized in their extinct predecessors. Snarling hyenas and huge cave bears; a giant sloth as tall as a tree, and a moa—one of les oiseaux géants terrestres—stalking on giant chicken legs. A glyptodon ambles along like a walking coral dome. In a side case Lucy the hominid looks on, half my size, disconcertingly naked in plaster, peering at the dinosaurs through her glass eyes: chirotheriums, bradysaurs and ichthyosaurs; along with tractor-tyre ammonites and oysters as big as boulders, still as they are.

A drama waiting to happen. At the turn of the century, Thomas Mann's alter-ego, Felix Krull, the fancy-dress boy, a pretty impost-er in the dandy disguise of a marquis, meets a man on the train from Paris. The professor has just collected the bones of a tapir from this museum to take to his own institution in Lisbon. He has starlike eyes, says Krull, and he explains, during the journey, how everything in existence is connected, from the minerals in the earth to the bones of a beautiful girl. They discuss whales and dinosaurs. When Krull visits his museum, he sees the five-metre-long model of an ichthyosaur floating in a tank. That is how it is in museums, he says, they offer too much.

Dürer walks in, in wonder, reading the guidebook: C'est le cas du squelette du rhinocéros de la ménagerie de Versailles rescapé de la Révolution. This Indian rhino arrived on 11 September 1770, a gift to another king, Louis XV. For twenty-three years people came to see him in his stable, where he was fed two pounds of oats and flour every day and drank water from a large basin. As he got older, he refused to come out; he preferred to hide in his hay, showing only his nose and ears.

He knew what was coming. Having outlived Year I of the Republic and its Terror, when the menagerie was pillaged and its animals eaten, leaving only five alive, among them a Senegal lion and a quagga from the Cape of Good Hope, the pessimistic rhino perished by drowning, not in the Mediterranean, but in his basin of water, in the summer of 1793. It was a doubly sad ending since he was about to be given a new home at Malmaison, where Empress Joséphine assembled a zoo of her own: leaping kangaroos from Terra Australis, emus, parrots and black swans joining gazelles, ostriches, llamas and zebras, and a single lonely seal.

In this dead palace, many animals boast royal or presidential status, being mostly stolen from other states. From l'orangoutan de Bornéo qui se trouvait dans le collection du stathouder Guillaume d'Orange to des ossements du grand mastodonte d'Amérique offerts en cadeau à la France par le président Thomas Jefferson—who was so fascinated by mastodons he believed they might still survive out in the wild west, even though their tusks were hardly in a position to resist manifest destiny—the guidebook informs us of the cultural as well as scientific importance of this monstrous regiment. Ces galeries ont inspiré des écrivains comme Léon-Paul Fargue, des poètes comme Paul Claudel, des dessinateurs comme Tardi, des photographes comme Henri Cartier-Bresson et des cinéastes comme Joseph Losey. Sartre and de Beauvoir use the bones to muse on the illusion of existence; Philippe Taquet, Professeur émérite de Paléontologie, expresses his enthusiasm for Ces troupeaux de vertébrés, ces forêts de

pattes, ces successions de colonnes vertébrales, cette profusion de crânes de la ceintures scapulaires. It's hard to know who might go extinct first in this race to the finish.

In November 1849, a chronicler of salt-sea mastodons arrived in this city, having sailed across the Atlantic, seeking culture and excitement.

I am full (just now)—Melville wrote in his journal, in his stateroom on SS *Southampton*—of this glorious *Eastern* jaunt.

He stays in the rue de Buci, snugly *roomed* on the fifth floor, with a fire lit by the maid and a bottle of spirits to cheer him. The next morning he leaves his room with a blue nose (so cold it was) and, proudly wearing his new green coat, walks over the river to Notre-Dame—They are repairing it, he reports—then down the bank to the Louvre. Beats the British Museum, he thinks. Then he goes to the royal library, to look over plates by Albert Dürer. The next day he finds his way to the Musée Dupuytren on the rue de l'École-de-Médecine.

Pathological, he says. Rows of cracked skulls. Skeletons & things without a name.

I'm glad the collection moved out a year before I arrived. All those eaten faces and cyclopes and freakish things in jars which looked neither human nor animal—nor even as if they were ever alive. Herman's spirits would have been raised had he been able to stand here instead, in this hall, dazed by its splendour, by its perfection, by the whales he had met with in real life.

Museums turn back time twice over: they propose a perfect past, and make you a child again. I long to climb the giant sloth's shoulders, to pet the peltless thylacine and swim with the bare-ribbed dolphin. In their discrete, dead beauty, they do not know the disservice we have done to them. I feel like sitting down and weeping for these eyeless souls and homeless bones, for the spaces they have left and are leaving behind. But what good did

tears ever do? They're never enough. As our parish priest once told us, If you're unhappy, it's your own bloody fault.

In my room high above the shop where I'm trying to sleep, made restless by the thousands of books below me, I give up and get up to look at the cathedral through the window, the full moon rolling over its twin towers.

If it weren't for the traffic on the embankment and the whine of sirens through the night, it might be any century. I have no watch, no computer, no phone; the bells tell me the time and keep me awake. I feel them all below me, the rows of the dead. This tall old house was once full of monks. Careful lest I should wake them, hanging on the cellar walls, I creep down the stairs and let myself out.

There's no one about as I walk over the bridge. The building is moored in the middle of the river. The doors are firmly closed. There are creatures fixed in stone, a medieval evolution of snaggle-toothed dragons and wild men, of flying buttresses and coral spires, all crowned with pinnacles and parapets. Everything is still, revolving around me and the moon. I feel a little drunk.

And as I stand there, in the dark and sober world, the water running either side of me, I realise that nothing had ever changed, and nothing ever would.

ANATOMY

All this happens in midwinter, as time slows down. The tipping point, when things might go either way. It's a good place to hide. I pack my bag with the same things my mother packed hers. The taxi takes me through the city. There's a crescent moon and the starman sings on the radio. I remember those long nights, and the last one, when I left her here. It's my second visit in a week. At the assessment, the nurse wired me up like a car. With sticky conductive pads plugged to my torso, I lay back on the narrow bed. I told her I felt like the creature, waiting for the doctor to start me up.

About to be reborn as someone else, I joked.

Who would you like to be? she asked. I didn't dare say.

B/P 118/70 Heart rate. 5.6

The bleeping machine rewrote my life as an electrical pulse; my biography reduced to a single black line. All the peaks and troughs, all the tides and the moons passed by. We waited for the print-out, about to betray my unnatural history. I could have annotated it with notable events, where my heart leapt and where it fell. It fell in this building, upstairs, when I asked them to disconnect my mother from the machine. I always knew that everything was just a series of ups and downs. Like the future, the past would always be taken away from you.

The nurse unplugged me; I checked to see my heart was still beating. There were forms to be filled in, multiple choices. Why, when, where, what. What if I'd lied? What if, after they'd tested everything, my heart and my blood and my germs, my inside and out; what if, after all that, they found I was someone only pretending to be me, that I'd been an imposter all along?

For some time my little finger on my right hand had been showing accelerating signs of the syndrome that was slowly dragging my other digits down. I'd become used to this process. First the lumps formed under the knuckles and other joints. Then they thickened and tugged and threatened, under tension, to turn my hands into claws.

It was a struggle with my skin, some tiny demon tugging inside. My little finger had acquired a new momentum and I knew it was my own fault. I read about a Scottish sailor who blamed his condition on the fact that his hands were often numb from catching seabirds in the North Atlantic, taking them from snares on floating planks. The accompanying medical photographs, flat and functionary, showed that one of his little fingers had been amputated. At the age of seventy-nine he declined further surgery, preferring the traditional remedy of shark oil. It was sympathetic magic: as the sea bent his hands into the claws of the birds he'd caught, so he'd sought the cure of the sea in turn.

Had I inflicted this on myself? Was it a punishment for daring to swim at night in the cold dark sea? I'd learned from my consultant that it was genetic, this malfunctioning; that it was something else I owed to my mother. I couldn't hate it. But its name belonged to someone else: Baron Guillaume Dupuytren, the Parisian surgeon who presided over the Hôtel-Dieu, the monumental hospital next to Notre-Dame; it was his museum that had so disturbed Melville in 1849.

By then the baron had been dead some fourteen years. He was not much mourned. Melville's friend Oliver Wendell Holmes, professor of anatomy at Harvard and inventor of the term

Philip Hoare

anaesthesia, had trained with Dupuytren. He described his tutor as a square solid man with a high domed head, oracular in his utterance, indifferent to those around him, sometimes, Holmes said, very rough with them. Dupuytren's peers were more blunt: Pierre-François Percy declared the baron first among surgeons, least among men.

His appearances were performances. On hospital visits he wore a green coat, white waistcoat, blue trousers and green cap of his own design; this medical dandy was often seen gnawing the nails of his thumb and forefinger. Such nerviness could hardly have instilled confidence, but his hauteur earned him the nickname Beast of the Seine, as if he were some serpentine abductor or bad actor. He declared it was better to die of the disease than of the operation, and it was claimed that, in those days before anaesthetics, he prepared genteel female patients for surgery by whispering into their ears remarks of such obscenity that they would swoon away, leaving them insensible to pain.

As a boy he'd been so good-looking that at the age of twelve he was taken away from his country home by a cavalry officer who had him educated in Paris. It was the same year that the Revolution broke out, 1789. Dupuytren grew up to be a rake and a gambler, but also a surgical genius. He treated Napoleon's haemorrhoids and was surgeon to Louis XVIII, who ennobled him. The baron

proposed theories on spontaneous combustion (he believed the victims' clothes acted like candle wicks, drawing fat from their burning bodies); wrote a paper on the artificial anus, the unfortunate by-product of a hernia; and had a fascination for self-castration among the mentally disturbed. (A friend who worked as a psychiatric nurse once told me how he came into his ward one morning and found a patient with his penis lying by the side of his bed.) Given such gothic interests, it was inevitable that the baron's dark renown should lead to fictional roles. In Balzac's story The Atheist's Mass, the surgeon passes through the scientific world like a meteor; he also appears in Flaubert's *Madame Bovary* and Hugo's *Les Miserables*. But it is in my hands that he lives on.

RETRACTION of the fingers, Gentlemen, and particularly of the ring-finger, has been observed for many years, the baron announced, but it was only very lately that the cause of this deformity has been investigated with success. Many claims for the condition had been promoted, but most surgeons regarded it as incurable. Not so the baron, whose hubris knew no bounds. He simply stole the disease in his own name. His fingers were itching to get to work. His guinea pig was M.L., a wine merchant who, in 1811, had felt his left hand crack when raising a cask. The man's ring and little fingers began to bend. By 1831, they were completely flexed, and applied to the palm of the hand.

The hand of the patient being firmly fixed, Dupuytren commenced the operation by making a transverse incision nearly an inch long. As his knife divided first the skin and then the palmar fascia, there was a cracking sound perceptible to the ear, he observed. (He might have been at Waterloo, sawing off a leg.) After this incision the ring finger recovered its position, and could be extended nearly as completely as ever. With further deft cuts of his sabre-like scalpel, he succeeded in liberating the merchant's little finger, too. The wounds were dressed, and the hand kept rigid by a suitable apparatus. A month later, after the wound had healed, the machine was removed. M.L.'s fingers remained straight. The Beast professed himself pleased. At the Hôtel-Dieu, Dupuytren was God.

It was odd to be associated with someone else's name, as if my hand were licensed to another owner, in the way whales belonged to worthy men—Cuvier's whale, Bryde's whale, True's whale. Subject to Dupuytren's contracture, I felt the unfurling embryonic me going in the wrong direction, curling back into a foetal position, fingers fusing into fins. Like some sea creature, as John said to me over supper. Mark sent me a postcard of Cranach's Adam and Eve under the tree; he'd added a Tippex arrow of his own, pointing to their kinked little fingers.

There was something tempting about what was happening to my hands; not so much a disease as an acquisition, something I invented for myself. I felt attracted, in a perverse manner, to the disorder, given order in a non-genealogical lineage that bound me to the past; to kings and queens and presidents and actors. James Barrie took his captain's hook from his own crooked fingers; Beckett complained of his Dupuytren's claws, as if they were the legacy of the black waters of Lough Erne on whose shores he had been schooled, as had Wilde, and where, over the years, a dozen or more boys had drowned in the lake, one crying out,

as he fell, I am in the weeds, and fast sinking, as if the dark ones had got a taste of him and were pulling their prize below. Those same waters wound round my legs too, like this disease. It was an act of faith or faithlessness, this contract, this contraction. An original sin. Ever since I could remember, the hand of blessing had been waved over my head as I peered up at the altar through clasped hands and clouds of blue incense. A sign as indelible as sixties stilettos performing their stigmata on the parquet floor in the communion queue. I knelt there in my grey shorts and home-knitted snot-green jumper, praying to these beautiful people, frozen in stained glass, telling me what to do.

Some said this gesture of benediction began with the bent fingers of an early pope; others that statues of the Caesars, their hands clenched in justice and truth, pre-dated such papal affectation. They pointed back even further, to the pagan god Sabazios, worshipped by Thracians, Romans and Jews, whose mysterious cult was celebrated in disembodied hands, cast in bronze or carved out of ivory; votive objects, ornate prosthetics to be screwed into a dead emperor's wrist.

Obscure cones and weird foliage sprout at their tips; basilisk-snake cords bind them, and oddest of all, dangling from chains like anchors are little bent phalluses, an indication that the condition could even affect the male organ. (It was said that the kink made Casanova a good lover.) But in northern Europe,

it was blamed on the Vikings, travelling down their whale roads, invading our genes and leaving me and my bent fingers behind.

The fourteenth-century Longer Saga of Magnús retells the story of the isle-earl of Orkney, a convert to Christianity, a gentle Viking who swam in cold water to maintain the celibate state between him and his wife and who, after his martyrdom in 1117, became celebrated as a saint. Years later, an islander named Sigurd, suffering cramped hands—all his fingers lay in the palms—sought the intercession of Magnús at his shrine in Kirkwall, which had proved miraculous for the devil-mad, the witless and the infected alike. One man, so stricken with madness that he had to be sewn up in a hide, was restored to sanity. Another's leprosy fell from his body when Magnús's spirit appeared before him. Sigurd's mission was successful: he was rewarded with straight and lissom fingers for all his needs, with no need for a beastly baron.

I felt this northern affinity in my ancestry, in my mother's red-blonde hair that I inherited, and the lumps in her fingers that now corrugated mine. I could not hate this affliction for the loving way it folded my hands; the way that, after I came home from the winter sea, she held my fingers to warm them and reproved me: No one's *making* you do it. No one was making me do this, either. It was my decision to correct myself. I was warned of the risks, informed of the advantages. I had no shrine to visit, only a dingy consulting room in a red-brick hospital. It's not a big operation,

the consultant told me, with a wry smile. I thought he was being encouraging. After a beat, he added, It's a massive one.

I walk into the hospital to wait with my fellow patients, patiently. It's the eve of St Lucy's Day, the patron of light; the year's midnight. Trapped in the well of the building—its open space netted to prevent pigeons and crows encroaching on sterile territory—I watch the sun struggle to rise, and having exhausted the newspaper—with its report of a gigantic cigar-shaped object that has flown into our solar system at 196,000 miles an hour and which is being investigated for alien signals.

It's seven hours before someone calls my name. I'm led into a calm white anteroom. All the uncertainty is replaced by order and inevitability, and new choices to make. The anaesthetist, a charming man, offers me the options for insensitivity. I could go for the general, or a nerve block. Sadly, he does not propose sending me into a swoon with a whisper in my ear.

With a mixture of trepidation and excitement, I elect to be conscious, liking the no-nonsense assertion of a *block*, switching off my nerves. My man does recommend, however—can he detect a twitch of anxiety in my eyes?—a little sedative to loosen me up.

It's like a large G&T, says his bright-eyed assistant, as he reaches up to a cabinet with the air of a waiter in a cocktail bar. The needle goes in and a gentle numbness overcomes me. I'm ready for anything now. Anaesthesia is such a consoling word, sure and scientific, with an edge of ghostly glamour and transitional myth. You can't say it without sounding woozy, without wanting to sink. A little Venetian treacle, loosening my body and brain. Not having to think.

As they prepare me, the assistant pokes his head through the big white double doors to tell the cast to be quiet; their laughter is distracting. I'm wheeled into the theatre through the swing doors, expecting a round of applause. They're all in billowing gowns. The

sisters hover in the wings. For everyone, this room is the peak of their profession. At the centre of it all stands their leader, our baron, glowing with an island tan, light brown brogues under his robe.

For three and a half hours I lie beneath two huge round lights like silvery sunflowers, their handles covered, for sterility's sake, by blue and orange rubbers rolled down their length. Perverse textures mimic skin and bone. A latex cuff around my left bicep gently inflates and deflates, persistently pressing on my paltry muscle. My body no longer belongs to me; I've signed it away for the day. The nerve block has separated my limb from my shoulder, which floats free beyond me, the way an octopus's arm contains its own independent brain. I remember Ishmael's curious sensation, waking with Queequeg's arm thrown over him, an embrace that recalls a childhood episode when, banished to his bedroom on midsummer's afternoon, he wakes to find a supernatural hand clasping his own. And I think of Marianne Moore's father, obeying Matthew 5:30.

It's three in the afternoon. Three o'clock is always too late or too early for anything you want to do, says Sartre. I ought to be in the sea. Instead, I'm stretched out on a table as the three surgeons set to work. They fall on my hand, not with nails, but knives. The site is laid with a tablecloth. Panofsky, the anatomist of art, describes Dürer in the operation of engraving, masking the parts on which he is not working with a sheet through which he cuts, much as a surgeon concentrates on a small portion of a body swathed in aseptic cloth.

The primary surgeon teases out his prize: gristly morsels from a crab's claw. The yellowy collagen, glistening with blood, wobbles as it springs free. I can't believe something so big could be taken from my hand without the rest of it falling apart. Without noticing it, my finger has uncurled. Giddy with my liberation, and wanting to entertain, like a nervous guest at a cocktail party, I start to talk about whales. They nod politely. They're paid to care about this odd creature for an hour or two.

Do they know Rembrandt's Anatomy Lesson? I ask them.

We don't often talk about culture in here, one replies.

I stop talking for fear of distracting them from their work, which is me. As the point of the scalpel pushes into my skin to excise a scrap for the graft, I become aware, with a sort of bravado, that the nerve block has begun to wear off. I can feel the knife. I point out, calmly as I can, nervously, that sensation is returning. The anaesthetist comes to my rescue, pumping more drugs into me, and the party carries on. The new skin slips into place. Having taken apart my hand, expert hands stitch it back up. They have the deft fingers of tailors, sewing quickly for their waiting client. The flaps are neatly parcelled with electric blue line, then they stand back to admire their handiwork. It must be satisfying to achieve such instant results. So long as I don't expire on the table, their job is done.

The excitement starts to fade the moment I leave the theatre, as I'm wheeled back to the ordinary world, light-headed from drugs, deprived of food and light. The day has disappeared. Soon the moon would be rising again. I might have been here for a year or a day. Down there, on the floor below me, time stopped when my mother was wheeled out of intensive care. I told them I didn't want her left there. I'd led her out of the house. She didn't want to go. Then I left her here. It still feels like a betrayal, the opposite of what she did for me. Maybe I could go back to the ward and make it all right, bring her home.

Once, I did go back. I found the ward and the bed where I last held her, the way she first held me. As I got nearer the room, I knew I didn't want to see it. The nurses were busy; someone would ask me who I'd come to visit. I was a shadow, the past; many people had died in that bed since, everyone was going on with their human lives. I'd find no name plate, no bunch of scraggy flowers tied to the bedhead, even though its grey frame meant more to me than the suburban field where her bones now lay.

❖

Back home, I wake in the dark, in pain. I check my fingers again. They haven't turned black. I lied when I said there was someone to look after me.

What do I do now?

I feel the memory of the drugs in my limb. I'm awkward, lop-sided, lost my grace. I realise how far I depend on my outstretched hand, how far I feel the world. Trussed like a swan, I can't be me. I can't read anything new, it's too disturbing; new ideas only make you weary, a philosopher once said.

So I crawl out of bed and take *The Rings of Saturn* off the shelf, where I left it, in mid-conversation. I've read it many times before. Unlike old friends, books don't betray you. Sebald's book was published in English in 1998; my friend Adam gave it to me for my birthday that year. It already seemed old, even then, slowed down by the speed with which it unfolds, told so slowly you're never quite sure where you are. On the cover, a lone figure in a slouchy hat stands on a misty shore. Is the water coming in, or going out? You can't tell sea from sky. It might be a painting by Whistler, but that's Sebald on the beach.

The story starts in the dog days of August, under Sirius, the Dog Star that can sway the spirit to deep despair. The narrator's mission is fated, even before we start. Instead of accompanying him on his walk to exorcise his sadness, we find ourselves a year later looking down on him, immobilised and in severe pain, lying in a hospital bed from where he stares up at a netted window.

In the silence of the afternoon—it must be three o'clock—he watches a contrail scar the sky. Contained in isolation, all he can hear is the never entirely ceasing murmur in his ears. He's trapped in his own inner space. And, like a dream you remember but choose to forget, he tells the story of his journey, one conducted entirely at or below sea level, as if he were walking on the ocean bed.

In the summer heat, on the flat land, he hikes through East Anglia, moving towards the German Ocean, drawn on by signs and wonders and by his own words circling in sentences that, like Mann's, leave you wondering if it's all a ruse, a clever device to confuse. That was why I had to read this book again, in my opiated state. I had to follow him on his dreamlike walk, like a dog.

Starting from his village home, leaving his big black labrador, Morris, behind, he encounters scenes like postcards found in junk-shop boxes: country houses overcome with the clutter of the past; a retired major sitting in a cave; fields from which fleets of planes flew to carpet-bomb the country of his birth; schools of herrings that glow as they die. Eastern England seems about to tip into the sea. Nothing can save it. The view overcomes him. Distances lie. The shore is forever far away. An ambiguous place. Sebald may or may not have known that the Greeks recommended malaria as a therapy for the insane, and that eighteenth-century doctors would send melancholics to East Anglia to contract the fever. In the early twentieth century malaria-infected blood was injected into patients suffering psychosis brought on by tertiary syphilis.

One of Sebald's characters says that, before the First World

Philip Hoare

War, a vast resort for the worship of the body and the sun and the sea was envisaged, linking England's eastern coast with the Netherlands and as far as the island of Sylt. It might have taken in merchants, pretty young waiters and whales deceived by the stars. It's difficult to know if these stories are true. I'm not reading the writer's words, after all, only a translation. In this atlas of confusion, Sebald reproduces a world exactly like this one, only different. His book appears calm—the clear-set type, the photographs laid out in their echo space—but it pulls you in like the tide.

The murky waves throw up fleeting figures. Edward Fitz-Gerald, the Victorian translator of the Rubáiyát of Omar Khayyám, compiles a commonplace book of the sea and, dressed in an archaic frock coat, top hat tied to his head and white feather boa around his neck, he sails out on his yacht *Scandal*, mourning his friend William Browne. He takes solace in the black labrador given to him by Browne, and is plagued by weak eyesight, for which he wears blue- or green-tinted spectacles; his hearing is clouded, as was Sebald's, by one long noise like the sound of the sea in a shell; the same sound that has lodged in my own ears for years now.

Dogs haunted Sebald, too. In an earlier essay, he described the dog as a Vehikel der Erlösung des Menschen, a vehicle for man's redemption, and said that to approximate one's transformation into a dog has always been the calling of the truly chosen. It was the sadness of an animal whose life is spent at human beck and call. They possess dogged persistence; we are dogged by dismay. Rather a dog's tail than a poker across the face. In Sebald's book *Vertigo*, a black Newfoundland, its natural gentleness broken by ill-treatment, continually leaps at a gate. The narrator considers setting the animal free. It would probably have ambled along beside us, he says, leaving its evil spirit to find another host.

See'st thou yon black dog, scouring thro' fields and stubble? asks Goethe's Faust, What do you take him for? See how he wheels about us, leaving a track of fire behind. Joyce's dog on the

beach ambles about on a bank of dwindling sand, trotting, sniffing on all sides, looking for something lost in the past, suddenly making off like a bounding hare, his hindpaws scattering sand, his forepaws dabbing and delving to find something he buried there, his grandmother. The only way Sebald could describe his writing was like his dog let loose in a field, investigating its corners, reporting back on what he has found.

I never liked doing things systematically, he said (or perhaps it was his dog speaking); the more I got on, the more I felt that, really, one can find something only in that way. Dogs always lead you towards water, like the boy's beckoning finger. And such is the erotic momentum of Sebald's book, the way his words circle and sway, you expect it to lead you into oblivion, too.

I went out into the garden to read the postcard. It had arrived in an envelope addressed in handwriting taught in a classroom a century ago. On one side, someone who signed himself as Max sent a few words about my work. On the other side of the card—from a museum in Rouen—was a thunderstorm, painted in 1651. It took me a moment to work out who it was from. I wrote back. He answered me, and wrote other letters, replying to mine: on postcards from European museums; on elegant headed paper from his old rectory; on lined sheets torn from a university file pad. He invited me to come and see him. He was just being polite. I went to see him speak.

Standing in a concrete hall on the riverbank, he read in German, leaving the English to his translator. In between, I saw his power: it lay in his naïveté, his art for collection, his willingness to be shocked, like a child. It is the most hard-headed ones among us, he had told me, who appear to have an inkling of metaphysics. After the reading I asked him to sign my copy of his new novel. I could smell the cigarette he'd just smoked; over time, the tar had turned his grey walrus moustache brown. He had big glassy eyes and said, I hope you don't mind if I steal from your book?

Philip Hoare

Certainly—he'd told a magazine a few weeks before—my own life experience is that when I thought I had things sorted and I was in control, something happened that completely undid everything I had wanted to do. And so it goes on. The illusion that I had some control over my life went up to about my thirty-fifth birthday. Then it stopped. Now I'm out of control, he said.

A few weeks later, on a Sunday morning, I opened the paper to find his face on page two. It looked like an image from one of his books. The article said he'd been killed in a car crash, but I wasn't quite sure it could be true.

He was fifty-seven, the same age as Dürer when he died.

My fist is a spongy boxing glove into which the blood is slowly soaking. I count the feeling in my fingertips, one, two, three. . . Only the fourth seems not to be returning to sensation. Unable to type to keep up with myself, I write in my notebook. Everything has become long, handed down. Even dropping a pen is problematic without a flight attendant to pluck it out of zero gravity.

In *The Rings of Saturn*, the narrator describes a colleague who hoards all her files and papers in towering stacks round her room and yet knows exactly where to find any reference she seeks. He says she's like Dürer's angel, steadfast, amongst the instruments of destruction. He sets off to see The Anatomy Lesson of Dr Nicolaes Tulp in The Hague, a civilised outing brought to an abrupt halt at the seafront by down-at-heel cafés, a sex shop and graffiti saying, Welcome to the Royal Dutch Graveyard. On the beach—the same shore from which Mann left in an ambulance—is a vast hotel of faded grandeur. Sebald spends the night in a run-down hostel. Trams squeal throughout. The next morning he reaches the gallery in a distressed and distracted state.

He takes out a cigarette and looks at his watch. It says 9.25. The painting is a lesson in melancholy.All those old masters, those bearded men and their big white wavy ruffs and voluminous

black silk gowns, knew nothing of suffering. They gather round a dead man whose nakedness is extended by the flaying of his arm. They have lowland complexions; he's pale green. Tulp was the first person to accurately describe a narwhal; here he presides over a silent drama, set in a city of skies and art, where you could look through an uncurtained window and see a man's soul bared. Rembrandt collected Dürer's work; he said it was the business of life to support art, not the other way around.

We need the dead to recognise ourselves, said John Berger. Tulp is a magician; his audience's faces glow in the corpselight. He holds his hand over the dead hand in blessing it, about to pull a rabbit from his hat. The criminal lies pigeon-chested, like Christ; his defleshed hand, a bird's claw. The artist conducts a symphony of the dead. A century before, Dürer came to these low lands and nearly drowned. Sebald saw the future fall into the sea: whitened bones lay down there. He's overwhelmed by signs and wonders and bodies of water; even his own village of Poringland sounds as if it's running away.

He turns to Thomas Browne, the doctor and writer who lived in seventeenth-century Norfolk, and whom Melville called a crack'd

Philip Hoare

Archangel. (Was ever any thing of this sort said before by a sailor? marvelled Herman's friend.) Browne said—says Sebald, somewhat portentously—that all knowledge is enveloped in darkness, and that what we perceive is no more than the isolated lights in the abyss of ignorance.

But Browne's explorations are hardly solemn at all. They lurch from buried urns in East Anglia to the whales and walruses of Greenland. (You can see why he was one of Marianne's favourite writers.) He asks his correspondent to bring him the white of a whale's eye made hard by boiling, and the bladder of a whale or morse, cleansed and dried so that it may be blown up, and asks, What is also found in the stomachs of sea horses or morses: what herb it is that they are said to feed on at the bottom of the sea?

Browne liked questions; they provoked impossible propositions. His *Enquiries Into Vulgar and Common Errors* are masquerades of intent: That men swim naturally, if not disturbed by fear; that men being drowned and sunk do float the ninth day, when their gall breaketh; that women drowned swim prone, but men supine, or upon their backs, are popular affirmations whereto we cannot assent.

Even man is a bubble, he asserts, if we consider the *vesicula* or *bulla pulsans*, wherein begins the rudiment of life. And if some have swooned, he went on, they may have also died in dreams, since death is but a confirmed swooning.

That there are demoniacal dreams we have little reason to doubt. Why may there not be angelical? he concludes. A modern survey says one in three of my fellow citizens believes in angels. The first boy I ever loved said I looked like an angel in the classroom. Four men sit on plastic chairs. Black dogs slumber at their feet. The clock ticks quarter past three.

Max stands up to speak.

Melancholia, he says, the contemplation of the dismal plight we are in, has nothing in common with the desire to die.

He goes on, rustling through his notes.

Describing the dismal plight we face contains the possibility of overcoming it, he says.

Herman clears his throat.

I saw a regal, feathery thing of unspotted whiteness, he says, waving his hands in the air. At intervals, it arched forth its vast archangel wings, as if to embrace some holy ark.

Albert rises, thinks better of it.

Thomas, smoothing his moustache, takes out his cigar case and offers it round.

I stood here and lived for him, he says. What is fidelity? It is love without seeing, victory over a hated forgetting.

Marianne arrives, in slashback lapels and a black velvet hat.

The sea is a collector, quick to return a rapacious look, she says.

The dogs get up, yawning and stretching, then settle back down with a sigh, waiting for their humans to make up their minds.

03:50

My bedside radio, which was the future, blinks out a fading red light. I go and stand in the street. The trees drip with rain. I've known this road all my life but it looks entirely strange.

Not knowing what else to do, I walk to the beach. I can't swim. The sea wall is broken, lapped by a dull roar. The water withdraws. I pick my way through the rubble left by the last great storm. A month later a gang of young offenders had arrived in high-vis vests. They shuffled about, making piles of probationary stones, stopping now and then to smoke roll-ups, before being led away again.

Behind me, through the trees, is the abbey. Its monks would rise at two to pray. They kept a red light for the guidance of shipping, offering mariners a secure port from the ocean of the world. They believed the plague came up this way. The same crow always perches on the rubble, eyeing me with her cocked eye. Maybe she has adopted me. Either that or she's mocking my broken wing. (She was there again yesterday, taking one-step, two-steps behind

me.) I'm attached to this landscape because I owe it something, says Mann, and am grateful; therefore I have described it.

All along this shore the sea has scoured out shingle hards, natural landing places. No one lands there now, only hovercraft on trial runs, scaring the birds away. But in 1808 Miss Austen was rowed across in a little water-party to admire the abbey and the newly built warship, *Victorious*, seventy-four guns. Her nephews made paper ships, floated them out to sea, then bombarded them with horse chestnuts. In 1911, Dorothy Shakespear looked across from the other side of the water. I have seen one or two lovely things these last days, she told her fiancé, Ezra Pound. Yesterday the sea & sky were all one grayish surface, because it was so hot. In the evening six large silent gray destroyers took up their moorings just outside here: & they signalled from the mast-head to each other for ages. We feared a night attack, she said, but they were gone away by this morning. Last night, the harvest moon presided over the waters—I am afraid of the moon.

This side of the estuary barely gets light in winter; the sun falls short before the day has begun. Odd things appear at the year's end, where fallen archangels flung the stars of their brows, as Stephen Dedalus says. Sea urchins crowned with purple spines, starfish stiff with pain; a fingernail-thin slip of brass, part of something old, perhaps very old, greenish, its edge pricked with holes. I taste it with my tongue the way I used to lick batteries. One day I'll find something on this beach that will change my life. I know these stones so well I could account for them all; I used to have nightmares about having to count every one.

Sometimes this beach is patrolled by an old man. At least, he looks old, I haven't bitten him to find out. He wheels a customised cart made of bits of old bikes. His outfit is patched together, the flap at the back of his cap hangs down his neck like a Victorian dustman. His self-appointed mission is to pick litter from the shore with a lobster claw like an extension of his body. He's a scavenger, like me. We circle about. I met him once in the

car park of the supermarket where I'd parked my bike next to his. I thanked him for what he did. Up close, under his hat, his face was brown and cracked, and when he spoke, he revealed crowns worn down to their metal stumps. He might bite me. But when he talked, he was beautiful, and he spoke of the many countries he had been to, and why he did what he did.

I look to the horizon—only at this time of the year can you peer at the sun (Regulus was tied to a post, eyelids shorn off, and forced to face the rising sun). The refinery's flame sets the sea on fire. The tide and the sun are as low as they can be; the day has run away. As I turn for home, I see a pale green chunk stuck in the silt. A glass stopper, an unlicked glacier mint. I pick it up, this tiny prize of a dark afternoon, and hold it to the remaining light. It glitters like a decayed frame of film. I wonder if there had been a god in its bottle, or at least a little imp.

But this is all it is, a chipped lump. The stones in my pocket talk to one another. I collect things about my person. I'm losing it as the sun goes down.

You'd hardly notice my house if you passed by, unless you have the sort of mind that takes exception to unrestrained trees and ivy snaking up red-brick walls. You might think the place unloved. You would be wrong.

The sea is a mile away, down the hill. This place was once known as Shoreland, but my father told the insurance our policy should be reduced because we'd never be subjected to flood. It's a modest house, apologetic, built on a scrubby heath in the twenties, when the sun was God and people played tennis in the courts round the corner. It has stood for one hundred years of history. I have lived six decades of it, mostly in this same place.

At the back, at the top, is my box bedroom, held out like a prow, its ceiling sloping down to the eaves. The picture window was installed by my father because he was born in a northern

town. All that light pouring in and out of me. You can't open a picture window. You can't let the inside out. The sun heats my room in the summer; in the winter the rain patters on its slates like an Australian tin roof. The warmth of the elderly radiators barely gets this far. I make encouraging noises to myself. When I was young, nine people lived in this three-bedroomed house. I had no space beyond my bed; I had to make up the rest in my head. Now it's just me, waiting for the tide to turn.

My 1966 pocket book of astronomy, Saturn spinning on its front cover, tells me the full moon is too bright to observe; it's best seen after the first quarter, when its receding shadow reveals its mountains and craters. The moon and sea conspire to slow down time. Four hundred million years ago a day lasted twenty-one hours; as the moon moved away, the sea dragged it back to twenty-four. Shakespeare said the moon is a watery star.

Why wouldn't these heavenly bodies have an effect on ours? Medieval illuminations portrayed naked people bathing under the moon and sun, charged by the spring tides. I check the lunar state on the day of my surgery. The moon was full, I was too late: operations are recommended during the waning, a time of taking away, diminishment and melancholy. My consultant never told me that. No one said anything about my bones being trees, whales, birds, stones, or how the moon dissolves my shadow on the seabed. The ocean, says Ishmael, is the dark side of this earth.

I'm told twilight has three graduations: *Civil Twilight*, when the residual light of the sun remains although it has set; *Nautical Twilight*, as it falls away for a further six degrees, leaving enough light for sailors to navigate; and *Astronomical Twilight*, when it moves to eighteen degrees away: it is then that most, but not quite all, celestial objects appear. But like history, it depends on where you stand; darkness is always waiting to happen. It eats away the moon to a scratch, the most beautiful thing I've ever seen, along with all the others. The dark side has turned lavender in the earth

glow; I turn away, afraid it will make everything else look ugly, and because it is descending, very slowly through the trees, a starship coming to get me.

Night, says Sebald, the astonishing, the stranger to all that is human.

Suburbia is the furthest from anywhere you can be. In these little rooms in this little house we lived out our little lives. There was nothing dull about them at all. My father, born in the second year of the First World War, never read a book but was always inquisitive, wearing his shorts in summer, his binocular case slung round his neck as if he were going on patrol. (In the war he laid telephone lines to Cornwall; the Salvation Army refused to give him tea and sandwiches because he wasn't in uniform.) He breathed in deep by the sea; he never learned to swim, and neither did I. My mother, born the same year this house was built, with her red hair, her necklaces and bright dresses. She wanted to be an actress (she liked it when the Polish officers arrived; one had a silver streak in his hair). Her middle name was Marion; our family name was Moore. She made me pink satin Oxford bags out of curtains, a kimono out of a bedspread, and a doublet out of a woman's black velvet jacket with the sleeves slit. She knitted me out of Norwegian jumpers I wore to school, and pop-art jumpers I wore to the Roxy. I was a fancy-dress boy. It was my defence, my defiance, my fear of being ordinary. I wanted to be an artist. This house contained all these dreams, pasted under one layer of wallpaper after another. When I peeled it away I found a cigarette card of a dandy figure, pressed into the plaster by the builders a hundred years ago.

In the hospital the dressings are taken off. I call Pat in Provincetown, to report on it all. She asks when I'm coming back, says she misses me, and people there like me. I sit on the edge of my bed as the sun sets; it's bright morning over there. She's thousands of miles away, but our shores share the same spring tides, high at noon and at midnight, under the full moon that summoned

me into the sea from my bed in the attic, that warm woody salty place where I knew I was happy then, in the way we only ever know afterwards.

We speak for an hour. We're interchangeable, we persist, despite everyone else. She adopted me, like the sea that ran under her house. I'd never met anyone so irresponsible. Her stepfather knew Thomas Mann; she distrusted her mother and her Manhattan society, designing parties for Truman Capote. I asked too many questions, she said, she had no interest in the past. Halfway through our conversation she starts to tell me about myself. She tells this third person who walks between us what I have been doing, how I'm not so old and am still pretty functional, and that soon I will be going away. She says all this matter-of-factly, in her decisive, done-deal way. The distance, between the person she believes she is addressing and the person she is talking about, is as wide as the ocean between us. I feel the way you do when you look in the mirror and catch yourself off-guard and for an instant you see someone else, someone good.

Pat keeps chatting, remote-reviewing my life. In a moment, I will receive the inner truth, from her eighty-eight years. She'll show me the way, the way she showed me the sea and its whales and birds. But I'm already a shadow to her; we're drifting away from reality in our altered states. Fifty years ago she was a thrower of parties where everyone got arrested. She used to tell me how she kept a stash of smack for the end. Now she tells me she's living in a replica of her own house, which actually lies down along the beach, although she can't work out how or why they have done it.

I do not demur; in fact, I believe her. I believe all of it, I always have, ever since she first took me into her house on the beach where the sea ran underneath to carry us away by night. Then she switches out of her reverie and returns to me, this artist who shaped me, always aware of her self and the sea and the air

around her. Now her life has been reduced to a few square yards, when it once encompassed the entirety of the grey-green ocean and the endless beach, leaving her bare footprints behind. She tells me, this winter's morning, the temperature barely above freezing, that she ought to get her kayak down from the rafters and paddle out to the breakwater, where her orca friend likes to feed. She describes exactly how the pulley system works and where to untie the boat, as if I was standing right by her to help, which of course I am.

By the time I click off—as she vanishes with a little blue *puff!*— the light is nearly gone. The newspaper says this has been the darkest winter in Europe since records began. I don't want it to stop. I live on tea and biscuits.

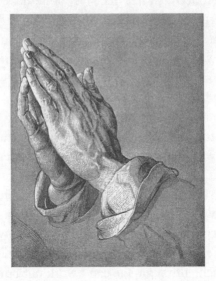

Dürer's pious hands hung in every home, the only work of art in the house. They appear at the back of gloomy churches, tattooed onto arms, carved into Warhol's grave, praying for the soul of the palest person I ever met. The little finger on the right can't quite meet the one on the left. It leaves a stutter of doubt. I lay three

cards over my bed. Melencolia; the 1493 portrait; a Polaroid of the starman in his dressing room in 1974, his bones cut into white skin, red hair, blue jumper with tiny white stars, pale blue trousers with red braces. I remember those clothes, the same pose, the same neck, the same eyes. Dürer had long bony hands like those he liked to paint, says Monneret. His self-portraits show a taste for costumes, rich and precious clothes. At the beginning of the century the artists known as Die Brücke, a bridge to the future, declared Dürer their hero. Erich Heckel shielded his face. These gestures are emblematic of melancholy, says Panofsky.

He and his friend read Mann in their apartment; the poets assemble in a downtown bookshop. Auden perches on a ladder, Marianne sits at his feet, wearing a borrowed brown tweed suit. She dearly loved clothes she could not afford. I met three of the people in that photograph, but she wasn't one of them. My eyes have changed since then. I go back to the hospital. The last stitches are prised out—the skin has begun to grow over them, reluctant to let them—so I go to the beach. I know it's a bad idea, but the sea is the only earthly power to which I defer. I tug one-handedly at my T-shirt, exposing pale flesh to the sky.

As I get out, I spit on my stitches to ward off infection. For God's sake stop shaking, my ribs show through my skin. In some ways, says Tristan Garcia, the romantic is a libertine who, having deserted cities and salons, discovers outside of her body a sort of nervosity belonging to all of nature. I've turned the colour of denim. I ought to have tried shark oil, or followed the man who dived in water and, pulling himself out by his numb hands, heard his fingers crack back into place. As the light rises, the scar on my arm glows pink, a root system. I got a tattoo after all. I chart my natural history in scars, from my head to my knees. Sailors who contracted scurvy discovered that the disease opened up old wounds, as if they'd never healed in the first place.

The next day I go back, long before dawn. As I undress, I hear footsteps in the shingle. I freeze at the sound. I look down and see a vixen at my feet. She stares at me with shiny night eyes. I'm just going for a swim, I say. [run on here] I reach into the water. Stars spark from my fingers. I wonder if my scars will burst apart. When I come back the fox is still there. She sniffs at my little pile of human property, then pads off into the dark.

In 1504, Dürer's mother came to live with him; she was ill and nearly blind. His father had died two years before. Albrecht was not at his bedside. His father's last wish was that he should never

leave his mother; she died in 1514, the year of his Melencolia. Albrecht was there, but wished he hadn't been.

She had seen something frightening because she asked for some holy water and for a long time she had not uttered a word, he said. And then her eyes glazed over. I also saw how death gave her two great blows to the heart, how she closed her mouth and eyes, and departed in pain. I prayed aloud beside her. This caused me such pain that I cannot express it. And in her death she appeared much more peaceful than if she had still been alive.

I watched my mother being washed by the nurses. I turned away as they pulled aside her gown. As I faced the wall, I saw the scene behind me reflected in the tarnished mirror over the washbasin. She lay on her side, back towards me, stretched out on the sheets. Her silver hair, the silvered glass. The morning light shone on her naked body which I had not seen since I was a child.

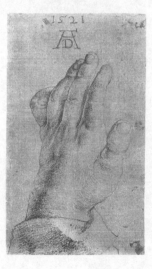

In 1521, Dürer drew his hand again; he had no one to correct his bent finger. A year later, he made his last self-portrait. Naked, dishevelled, assailed by fever, his muscles had begun to sag. His clenched hands clutch a scourge and a flail. The art of painting

also preserves the figure of a man after his death, he said. His locks blow in an interior wind, his mouth half open, trying to speak. His wonky eyes look out of the picture, at something his mother had seen.

And then he told us—Pirckheimer reported—how sometimes in his dreams he seemed to live amongst things so beautiful that if such only really existed he would be the happiest of men. But at the end he was withered like a bundle of straw, and could never mingle with people.

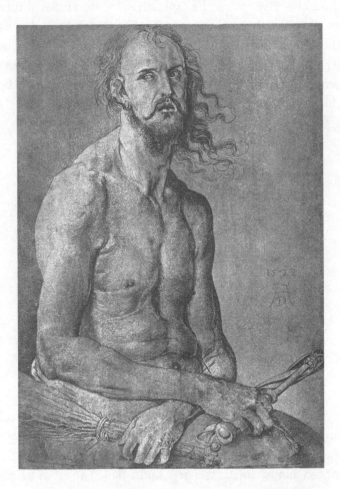

Philip Hoare

He died before his friends could arrive. A lock of his hair was sent to Hans Baldung Grien, his favourite student, and Pirckheimer had the final engraving made—

QVICQVID ALBERTI DVRERI MORTALE
FVIT SVB HOC CONDITVR TVMVLO
EMIGRAVIT, VIII, IDVS APRILIS, MDXXVIII

—as though he were a king who had not gone, just moved on. The next day his fellow artists dug him up and took casts of his face and hands. They wanted to put him back together again. Twenty years later, in accordance with the custom applied to anyone who died without descendants, the tomb was emptied and Dürer's bones were unceremoniously and decisively lost.

ADORATION

All this happens in midsummer, as time speeds up and slows me down. They tell me this hotel is fully booked, but it's dark and shadowy at eight in the evening, and there's no sign of any other guests.

Outside, the walls are graffiti'd. I eat at a café called Utopia. The night is warm and I sit out on the street. A dog nuzzles my shins. A little girl plays I-Spy. The young woman who serves loves London, where she once lived, and wishes she were still there. She stretches out her thin arms as if reaching for the city.

Back in my room, I lick the crushed remains of a Temazepam from its blister. I wake up wet, having forgotten where or who I am. I stumble out to the balcony. The garden below is strewn with trash. It's also filled with flowers so blue they look lit from within, like the sky.

In a workshop off a fashionable street, a dark-haired woman named Rosetta plunges loops of thin gold wire into a series of electrolyte baths the size of small fish tanks. The wire sizzles in each one as it turns from yellow to white and then to rose. Rosetta knows she's showing me alchemy. I promise not to specify the liquid, the process or the place. The little baths steam with metal vapour. I might inhale gold; thievery by inspiration.

Three workers sit at wooden benches whose edges are notched

Philip Hoare

and scarred; they use tweezers to implant precious stones in tiny golden shapes, becoming the eyes of birds and bees and dogs. My host, the owner's daughter, a young woman in drainpipe jeans and a long brightly coloured jumper, tells me that until recently the maquettes for these charms were carved from cuttlefish bones, and the gold cast in the same lost-wax process used in this city since medieval times. Then she takes me into the back room and shows me a safe the size of an American fridge.

Inside, instead of eggs and milk and hard bits of cheese, the shelves are filled with little manila envelopes like packets of seeds. Each contains carefully graded stones: rubies, emeralds and diamonds, from places with archaic names. I've never seen things so small and so powerful. I want to swallow them like pills. Next door, in the showroom, my host opens a discreetly frosted glass cabinet and produces another tiny thing. It shines like a watery star.

A pink diamond, internally flawless, she says.

It has its own passport, South Africa via Manhattan to Milan. It sucks the energy from the room. She holds it up to the window.

It could buy you a villa anywhere in the world, she says.

None of the fashionable people strolling the street below could know what was being held over their heads. Surrounded by her inheritance, my host becomes animated, as if catching silk shirts thrown from a closet. She drapes stones in waterfall strips over her thin bare wrist and says she can wear anything from these cabinets when she goes out dancing on nightclub tables.

Then she tells me how her grandparents had to leave this city, having been told they were about to be led away by train and not to bother bringing any luggage. They escaped overnight, over the mountain pass, where her grandfather used a bag of diamonds to bribe their way across the border.

I leave the shop and walk fast, pushing through the market square, round the back of the cathedral and into a courtyard. At the top of the wide stone stairs, I reach the door, breathless, only to be told no, I can't go in.

The last ticket has been issued, says the young woman; the cash register has stopped its work for the day. No amount of pleading will sway her. The door closes firmly on the rooms beyond me, and I walk away.

Back in the hotel, on the balcony, mesmerised by swifts slicing the air, I wonder what it would be like to fall into the blue flowers and lie in their sappy scent, next to a rusty bike and some discarded bricks.

I arrive the next day, at the same door, waiting for it to open. Yes, I can go in. (Twelve euros.)

There he is, in the gloom, in front of my face. I almost walk into and through the picture. Jewel-bright, as big as this palace. What was I expecting? Not this glossy wall of oil glowing in the dark.

My God, I say, under my breath. Or words to that effect.

The Adoration of the Magi. (A hundred million euros.)

| Plate VIII |

Straight from the studio, still wet. I could lick it and no one would know.

The young prince from Africa looks on quizzically. Has he come to the right place? They're all playing their part. A pair of dogs, one black, one brown, bark; a beetle raises its horns. A butterfly quivers on a leaf; we can see right through its wings. The Virgin and her baby, the cooing eastern visitors with their gifts, like the little latex figures we'd arrange around the crib. It's the backdrop that is fantastic. A city winds round a hill, so detailed I want to shrink and scrabble up the path. Right at the back is the sea, bigger than anything. You can only see it in the thing itself.

You'll have to take my word for it.

After all this time—all those reproductions, conspiring to keeping me away—after all that looking and not seeing, I'm told this is his first masterpiece. An epiphany. It's dated 1504. He's in

Philip Hoare

it: his fingerprints in the paint, along with his hair, his spit and his poise at the centre of it all, so laden with golden chains he'd sink if he fell into that far-off sea.

Gold is his inheritance, untarnishable. He holds a chalice made by Nuremberg goldsmiths. Vessel, a container. It's not clear who or what is being worshipped here: the gurgling Christchild, or the glory of Dürer, adored.

I duck through an arch into another room. There it is.

Melencolia. So small, I hardly noticed it at all; dense as silk, so familiar I'd forgotten what it looked like. It ought to be as wide and as tall as this room, but it's only ten by eight. A giant angel, glowering, muscular; tumbling hair, crumpled gown.

I'm back where I started. I let slip a single word. I'm swearing in church. Around the corner comes an attendant, another smart young woman.

I start to babble. Does she know this work? Isn't it, isn't it— *beautiful?*

She stares sternly from under her fringe. Is this the day she will have to call for assistance? She runs through that exciting scene in her head.

You're going round the wrong way, she says.

I know Dürer really well, I tell her, as if I mean it personally.

Her colleague has drawn a chair across the arch to deter further offenders. I stand my ground, fixed by angel eyes. I was never good at taking orders. I check out the exits and entrances. There are windows. I could climb in overnight. I turn another corner. There they are.

In a heavy gilt frame too big for them, another pair of eyes. I'm aware of my own stare, embarrassed at standing so close. I step back and fix on the black pearl dangling from the red beret. Things could go either way. It's been a harsh career for a fragile spirit: conceived in Venice, born in Nuremberg, sold in Amsterdam; trafficked in London, given refuge in Berlin, forced to flaunt their wares for a few marks per head, and now trolled out in Milan.

This picture changed sex, I tell a pair of passers-by, a shaven-headed couple. They move on.

(Felix Krull, the fancy-dress boy, watched the eccentrics who were seeking neither a woman nor a man, but some extraordinary being in between. And I was that extraordinary being, he said.)

None of this was meant to be seen all at once. A lavish drama in this over-costumed city, outdoing the crowd out in the square. I'm not sure he took it all seriously. In another frame, his loopy hand sends a letter home, adding a caricature of himself with frizzy hair as if all those portraits were one big joke.

I take one last look round, at the snappy crab he found on a quayside and sketched on a scrap of paper; at a dead duck hanging from a nail; and Jerome and his lion, having flown here in the hold, growling and praying all the way. I leave through the shop. I could buy a cushion decorated with a detail from Melencolia, but I'd fear for my dreams with an angel under my head.

Back home in England, another package arrives. Carefully wrapped up, in a tiny tin, is the little green baboon which stood on Pat's cast-iron stove. He perched there all those long dark

winters, her familiar, gently warming his hollow behind, his wiry tail curled as high as his head, over her dog's empty bed.

Down in Devon, Tangle is ready for his walk. He stands at the door, tail wagging wildly. He can't contain himself; had I a tail, I'd do the same. He leads me down to the river in the dark. He barks so seldom that when he does it seems like he's picking up on some conversation we left off at my last visit. He sits beside me and places a reassuring paw on my arm. He's the retriever of memory, the black dog of anti-depression, a high pressure all of his own. Everyone looks at him when he walks down the street. He carries his glory before him, my prince. He needs no painters to prepare his way; his majesty falls in shaggy locks. I find a picture I drew before he was born; I'd cut him out of a book.

That last summer he struggled to keep up with the young dog inside of him, the dog he knew, the dog beneath my skin. He led us through the woods hung with moss to a shallow pool and gently lowered his body. We heard him sigh. He was trained to help humans. If you laid his lead over his back, he'd slow to a measured pace. Take it off and he'd resume his lolloping stride.

Every time I left him I kissed his sleek black head and said things I wouldn't say to anyone else. He was what God had in store for me. Then they led him away. His heart stopped beating in that unfamiliar room. But he still walks with me, never quite out of sight, ever ready to run back to my side.

In the calm of a New England museum, overlooked by a painting of a stranded whale on a Dutch shore and a librarian in her business suit whose sleeve slips discreetly to reveal a tattoo or two, I turn the floppy pages of Conrad Gesner's *Historiae animalium* and the beasts fall out, fluttering and crawling and sliding. The book is crammed with avocets, badgers, camelopards, martens, owls, unicorns, and lions and tigers and bears. An octopus so real she might have been glimpsed through a bathysphere turns the page over like a glacier, to reveal a pair of sturgeons, studded and spurred like the one Dennis and I found on the frozen beach near here, snout pointing out to the navy-blue ocean.

Born in Zurich in 1516, Gesner was a physician, a botanist, a mountaineer, a philologist, a bibliographer; a new Albertus. In order to compile his *Historiae*, in which he proposed to include every living animal (he'd already written a book listing every known publication since history began), Gesner drew on

his own observations, and declared that the pictures in his books were commissioned from the life, or from dried specimens. But he stole his octopus from Rondelet's *De piscibus marinis*, and declined to ask Dürer for permission to recycle his creations, since the artist was long since deceased. Here was Ganda again, all forlorn; Eustace's dogs, rounded up from the streets of Nuremberg, sniffing the air for their lost master; and his monkey, on a chain.

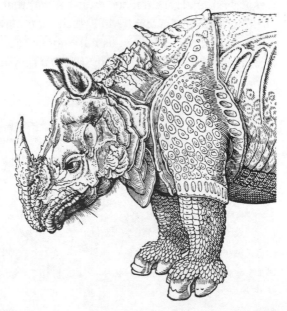

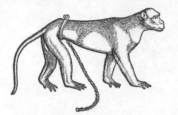

Gesner's bestiary was a sermon declaimed to an animal congregation, waiting to hear what we had in store. In four volumes and a thousand pages, the doctor ordered the origin of species into quadrupeds, birds and aquatic animals; a fifth book dealing with scorpions and snakes appeared after Gesner's death in 1565, another victim of the plague. The *Historiae animalium* was an act of appropriation, curiosity and disaster; a recipe book, a necropsy report. A toucan is put together from a beak sent by an Italian correspondent and a description found in a French book; a hamster is revivified from a pelt Gesner saw at Frankfurt fair; and a bird of paradise is drawn from a dead specimen bought in Nuremberg for 800 talers.

They all answer to their names, this roll call of roadkill. Gesner's animals are archetypes, in the way that his fellow Swiss, Dr Jung, delivered a lecture in Zurich on 6 May 1936 telling his students that the unconscious does not choose its symbols with a complete ignorance of zoology, but that they are born out of the

Philip Hoare

very substance found in those animals. (Thomas Mann, recently arrived in the same canton, did not agree. He was more interested in the circus at the Corso, with its Hungarian acrobats, the amazing trained seal, and an uncanny sword and flame-swallower. And even as Jung was speaking to this students, Mann was on his way to Vienna to deliver his lecture on Freud, before visiting the psychologist in his apartment, and lunch with Alma Mahler and Franz Werfel.)

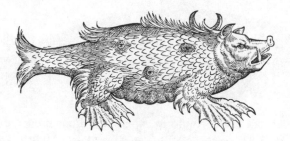

Meanwhile Melville, his head in his library (he'd shipped out from this port in 1840), credited his crazy Dewey system—The FOLIO WHALE, The OCTAVO WHALE, The DUODECIMO WHALE—to Gesner; who in turn, presented with the howling and tempest-stirring *monsters* of Olaus Magnus and his sea hyena with the head of a boar and eyes set in its side, asked in deadpan Latin, Hoc mirum quod in eius latere tres velut oculi apparent expressi—Does this seem surprising to you?—before producing his star act, his singing walrus, now fully extended as if, like a cathedral, his anonymous artist had completed what Dürer had begun.

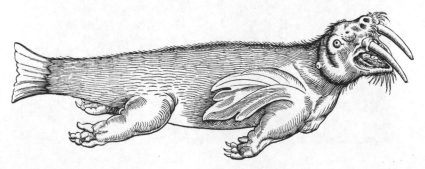

The drawing that can be seen in the town hall in Strasbourg also includes the feet, wrote Gesner. The rest of the body is supposed to have been added according to guesses or calculations, he diagnosed. The doctor wasn't fooled. He knew that some of these creatures simply did not exist. Others did, but not like that. And he laid out a naked porpoise to prove it, as if frozen in the river; the kind of creature Dürer would have drawn for his own collection,

if only Gesner had been around to explain all those bones, or to account for the walrus climbing the shelves in an Italian cabinet of curiosities, while Dürer's dogs played chess on the chequerboard floor.

The island of Texel hangs off the continent, the North Sea to one side, the Wadden Sea to the other. This place is naked too, stripped bare by the wind. The sky is so big it's falling down. I wade for ages before getting out of my depth; I could walk across to the other side and come out on the same beach. Jeroen saw the whales dying here. A few days before I arrived a whale appeared in the harbour. They lifted him out before I could see him, and cut him up.

Adrie meets us in his barn. The smell is familiar: the sharp stink of whale. From floor to ceiling, the place bursts with bones. It is an implosion of cetacean remains. They're everywhere—shelved in steel cabinets, dangling from the rafters, hanging on the walls—from tiny ear ossicles, the last to survive after all else has rotted away, to the vast arch of a blue whale's jaw, rising to the roof like a nave. Some of these specimens found their way to Adrie; others he sought out. Most were dragged up hither from the bottom of the sea, like flowers in a garden. They stand, awaiting the judgement of Adrie's precise hand, writing labels that proclaim their provenance, though they lost their flesh long ago.

Not that Adrie needs labels: he knows to whom they belong, each and every one. He is a fisherman by trade, a solid square man. He has a ruddy complexion, fair curly hair and a single gold hoop looped through his left ear. He might have been painted by Rembrandt. He owns his own fleet of bright blue trawlers; they're moored in the harbour, lined up like toys. His skippers observe standing orders: any bone in their nets must be reported to their boss.

That harvest lies stored in this barn. Boxes of block-like mammoth molars that once munched through the meadows of Doggerland; hooves of woolly rhinos, long gone under the waves; a walrus skull with scimitar teeth; and narwhal tusks that, despite rolling in the silt of an industrial sea, retain their magical powers, like their medieval counterparts in the Rijksmuseum—the eenhoorn-hoorns serving on altars as grand candlesticks,

or standing ready on the duke of Burgundy's sideboard lest he should be poisoned. On the last shelf lie the rarest remains: a pair of ribs from grey whales, a species extinct in these waters since the duke ate his dinner and licked the bones clean. All these relics are stories tumbled in the tides. Adrie's obsession does not end with dry bones. Whole harbour porpoises wallow in baths of smoky liquid like clients at a luxurious spa, skins puckered from extended immersion, snub noses pressed to the glass. One tank holds a still-born minke, appallingly pale.

And in a plastic box the size of a family suitcase, steeped in formalin so acrid it tears at my nostrils when I lift the lid (Adrie warns me, too late, not to breathe in), is a square section of a humpback whale, sliced from its belly, its rorqual pleats an obscene concertina. The black-and-white markings are so raw and clear that the sample looks like a replica; I have to prod it to make sure it's real. Its very regularity, this butchered slab, is terrifying, since it evokes the entire whale: the living, expanding and contracting throats I saw only weeks before as the whales wallowed on Stellwagen Bank, blatantly displaying the same furrows, their ridges flushed pink with the lifeblood coursing through them.

Nothing could be more alive; nothing could be more dead. I wouldn't be surprised to open another box and find a walrus stuffed in there, a shrunken head peering up at me. A coffee jar contains the testes of a porpoise. They're proportionately ridiculous, aubergine-sized; far larger, surely, than necessary. At least I would have thought so, had Jeroen not shown me that morning, in a nearby rescue centre, a pair of porpoises swimming round and round. One, whose human name was Michael—I've no idea

what his partner called him—zoomed up to the viewing window and extended his penis, at least a third the length of his body. It shot out like a sausage-shaped balloon at a children's party; it would not have been easy to explain to the young visitors. Then he turned upside down and tapped the glass with his beak. He probably recognised Jeroen, who, as a volunteer, had often cradled Michael in his arms.

In Adrie's loving collection whales live on in all their glory; free, but taken apart. His workshop next door has all his tools ready should the occasion arise. Fin whale? Certainly, says the whale mechanic, as he fetches the requisite bits.

We leave the stable of whales and step out into the bright sun. A rusting harpoon gun is aimed at us as we cross the lawn. The sea lies just over the dunes. Adrie and Ineke take us into their house. It looks almost ordinary, till I realise it too is filled with whales. Whales as perfumes and oils and unguents; whales as shoelaces and hairbrushes and brooms; whales as umbrellas and domestic objects, to be used. In one corner stands an electric lamp made from a polished sperm whale tooth, its shade shaped from the foreskin of a whale, an exceptional art.

Does the whole house
stand on bones, the
island a slumbering
leviathan ready to cast off
its humans? From
the last vitrine, I pick
up the preserved eye
of a whale and peer
through it, not knowing
what I expect to see.
The deep ocean, the dark
backward abyss of time.
Or just Jeroen's lens,
looking back at me.

I ride along the city's canals; no one jumps out with their coat over their head. I arrive at the building that houses special collections. It is bright and sharp. Another pair of books are handed over to my care; it's amazing what trust people place in me. I'm scared to open them. The bindings are blocked and dark green, worn bare as a bible. Supported by pillows, weary with the past four hundred years, volume one swings open without a hiss. The bikes run over the cobbles outside. Pressed between the covers are the original watercolours made for the *Historiae animalium*. I run my fingers over the page, feeling the fingers that cut out and glued down these pictures, like the scrapbook my little sister used to keep. Gesner recommended that his black-and-white illustrations should be coloured in by his readers.

This is a secure, modern building, but no amount of climate control can suppress the scent and feel of human and animal that pervades these pages; the glue and the skin, the dead things that make books, ground up and sewn and blocked, so that someone from the twenty-first century can stand over a desk turning these stiff sheets. The librarian peers from under her desklight, making sure I'm handling her charges with due care, as if books themselves were already extinct.

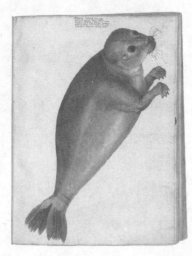

The glitter and squalor of it all.

Philip Hoare

The illustrations glow because they've never seen the sun. Briefly free of the chill of the archive, bejewelled butterflies flutter and pink gurnards swim, scaled in filigree gold; stoats and badgers and wolves prowl against tarry backgrounds. And hauled out on a page of her own, which she fills with her big belladonna eyes, is a sealish courtier to the duke of Bavaria, a handsome man who gave up his life to idleness and pleasure and who was accompanied on his progress through the German lands by his flippered pet in her sea-water tank.

There she is. Green and weedy, tusks clattering on the cobbles, dragged out of the canal; as chimerical as a platypus, as real as a centaur. It's a shock to see her, lying in a puddle, as if I'd discovered a new Dürer, waiting for me.

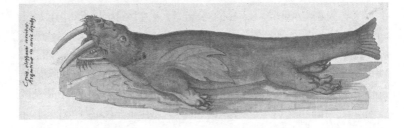

I turn the page, not knowing what to expect, and another performer leaps out. The inscription says he was captured in Hartlepool, England, and measured twenty-four feet long. He looks like a cartoon, like the first whale I ever saw, Ramu, an orca in a suburban safari park, jumping through a hoop and catching a fish in his beak. I tried to collect him too, painting him in my teenage journal, turning him glossy with nail varnish, like a caul. An animal filled with a strangely haunted beauty, as my friend David said when he saw one break the surface, as though the whale were coming out of the past or some other way through time. Another myth: those white patches that were the source of the sea hyena's manifold eyes become the eyes of the all-seeing predator; eyes I had seen, and that saw me, out there in the Indian Ocean.

We'd been looking for days and days. The little fishing boat that we'd chartered headed out each dawn from the sandy cove, where I said my prayers to the statue in the beachside shrine before we cast off. The horizon just went on and on. Equatorial, equally day, equally night; equally sky, equally sea. Nothing broke it, no arching back or sharp flukes. We argued back on land, in the tropical night, about what we or someone else (some deity, perhaps) were doing wrong.

The next morning, there they were, waiting for us. One hundred and fifty sperm whales. There was nowhere we could look and not see a whale. We dove in, again and again. Two whales swam towards me, their heads bobbing out of the water; I sang to them as if I had seen old friends. It is impossible to say how excited I was at that moment. One whale lay alongside our boat, napping. Another pair, mating belly to belly, slid directly beneath us, their amorousness discreetly masked by our patched-up hull. We felt their clicks through the water, connecting them to us. The ocean was not empty after all.

Suddenly, they started to move towards the north. We followed, having no idea what was happening or where we were being taken.

Philip Hoare

Their great square heads rose like prows as they swam at speed. I laughed, because it seemed so ridiculously like a scene out of Melville's head; and because I saw that all those pictures were no exaggerations after all. As we came to a halt, expecting to find an orgy, we discovered a site of violence instead. Thirty whales hung tightly packed at the surface like a raft. As Drew and I lowered ourselves in, I said, Oh look, dolphins. But they were not dolphins.

A pod of orcas was circling the sperm whales, as if to herd them up. Beneath the surface, we could see the extent of their attack: the orcas were trying to break through the whales' defence from below, whales snapping their jaws and defecating to obscure their assailants' assault. As we looked on, mesmerised, a pair of orcas headed towards us. Drew gestured urgently to get back to the boat.

For the next three hours we watched as the drama played out —three species, sperm whales, killer whales and humans—each in their roles. It was like watching a film, only we were in it. At one point I worried that we were blocking the sperm whales in, preventing their escape; that they were paying the price for our adoration. Then we realised they were using our boat as a defence,

a fourth wall. We were part of the performance. It was the most extraordinary thing I could ever witness, yet it was happening in some other, pre-human time.

Eventually the orcas tired of their efforts to penetrate those great grey flanks, as armoured as rhinoceroses, and they peeled away. Thinking the sperm whales were safe, we moved further north, to where the killers had reassembled and appeared to be playing, spy-hopping and slapping the sea with their flukes.

They came alongside: intensely graphic, generated, black and white back-projected on a blue screen. I was impossibly excited, shouting involuntarily, infected by their beauty and speed. Then they started circling us, closer and closer, slicing through the waves. Five times they butted our bow with their beaks. As I looked over the side, while everyone else was facing the other way, I saw five of them charging directly at us, ready to tip us over like seals on a floe.

I felt we were being honoured. At the last moment they slipped under the boat. They were playing with the distance between us. It was they who were the most successful mammals on the planet. Present in every ocean, six million years in their evolved state, they were just waiting. They'd always had their eyes on us.

Philip Hoare

For all its long-lost animals and those yet to be lost, Gesner's album is making me childishly happy. I'm smiling to myself, a grin as broad as a whale's. Perhaps it's the sunny day in the city, or the bike ride as we took the children to school, or the afternoon we spent at the lake, leaping in and out; perhaps it is all these things that make me see these pictures in this way. They make me feel glad to be part of this world of things.

As I leave the study room, I meet an older man standing by the lockers; he's wearing a kippah. He asks me what I was laughing at in there. He has nice eyes.

You seemed to be very amused, he says.

I ride to the river, where the boys are jumping in, just as Mark said. They leap off the bridge, carelessly; they might be going up or down. The water runs green and brown. The summer has slowed everything to this afternoon. I find a quieter way in, holding on to a wooden post before letting go.

The world bobs above me, I'm level with the ducks. An older woman in a bikini wades in gracefully from the deck of her wooden hut. I glide with the current, then climb out. In the stadium nearby, Freddie and I watch Lilian run a race with her friends. The city goes on, calmly, and we cycle home for tea.

REMAINS

It's hotter than ever. I could have swum here down the river, like a dog. I'm drawn on and on, deeper into the continent.

I leave the station, its pale walls and Jugendstil decorations, and cross the tramlines. Elderly apartments retreat from the heatwave, their tiled halls and iron banisters winding up into endless interiors. Over the street is the campus. To get to the library, I must pass through a concrete hall more like a car park; the students hurry upstairs as if scared of the dark.

Martin appears with a big grey cardboard box.

Where would you like to look at it? he asks. He's used to an older, grander place. He's younger than me, wears his hair slicked back, shoes with no socks, a concession to the heat. There's a crested ring on his little finger. We descend to the lower floor, which could be a warehouse for shipping out stock. It has no characteristics at all.

Laying the box on a table, Martin opens it up. Inside is a morocco leather folder, its edges rubbed with age. A slender pouch is attached to it, the size and shape of a nineteen-twenties cigarette case. Martin unfolds its flaps. They come apart like a flower. Embedded within it is a slab of glass, contained in a silver frame.

Martin gently eases it out.

Philip Hoare

I keep chatting, reluctant to address the thing in his hand. I've come hundreds of miles to see it, but I'm looking anywhere else. He must think me very odd. Unable to avert my eyes any longer, I look down. Caught in the glass, as in amber, is a long, surprisingly blond lock of hair.

It doesn't look human at all; it might have been snipped from a thoroughbred's mane. It appears to be two colours: a pale straw yellow, and a darker mousey brown, with a hint of red. It twirls, as if alive.

A bracelet of bright haire about the bone. My hands hover over it. May I pick it up? Yes, but I must keep it close to its case.

I'm holding Dürer

He's as heavy as a tooth or a tusk. He doesn't feel safe in my bent hands. He ought to be in a baroque chapel, in a monstrance, not this academic basement.

Martin and I talk about what it means. Neither of us is sure. Because I don't speak his first language, and he only fitfully speaks mine, and because there's this powerful thing between us, our words are more precise.

Actually, Martin says, we're not sure if it's his hair at all.

But then, he says, how many True Crosses were there?

Dürer was raised on relics. Now he is one. His hair growing on after he's gone, a floppy lock fallen from the barber's chair. A token for a lost loved one. Locked up, like the princess in her crystal coffin, waiting to regenerate. We could make a new Dürer from his genes.

Only as we set the box back in its leather bed do we discover a single sheet tucked inside the folder like a will, written in many hands.

The first entry, in 1550, is by Sebold Büheler, the merchant who owned the hair. He certifies it was taken from the head of the world-famous artist; those are the words he uses. Below are other attestations, each dated as empires rose and fell.

1595, 1649, 1668, 1798, 1806, 1860

I hold the paper up to the window and a watermark appears: a double-headed eagle, the wings of the city's crest outstretched like an airport. The last note marks the framing of the lock on Dürer's anniversary, 1871. I want to add our own witness: 11.38 a.m., 4 July 2018.

Our business done, we take the box back to Martin's office. On the way, he tells me about his dog. I'm just asking what breed he is when the door opens and out leaps Andrássy, a sleek brown Hungarian hound, as big as me. He doesn't belong here. He bounds between us, longing to get out in the sun.

As Martin takes me to the exit, he tells me about the river where Andrássy swims like a Olympian. He scribbles a note of the metro stop, and I slip it in my pocket.

The horses stamp impatiently on the road. They wear blinkers over their eyes, and sheaths over their ears. Nobody seems to think it odd such huge animals are standing among us. All the tourists wear sunglasses and baseball caps, heads bent over phones. A tram pulls up and a dog and his human step off. He shakes his snout, eager to be free.

Müssen Hunde mit Maulkorb und Leine gesichert sein.

Philip Hoare

His muzzle is slipped off and he's a proud animal again. I suspect dogs run this city. They know the difference between nod and not. A man in a homburg hurries by. The museum rises above us in great walls of stone. People are taken in by the revolving door. I'm directed to the side entrance, like a tradesman.

In the study room I'm greeted by the curator. He's tall and precise as his voice. He's always busy. I shake his hand and say I can see he has to choreograph his day. He smiles. I follow him. I can barely suppress my excitement. We're accompanying the president on a morning briefing. A pair of visiting art historians from Germany join us, a woman and a man, both sharp in white shirts and grey trousers. My sandals squeak on the polished floor.

I hope you don't mind if they take the opportunity? says Christof, politely.

His aside slyly underlines the rarity. I feel the cool air on my legs, bared by my shorts. Our deputation sweeps down the corridor, through a series of double doors and into another basement.

This is the inner sanctum, Christof says. His master is a dead king in a pyramid.

Passing through the final gate, we emerge, not into heaven, but a low-ceilinged chamber. It's the engine room of everything above. Christof points out the sprinkler system which will, in the event of an emergency, dispense not water but gas in amounts to allow a human to breathe and the fire to be doused.

Rows of units disappear into the darkness. I can only guess at their contents. Standing on a chest-high shelf are four easels, each covered in black felt.

A stocky man wearing cloth gloves emerges from the stacks, carrying two large flat boxes made of that same grey archival card. He opens them, one by one. The monochrome room instantly turns into colour. It's our own private view.

I expect Christof to click his fingers and glasses of sekt to appear on a silver tray.

I do not like to move the works at all if I can help it, he confides, as if he were talking about the last aristocrats of a dying dynasty.

Not even to take them upstairs, he adds, looking at me.

Here they are.

The wing of the roller. And the whole bird.

The scale is one to one, says Christof, with precision.

Life-size. But dead.

The size of this open book. The gaping beak; the parted claw, the other behind the folded wing. The details are barbarous. The colour sings. I can't believe the otherness. I feel the swoop of those wings as they draw in.

I lean in to inspect the specimens. My bedside manner. The single wing unfolds. The most animate-inanimate thing, though it's five centuries since it last reached into the wind. Painted on parchment, on stretched-out skin. The red tufts at the shoulder seem stained with the bird's blood as they were ripped away, a ragged flag over a sinking ship. (Dürer longed to strap on a pair of wings and leap off his parapet once the students had gone.)

Christof has seen these paintings many times. They are showroom pieces, he says, in his showroom.

Dummies to show what Dürer could do. A sales pitch for immortality, with Christof as his agent.

The master can't be with us, he has other business to attend to. But see here, how exquisite his hand.

The hand of God. More paint per inch, more art to the eye. I ought to place an order. Days measured in pigments, ultramarine time, ten or twelve ducats an ounce, the head and neck powdered in gold. The laboratory assistant opens another box and steals out another frame. Reaching to the sun, from two floors beneath the sky. It too is one to one. We look through it, as he did, a mole's eye view. He turns us into botanists. The dandelions have flowered, ready to explode as puffball clocks.

The time the grass keeps when it grows, so unobservably, says Mann on the mountain, one would say it does not grow at all.

Time is a fluffy white thing. This is what will come. A proud act of humility. That's why it's cropped so close. I need to get nearer. Christof is talking.

He says a biologist concluded that all these plants could indeed be found growing together at the same time. He notes the exposed roots, white against the brown, brought indoors. The stalks bend in an invisible breeze. A forest or a scrubby patch of common ground.

The last box is brought to the table. There's a scrabbling noise from within.

The lid opens and she comes out, blinking into the light. Smaller than life-size, says Christof, almost disappointed. What was he expecting? Here she is. The young hare.

Christof points out the single white lines Dürer laid along the whiskers to highlight them. I came here to see his hair; he used hair to paint her fur. She twitches. She's an illusion, a sack full of tricks.

Un trompe-l'oeil. In Christof's cut accent, the words sound delicious. Of course, he adds, even before the drawing was finished the hare was in the pot. She was dinner. The window in her eye isn't her soul. It's the kitchen, her fate.

Dürer stands over her. Her shadow gives her away, her body quivers. She fears the hunter's dog, and runs into his arms, the little genius of the place. I want to cradle her, to save her. But her skin

will make glue for more canvases, and her bones will be licked clean, too late to tell her that she is the history of art.

Christof claps his hands. Our audience is at an end. She must go back in her box, and he must attend to other matters.

I photograph the pictures nervously, on their identity parade, as they answer for themselves, before they are all taken off the shelf, leaving me wondering if I'll ever see them again, these old friends, or even if they were there in the first place.

I step out blinking into the street. The horses have been led away. I turn my back on the gallery; I can't look at any other art. I can't hold my own weight.

Following Martin's instructions, I take the metro to the river, and slip down the bank as the trains roll overhead. We're on an island, water flowing either side. There are mountains and mountains in the distance. I let my body spin round, though I fear the weeds around my feet. I'm floating in the sky.

There are people on the bank, the scent of spliff and the sound of rap in the air. I walk back to the station. Someone has sprayed *CGAS* on the path. I go to bed before the sun sets.

Christof tells me to be at the main entrance at **3.30 p.m.** He types it in bold. I arrived ten minutes late yesterday.

He arrives at **3.29 p.m.**, with precise instructions.

Following orders, I report to the study room and wait among its steel chairs, blond wood and silent doors. It could be a private clinic or the office of a wealthy investor; only the books give it away. Books, like pedestrians, are suspicious these days. Who knows what they might be planning in here?

Three women are at work. One at her desktop computer, another turning the sheet of a portfolio. The third pecks away at her laptop, transcribing an old manuscript. We are all downloads now. The light is cool, controlled. No one speaks for fear of disturbing the shelved and the dead down there.

I loiter by a pillar, looking down the corridor. It's lit by strip lights. There are double doors at the other end. I wait for the star to sweep in, flunkeys holding off the importunate wanting a touch of his curing gown. The assistant walks in with another grey box. I saw it yesterday, from the corner of my eye. I had to have it; the river told me so. I'm directed to a seat.

There he is. His first self portrait.

Where he began. The fluorescent tubes reflect in the glass, echo-locating him. I'm dressed for the occasion this time, in my red-and-blue-striped shirt. Just him and me. All I can do is draw,

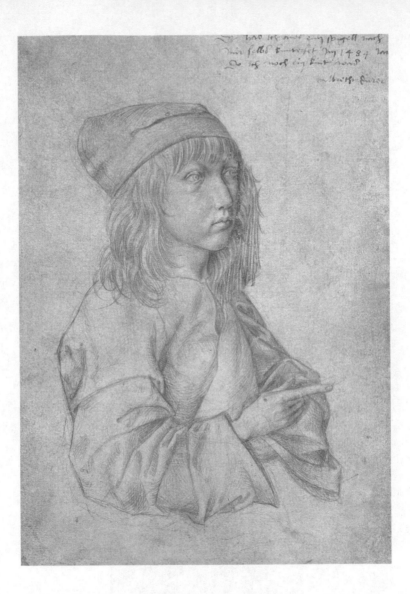

with the archive-issue yellow-and-black pencil, precision-made in Nuremberg. (Thoreau's family business was pencil-making; they used whale oil to bind the lead.)

Suddenly Christof appears by my side. I cover my sketch with my cuff. So, what is silverpoint? I ask, to deflect his attention.

Philip Hoare

Christof has a perpetually wry smile. He knows a thief when he sees one.

It's exactly what it sounds like, he says. A silver spike drawn across a ground of bone ash and rabbitskin glue, with added pigment. This layer—a skim of plaster or the kaolin sheen on a glossy magazine—is itself a skin.

There's no room for error, Christof tells me.

I keep my hand over my book. Students were trained in the technique as a test. It demands great skill because you only get one chance to make your mark. As the silver oxidises, the image appears slowly, developing like a photograph out of silver nitrate. He was thirteen years old. At thirty he added a note.

Here I portrayed myself from a mirror
in 1484, when I was still a child.

His face is chubby and pouting, his eyes almond-shaped, guilty of long nights. He looks like I did as a boy, too scared to go in the water, diving under the covers to read superhero comics by torchlight. He was bullied by the other students.

He can only draw one hand; the other disappears in his gown. The tassel on his cap merges with his locks. It's the first glimpse we have of him. Everything lies between this and that lock in its prism. His finger points at something in the future. My time has run out, and he's taken back to his cell below.

I cycle through the park in the heat. People ride horses through the trees like ghosts. Black dogs move in the long shadows of the afternoon. The white wheel turns above us. The local paper reports an intruder.

Wolf-Alarm im
Wienerwald!
Tier biss zu
MENSCHEN IN ANGST

The big wheel loads and unloads people. I ride down to the river. I swim out into the middle, emboldened by the bodies around me; I'm used to being alone in the water. We lie on the grass, in the warm evening air.

The day fades and I ride back, into a cobbled square. A low modern structure stands in the centre, its walls cast from inward-turned books. Sixty-five thousand people were taken from this city by train; their destinations are recorded around this memorial. An old plaque nearby marks the building that stood here five hundred years ago. It was set on fire by the people who took refuge in it. The clouds start to roll in. I go and eat an ice cream.

They put Pat in the sandy ground. They might as well have buried her on the beach. Jim sends me a photograph of her in a robe with her wolf by her side. Dennis says her paintings are being taken out of the house.

I'm still two hundred miles from the sea, surrounded by mountains, in a country that is black, refined, sanguinary, Mann said. In the dark before dawn, in the park where Philip the Planet King hunted, I slide down the side of a fountain and into the

ornamental pool. The water is thick and green; it's been here since sixteen-something. My subterfuge relies on me looking like a dog. The avenues are already roaring into life. This city's patron is St Eustace. That's why there are so many dogs.

In the museum (fifteen euros), Goya's dog lifts his head out of the water. A little boy falls to his knees in front of the painting; his father tries to explain it to him. Antonio Saura said this was the world's most beautiful picture, not its saddest.

Perro semihundido.

I remember what I came in here for, my shopping list. Folded in a golden frame, half life-size, he dominates the wall, the room, the palace. No one smiles for their portrait; they'd think you were insane. His rose-leaf lips say, I made all this.

| Plate V |

I swivel my eyes down to his hands; he always exaggerates their size. The gloved hands of a gentleman, not the bare knuckles of an artisan. He's holding on to himself. One neat-stitched cuff turns back to show the hairs on his wrist.

Such inordinate vanity, says Lord Clark, in his castle.

A masterpiece of self-love.

The tassel of his cap is tied up foppishly, like a ponytail; everything is arranged. The cape is rigged across his chest like a sail; its shadow falls over his pecs. He's a handsome sailor, as beautiful as a young god approaching out of the depths of the sky and sea, says Aschenbach.

None of these are useful items of clothing. How I shall freeze after this sun! he complains. Back in Germany they think he's a parasite. He's in his room overlooking the sea. Mountains fall down to the shore. His hair falls down to his shoulders. Leonardo loved that freshly oiled smell.

But there's something amiss. A lock has been lopped off, its lack balanced by a single curl on the other side, dangling like a lure for the future, for a lover. There's always some defect in the divine image to remind us of God's hand, says Melville. All the mediocrities, says Mann, refined by no deformity.

Beside him is Adam, his kit off in the middle of the palace, twice life-size. Long-limbed, he steps up to the edge of the pool, an Olympian limbering up for a bigger splash. He lifts one foot, then the other. A beautiful creature, newly made. (In 1520 this picture ends up in the Castle of Frankenstein.) The leaf strains over his modesty. Eve, a beautiful woman, came out of him. You can see the scar in his side. (My twelfth rib is gone, cried Mulligan, diving in the fortyfoot. I'm the Ubermensch. She will drown me, says Dedalus. Lank coils of seaweed hair around me, my heart, my soul, salt green death.)

| Plate VIII |

They are extravagantly, classically naked, the very opposite of those portraits of people looking like furniture, those men and women draped in velvet, furs and pearls. Her hair trails in the current; she's the colour of moonlight, being newer than him. The serpent is entwined in the tree. Coils, bodies, locks snipped off. Who saved him? Who blessed him? Some detect dismay in those parted lips; I see an ecstatic swoon.

They're specimens in a future museum, a black tank. A handsome couple, fresh from the agency. Oh, that's beautiful, hold it right there. She's poised like a dancer; he moves to her side, sways away. So neo-classical in their villa, still glossy and wet. They go back behind the art deco screen, lacquered like the night. He puts on a white dinner jacket, she steps into lavender chiffon, another time, another place. His little finger is kinked as he holds his hand out into outer space.

Albrecht stands back, admiring the sheen. A century later, the mannish queen of Sweden passes the pair on to the Planet King for safe-keeping. Forever apart, they never meet, never leave their rooms. It would be dangerous if they got free, wandering naked

in the streets, quite of their own accord. Until the twentieth century, they were kept under lock and key, too outrageous for public display. Virtue was its own reward.

Meanwhile, Dürer's self-portrait spends half a century with Charles I, only to be sold off after the king loses his curly head, along with his unicorn cane.

Now he sits there unblinking, an autoretrato, an icon of himself, a paramour armoured in fancy dress.

He doesn't look German at all.

Alberto Dürero

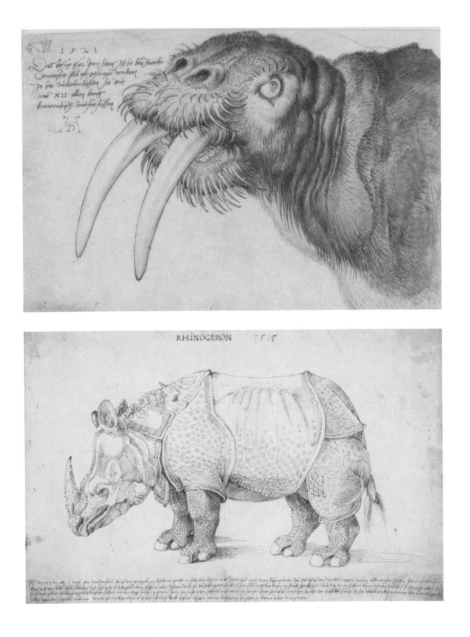

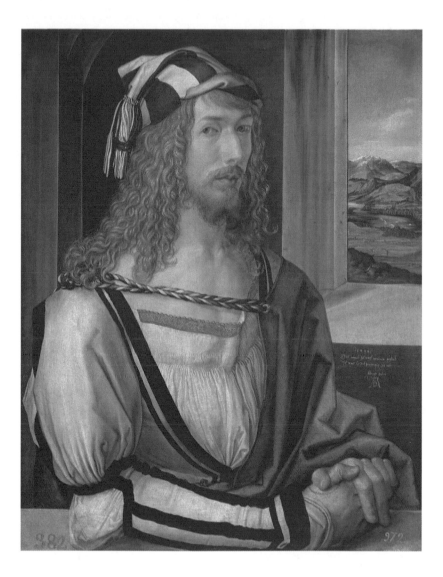

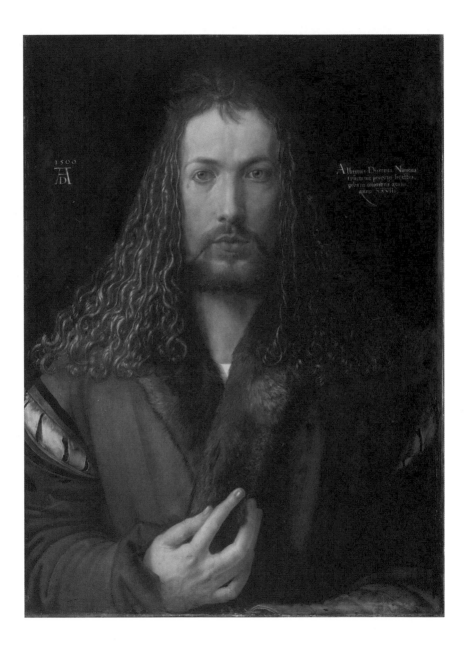

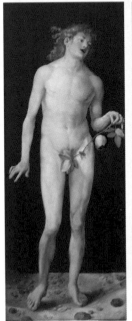

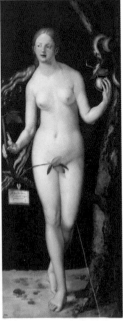

BEAUTIFUL

We're all in this compartment together, a little living room, moving along. The young man opposite me is asleep, his head lolling on a rolled-up hoodie, tangled hair hanging over his forehead. He has a straggly beard, wears headphones and a flannel shirt. The corridor door opens and a young couple come in with a baby, who settles down to feed. The train rolls on, lulling us into the late afternoon.

The city falls away to forests and fields. Dark larches, beeches and firs stand at the edge of bright meadows overlooked by fire-watching platforms. Everything is in order: piles of lumber ready for the mill, churches with spiky black steeples, houses tiled like pangolins; villages, farms and factories.

It's pouring with rain as we pull into town; it will rain for the rest of the week. The train carries on to the sea. My bike rattles on the cobbles; I'm carrying everything I need on my back. I ride round the walls, trying to find a way in. Fat round towers guard the gates, vents for an obscure industry going on underground. I get lost in the streets.

He's leading me on with his long hair on statues, plaques and squares. So insistent you'd think he'd never left or was never really there. Reaching my hotel room up in the attic, I pull off my sodden clothes, the only ones I have, and leave them on the

radiator to dry. I fall asleep under a single duvet on the double bed.

Next morning, before dawn, after drying my shoes with the hairdryer, I cycle through the castle gate and along a street marked by the seven falls of Christ. The cemetery is locked. I ride on down to the river and push my bike through the trees. The water is narrow like the streets. It runs fast and brown under low branches, catching itself on unseen obstacles underneath. Anything might have been left down there. I feel like I'm stealing something as I get in. I get out and ride back to the graveyard.

It's still raining.

The stones lie flat, no one gets up as I enter. A museum of humans, each grave only slightly different, pitted with lichen and newly swept. I find the gardener in his day-glo coat; he's not gruff but pleased and takes me to see him. He's weighed down with stones and grave flowers. The plaque says what is mortal of him lies below, but that's a lie. I came all this way and he's not here.

I leave a shell on his headstone and ride off. Everything smells better in the rain, shiny and new. The town looks even less real. The timbered buildings, the covered bridges, the spires and turrets, all arranged and composed by him. The houses tumble down from the castle, a man ties his vines to the wall. I follow a pattern set centuries ago. The Tiergärtnertor gate was named after a medieval menagerie kept in the moat. Animals growled down there. Ruskin came here in search of Dürer in 1859. The delight of the streets depended on the dormer windows in the steep roofs, he said; he found no exalted grandeur or deep beauty in the city, but an imaginative homeliness, mingled with some elements of melancholy and power, and a few even of grace.

Dürer's house lies at the foot of the castle. The town turns on this corner; a stone pillar stops carriages and tourists careering into it. The scaly roof sags under its own weight; its dormers are sea-hyena eyes. Everything is closed in like a film set; I expect an expressionist shadow to stalk up the street.

Philip Hoare

I stand on his doorstep, rehearsing my lines. On the strike of ten, the big black door opens up. I smile and ask the man if he knows what today is. He looks at me blankly. Another tourist.

It's his birthday, I say.

I was hoping for a free ticket, at least. The first tour party is backing up behind me as I pay my seven euros. The audio guide is hung round my neck like a placard. I'm sent to stand in front of the panels; they will tell me all I need to know. Instead, I run to the top of the house, two steps at a time, to surprise him in his attic, striking poses in the mirror. But he's not there either.

Down in his studio, colour lights up the room, in shells filled with saffron and cochineal and indigo, lapis lazuli and azurite, dragon's blood and verdigris, from Hungary and the Canaries, from Persia and the Indian Ocean. In the kitchen, hung with pots and pans, he installed a wooden closet without permission. The council's letter was stern: Albrecht Dürer is to be advised that we are favourably disposed towards him, it said. Nevertheless, in regard to his secret chamber, he cannot be treated differently from others. It was not a cell but a privy, his last resort in his illness.

He climbed upstairs to his observatory, to see the stars. Demons rapped on the panes. The past was dark, the future modern and bright. During the war the citizens saved the house from the fires by keeping it wet with towels. Their homes were destroyed but it survived, to be rebuilt like a ship, a version of itself. I look out of the window. I came to see this city, but it isn't there.

The street comes to a halt in the square. There he is, wreathed with red and yellow roses, on the twenty-first of May.

In May 1945, Auden—who'd surprised everyone by joining the US Army—drove his jeep into this dead end. (He was a bad driver, taking the wrong way down the autobahn.) He found no whales in the marketplace. He and Jimmy Stern had come to survey the damage. The fires had barely died down. All the houses had collapsed as if a deluge had washed up the hill, leaving waves of rubble and timber behind. Only the castle tower remained. A pair of women walked down the street as though they were going shopping, and a shirtless man scavenged in the debris.

Philip Hoare

The yawning voids, the chandeliers of bones. Among all the chaos, surrounded by deep holes full of twisted, broken drain-pipes, as Stern wrote, Albrecht Dürer stood high up, erect, like a lonely saint in his stone robes.

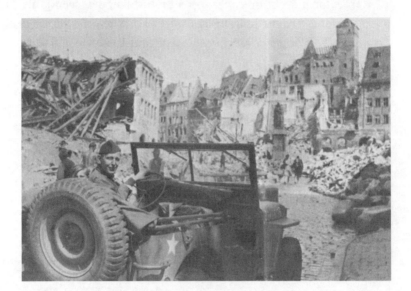

And here, every evening, said Stern, under the master's out-stretched hand, gathered a group of gangsters whose ages ranged from four to eight. Once spotted, they scattered like rabbits into their burrows. After a while they reappeared, carrying sticks and stones and iron bars. Their teeth were blackened and broken, he said. One had lost an arm, another used a crutch; they wore rags so dirty that they seemed camouflaged in filth, and the only clean spots on their bodies were the whites of their eyes.

They were not scared, but heartless, these orphans. A feral brood crawling out from under the artist's robe, spirits of ignor-ance and want. The houses, built of little brick and a lot of wood, had burned like wicks. People lived like animals. Some carried bunches of wilted wild flowers, scurrying home before the curfew. Bicycles were so prized people were shot for them.

Stern interviewed a woman who had visions. There must have been a call from Heaven, she said, becoming excited: BOOOOM! There comes the Devil—Satan, the Evil One, Lucifer, the Black Rider—bringing Death and Destruction!

A predator in tight breeches, on a motorbike, overseeing his plan. Imaginary cities, built to be destroyed. When the starman dreamed of his dog-ridden apocalypse, it was this place he saw, interbred with the ruins of Metropolis.

James Stern was Irish-bred, of English and Jewish descent. An exile of the inter-world, like his friends Brian Howard and Christopher Isherwood, Erika and Klaus Mann, Joyce and Beckett. Lost, damaged people. Stern remembered the disturbed and violent world of his childhood in nineteen-twenties Ireland, of country ambushes and cars pocked with bullets, and men burying their own breed up to their chins on wild deserted beaches where they were forced to spend the last hours of their lives watching the long ocean-tide approaching, foot by foot. (In the black lough in which Wilde and Beckett swam, as did I, informers were tied to stones and drowned like puppies.)

Short and slight, Jimmy was prone to a disabling melancholy and couldn't bear anyone touching his hair. He'd spent '31 in the Hôtel d'Alsace in Paris with his Berlin-born wife, Tania, writing in the room where Wilde died. He couldn't work, not because of the ghosts, but because of the view. (If you saw a man throw himself into the river here, Sherard asked, would you go after him? I should consider it an act of gross impertinence to do so, Wilde said.) The Sterns moved to New York in '37. Thomas Mann met them on the *Normandie*, along with the Huxleys, who were travelling tourist class; the ship was rolling, everyone was seasick. It was with the Sterns that Auden felt safest. They were his surrogate family. They thought he saw himself as a doctor or priest. He gave no good advice at all. Poets never get it right.

Stern published *The Hidden Damage*, his account of that time, in 1947. The idea had been to write it with Auden (Stern calls him

Mervyn in the book, a faint attempt at disguise), but faced with the occupied country where he spent so much time as a young man, preoccupied by its young men, Auden couldn't find words for what he saw. Stern had lived in Germany too, before the war, escaping his dreary day job at a Frankfurt bank in his lunch hour to swim in the muddy river, washing the airlessness of the city from his skinny bones. By night he'd descend into dive bars where, as he wrote, deformed creatures in men's clothes crawled to intoxicated life.

I have his book here, signed to his friend; its spine is battered, as if it were war-damaged itself. As I open it, a newspaper cutting falls out: under a photograph of the author is a scribbled note in the sort of red biro used for crosswords on empty afternoons: *Jimmy getting his prize 1966 born Jan 1904*. I expect a name-dropping memoir, a list of duchesses and drinks before dinner and people stumbling downstairs. Instead, the most intense record of war and its aftermath unfolds, as Stern returned to the Europe he had loved and discovers its damage was his own.

He heard himself in the silence, he wrote, in the roar which until recently had not been heard in history: the crash of thousands of tons of exploding bombs, the blast of the guns, the howl of the fire sweeping from house to house in the wind, the howl of vengeance and the destruction of Germany.

Stern's journey takes him in a black-and-white film, from New York to unnamed military airports and uncomfortable night flights from Newfoundland to the Azores to London, and on to Paris and hell. He looks for old friends in the city's bars and apartments and on a street corner sees an emaciated figure in steel spectacles and blue-and-white-striped pyjamas being beaten up. He was apparently masquerading as one of his own victims.

Finally Stern landed in the middle of a field. No sign or a word suggested that we were in Germany, or even in Europe, he says, until I finally saw, on an embankment in the distance, an entire

train that had been blown off its rails. Part on its back, with its little wheels in the air, part on its side, it lay there like a gigantic slug chopped into several equal chunks.

He drives through melancholy countryside, the same countryside where the Mann family spent their summers. Ludwig's castle stands like a living story, and the fields of the Allgäu seem blissful. But on the outskirts of a town he sees large grey buildings for men with one leg or no legs, and beyond them one for the armless. They wore white singlets, he reports, and sat or lay on the grass under copper-beeches in couples with their crutches, or in a line along the wall overlooking the road, like one-legged birds balancing on a telephone wire.

The shock at seeing them lasted only an instant, as he passed by, but Stern knew these scenes were being repeated all over the world. He detoured to interview a descendant of the Fuggers, who had taken part in the conspiracy to get rid of the leader. The aristocrat is still living in his castle, in its great white tower rising out of the trees. As he arrives, Stern is met by two young boys, who look more British to him, in their clean navy-blue gentleman's Sunday suits, with that dignified, self-assurance. They smiled with such magnificent, outrageous flirtatiousness in my face that I had to grit my teeth to stop myself laughing.

Conducted by the boys through the cool gloom—the older one continually turning back to stare at him up and down and smiling an outrageous smile—he passes boxes filled with treasures from churches and museums and watercolours of schloss after schloss. And over the next three hours, pausing now and again to light a new cigarette, Fugger describes the moment that everything might have changed.

Stern drives on, into the shimmering fields and mountains. Yet even here, the silence seemed a little sinister, he said, like the silence between claps of thunder, or the stillness that falls in the streets of a city with the sudden falling of snow. It is the silence of sudden death, he says. He and Auden arrive in Nuremberg, like

tourists with their Baedeker. It was only in a footnote that he could sum up the weight of what had come down.*

THE HIDDEN DAMAGE

Picking their way through the wreckage, stumbling down the hill, the two men—a shambolic poet in uniform and carpet slippers, and an Irish writer of whom a friend said, Jimmy, you have known everyone, and their boyfriend—come upon other scenes. A woman living in what looks like a dog kennel; families conducting their everyday lives in an apartment block with no front wall, like an open doll's house.

No one speaks above a whisper, says Stern, but he hears the sound of voices singing a psalm; a sound as sad, as timeless as the sea, a reminder that the human spirit was as indestructible as the Oceans.

It pleases him that the motor-pool outside the city, in the shadow of its great white stadium, in the summer heat, is run by a gang of powerful-looking African Americans, their muscles gleaming in the evening sun. And he thinks about the thousands of tons of rubble that was shipped to New York as ballast from bombed-out Bristol, to be used by Mr Moses to lay the foundation for Manhattan's East River Drive, and he wonders if these German remains too could be transported as far as the distant sea. (Sebald, born nearby, recalls a fictional character who puts out to sea in one of the barges used to clear out the ruins, only to sink. As the rubble falls to the bottom, the man sees a whole city down there, another Atlantis, and all that was destroyed still intact.)

* Raids: 47. Planes: 7,190. Tons of explosives: 17,115. Killed: 6,120. Seriously injured: 12,00—approximately, since the records were destroyed during the last great raid on April 5, 1945.

Sunk in depths of destruction, Auden and Stern, stern audi-
tors, chain-smoking recording angels, meet another survivor:
a German art historian who speaks impeccable, upper-class
English. His cut-glass voice cuts through the chaos. He asks the
visitors if they know his great friend Kenneth Clark; Stern says
he'd been at school with him; he remembers his big head.

The German had been sent from Berlin in 1943 to supervise
the removal of the city's treasures, the Holbeins, Burgkmairs,
Cranachs and Dürers, to be stored in great caves under the castle
rock. Now, to his horror, the damp in the Kunstbunker had begun
to attack the paintings. Refused permission, personnel or trans-
port to move them, he faced the possibility of their decay. Having
survived the bombing, they were about to rot away in their crypt.

He takes Stern and Auden to his house. He lives on the fifth
floor, and warns them they might experience a sense of vertigo,
since the banisters of the staircase, and the entire wall on that
side, had disappeared. As they climb, like steeplejacks, there's
nothing between them and destruction, says Stern. They walk
along a narrow, open ledge and climb up a rickety ladder, where
they find a single room with a corrugated iron roof and, on a
single divan bed, a pale, haggard woman, all bones, whose age it
was impossible to assess.

My wife, says the historian.

Look out! Auden shouted, just in time, as Stern was about to
step out onto the balcony, where there was no balcony.

Instead, he looked down into a crater which had been convert-
ed into a garden of rocks and flowers.

We asked them if they minded being bombed, Auden said
later. We went to a city which lay in ruins and asked if it had been
hit. We got no answers that we didn't expect.

Dürer looks over Auden's shoulder to St Sebald's, his parish
church on the same square, surmounted by a pair of spiky green

spires. Deep inside its gloomy interior is a blackened brass struc-
ture, hovering like a gothic diving bell over a silver-gilt casket
containing the saint's bones.

According to the black-and-white leaflet *Das Grab des heiligen
Sebald zu Nürnberg* (five euros), which folds out like Maximilian's
arch, this huge shrine, made by Peter Vischer, is a rising ladder
of virtues. It rests on twelve snails with curly shells; sea monsters

poke out their tongues; bare-breasted sirens bear candles; and bearded apostles consider their remarks. There are lions and turtles and mice, and at the top, like a doll on the Christmas tree, the Christchild holds an orb, ready to throw to the bookbinder's dolphins. The entire crew might flap their wings and thrash their tails, raising the casket to the roof like a balloon let go from a little girl's hand.

This is, after all, a memorial to miracles. Sebald was the son of a Danish king who married a Parisian princess. On his wedding night he had a vision, not of his wife's comeliness, but of his spiritual unworthiness, so he went off to spend fifteen years in the forest, praying on the banks of the river. From there he preached to many people and accomplished many miracles, and when death drew near, he was taken on a cart pulled by oxen, led by St Peter to a chapel on the riverbank where Sebald would be buried. It was the site of the city to which he would became patron. When people tried to move his bones, they always returned to the

same place. So a great ship of a church was built around them, although even then, in tribute to the wandering saint, Sebald's casket was fitted with wheels so that on feast days he could be trundled round town, like an errant supermarket trolley. His skull was taken separately to meet the emperor, one great man talking to another. Dürer fell to his knees. Devoted to Sebald, he drew him again and again, as a statue come to life, holding his own church like a Christmas cake. He was the saint of protection against the cold. I ought to have sought his intercession in the river.

In the nineteen-nineties, Max Sebald, another wanderer, trudged up this hill, to pay his respects to his patron. In *The Rings of Saturn* he marvels at the saint's miracles: how he made broken glass whole again and floated across the Danube on his cloak, and how he saved princes Winnibald and Wunibald from starvation by turning ashes into a loaf of bread. The modern Sebald wrote up his notes in an hotel overlooking Vondel Park, describing his medieval counterpart as a harbinger of a time when the tears would be wiped from our eyes and there would be no more grief, or pain, or weeping and wailing. But I'm not sure he really thought that.

The faithful mass of metal in front of me might have sprouted from black crystals, glowing and fizzing. A new cathedral seeded within the old, like a greenhouse. In the watery light of the nave, I can just make out the plaques that mark the Sebalduswunder. A poor family warm their hands on a bundle of icicles, which the saint has caused to burn like firelighters. Sebald supplies new eyes for a blinded man, holding an eyeball in his hand, ready to screw it in like a lightbulb. A sinner throws his hands in the air as he sinks into the ground as if drowning, realising, almost too late, his errors, as he calls for the saint's aid. This entire edifice is a performance, a story. I clamber round it like a climbing frame.

Begun in May 1507, the shrine wasn't completed until 1519; its slow progress may have been due to its intricacy, or the fact that the sculptor was so badly paid. At any rate, it was too late.

History had already passed it by like a bus stop. In 1521 the city adopted the Reformation in a pragmatic way, in order to prevent any iconoclasm in its churches; the merchants of the Great Council, on which Dürer sat, were hardly likely to tolerate the destruction of the expensive stained glass, statues and paintings they had commissioned to ensure their immortality.

By the time Dürer died, they'd stopped carrying the saint's bones about. No one believed in those old relics any more. Masses for the dead went unsaid, the holy water ran dry and no one sang Salve, Regina, mater misericordia to the Virgin. Services were heard in German, not Latin. Faith hadn't dried up, it was just diverted. The city, always set apart, became a Protestant island in a Catholic sea.

Then came the bombs. In January 1945 the church suffered serious damage, but this ark, being immoveable, was covered in stone, its own air-raid shelter, and survived. Yes, the woman at the desk assures me, his bones are still inside. Perhaps this is where I need to worship, to fall on my knees.

As I leave, I notice a tiny frog at the base of the shrine, worn to a shine, revealing the bright brass beneath the black patina. No one seems to know why the faithful were drawn to this amphibian, although medieval frogs were seen as good people, and those who lived in the water particularly monk-like. Nor is it clear why the face of a female figure of justice, a broadsword in her hands, has been similarly polished over the centuries.

I rub the frog's nose. She gives a little croak.

This place is divided by the river. I ride over the bridge, back to the modern world beyond the walls. I'd forgotten about roads. The houses turn suburban. It's still raining. Beyond the freeway, everything changes again.

Rising over the trees is a granite semicircle, its arched windows stacked in tiers. I try to ride round it, but its curve throws

me out. Through the curtain of rain, I find an opening at the back. From behind it's all red brick, hurriedly rendered, mortar squeezing through the cracks. I decline to step into the ring. They demolished the zoo to build this circus. The animals were led away.

Pulling my hood tight, eyebrows dripping, I ride on. I'd rather be wetter out here. A causeway takes me across the lake; the water is the colour of lead. The coots and geese keep their heads down. On the other side is a thoroughfare as wide as a runway; anything could land here. It too is deserted.

Scaffolding frames are hung with scenes of a wild west town, a gantry stretches across the great street. There are broad kerbs where they stood to cheer. A futuristic approach put to the service of an antifuture, Mann said. I knew someone who met their leader. He said he wore a cheap leather coat and had greasy hair. Over there is the station where they led them away. They were filmed as they went.

As I turn a path in the woods, another structure rears up like a temple, looking into an arena I cannot see. A chain-link fence surrounds the site. I find a gate open. There is no one about. Everything is turned to face a broad stand at the far end. The sign that stood above was blown up just before Stern and Auden arrived, but it still hovers there. I spit at it, then say a prayer.

I cycle round the lake, but the rain is so intense I can't go on. I seek shelter in an empty beer garden. A fellow cyclist is waiting under the awning. He grins at me, making a wringing gesture with his hands. We stand there together, neither speaking the other's language. The rain falls, as if released from the sky.

Plastic boats bob in the water. They're shaped like white swans and pink flamingoes, giant bath toys. I feel suddenly lonely, as if I'd been here before.

After half an hour, with no end to the clouds sliding off the mountains, I cross over to the lake, undress behind a tree and get

in. The surface is pimpled with rain. I swim like a frog. The coots and geese paddle around me.

The water is warm. It isn't deep at all.

I almost didn't see him there, on the wall, with his tumbling, waterfall locks. So dark and brown. After the eyes, the hand. It's huge. Then the features of the face, eyes, nose and mouth; the pale brow; the white undershirt, the slashed sleeves, the fur inside of him. He's one big triangle: heart, hands, head.

He's his own monogram. The eye in the door, the hare at his breast. His fringe sticks up like he went mad with the scissors. You don't see that on the postcards.

In 1933, Marsden Hartley, Marianne's friend from Maine (in his sea-green suit, 35 bucks from Macy's), came down from his retreat in the Bavarian alps to see this painting. Mourning his friend Hart Crane, who had drowned himself the year before, Hartley was drawn by the charge of this picture, and what it meant.

Philip Hoare

It is all around the best portrait that has ever been done by anyone at any time, he wrote. Dürer seemed to have all that the eye can have, he saw things exactly as they were. Never have I seen such eyes in a painting, for they seem to roll from side to side as you look into them—most portraits are an image of the outside, but this one is flesh, bone and mind all in one. I would like to make a painting of a mountain, and have it have all that this portrait has.

A man like a mountain like nothing else in this place. The emperors stare. He's all the people who looked at him, from him to me, from then to now. A questionnaire on the salvation of the world. He died a long, long time ago.

Selbstbildnis im Pelzrock, 1500 | Plate VI |

'I, Albrecht Dürer of Nuremberg, portrayed myself in appropriate colours aged twenty-eight years'—each word of this inscription in Latin was carefully chosen. This self-portrait, probably the most unusual in the history of art due to its immediate frontality and meticulous execution, touches most viewers. Dürer based the style of this portrait on icons of Christ the Saviour, his hand raised in the sign of a blessing; the details, however, are highly individual. The direct gaze and the hand in the picture address seeing and the act of creating.

I ask someone to take my photo; Albert makes bunny ears over my head. Send me a picture of a bird, the children ask me, draw me a whale, they say. A group of students gathers in front of me. The guide explains the Renaissance in a sentence and says the artist went to Italy quite a lot. It looks very natural, very realistic, she says. (I didn't pay for this tour.)

People come and go. It's my birthday.

Down in the café, I eat lavender cake and drink rooibos tea (eight euros fifty cents). There's a young woman in a cloche hat, red lips and dark eyes. She looks familiar. She crosses one ankle

over the other, sips her coffee, eats her cake, then leaves. I rang
Marlene once, in Paris. She told me, the person you want to talk
to is not here. I take the train back and swim in the river in the
rain. No one stares.

The next day I return to the museum, just to make sure he's
still there (ninety-eight euros and seventy cents for the train). The
curator and I stand in front of the painting. Martin says the art-
ist's hand is held not in blessing but in offering, a sacred gift.
Dürer is looking at himself in the mirror by candlelight. The
light falls from his right. You can see how his fingers are brighter
nearer the flame.

I see him in his dark attic, working on himself. It all comes
down to this: the handsome man, the genius, the narcissist. The
almond eyes, the oiled curls, the fur gown. This fierce ambiguity.
Would I have liked him? Would he have cared?

The Latin caption shows off his intellect, Martin says. He's
a philosopher, making his mark in appropriate colours. This
picture never left his room, a secret thing to be discussed with
friends. I lean in to look and Martin tells me to step back or I'll
set off the alarm.

Philip Hoare

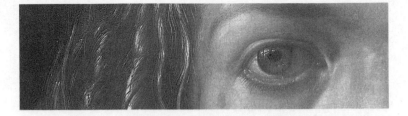

Each wolfish eye has been sliced through like a tear. The violence takes me aback. The first we hear of it, says Martin, is from an article published in 1904. He thinks the unknown assailant used a hair pin. She pulled it out of her picture hat, stared in Dürer's eyes and scored. Such love, such animus, such analysis, like a mad dog.

In the war they took him down to the bunker. The building received a direct hit, a deliberate act. They made the bombs, they had to use them. Afterwards, the pictures came back blinking into this room. Forty years later a man walked in and threw acid at them in an anti-blessing; you can still see the dribbles on the altarpiece. Stefan holds his dragon as a handbag, dragging it along. As we stand there admiring his red stockings, a piece of fluff escapes from my down jacket. It floats in mid-air for a moment, hovering between us and the art. Martin's hand shoots out to grab it,

like a chameleon's tongue. His charges are delicate, demanding, ever-changing. It is we who stand still. Dürer's portrait escaped that last attack because it was glazed, he says. It certainly would not have survived otherwise. We would have had to rely on the many copies made after his death, he says. Monarchs commissioned the picture they liked to imagine, repainted according to their wealth and taste. In one, the hare was added to the composition; others were proclaimed true imitations of Christ.

In a story written by Thomas Mann in 1902, a hooded figure stands before a painting in this city. It displays a sacred figure in a manner the onlooker finds offensive; he demands it be removed from view.

It attests to the blindness of the world, he says, his eyes aflame with a kind of mad ecstasy. He will not listen.

Beauty. What is beauty? he says. And he sees the pictures all piled up in a pyramid, consigned to the crackling flames.

Across the cobbled square from the church is a bookshop. I can't carry any more books. But I go in. Lying on a table is an old guide to the city, with Dürer's portrait on the cover. It looks like a fashion magazine. I flick through. Photographs show historic streets, sure and complete. Then they change to more modern scenes. The leader and his architect, holding the plans for the arena. There is the lake: people are drinking beer, cycling, swimming, waiting.

The woman wraps the booklet in plain paper (twelve euros). She only acquired it yesterday. She can't tell me why the artist is on the cover. Only later, when I get back home, do I realise that the portrait is a copy. A counterfeit. A fake.

That evening I take my place at a communal table in the restaurant named after him. A young family and their two young children sit opposite me, playing. The room is panelled and cosy. His prints line the walls. The owner's father appears at my side and asks if I'm the writer. Startled, I deny it. I don't know why.

He takes me on a tour of the building, pointing out the big black beam running floor to ceiling. It's dated 1559, he says. The staircase twists up through all four storeys like a shell winding round and round. At the top is a bright apartment. The walls are covered with pictures. A cabinet is filled with painted eggs. The Germans, says Jimmy Stern, are great collectors. A lemon-scented geranium climbs up the window.

This building was one of the few left standing, Josef tells me; the stone walls of the old houses are just veneers, centimetres thick, the rest is wood. That's why they burned so well. Like candles. He touches the toe of a statue of his patron saint. He's in remission. We wanted the bombs to find him here, he says.

Back downstairs I eat catfish and potatoes. The menu is always the same. Something and potatoes. I drink good German wine and wait for my apple doughnuts. I write in my notebook. It's my camera, my home.

The evenings are getting longer now. After my birthday dinner (twenty-one euros, fifty cents), I climb to the castle and look over the spires and cranes. The man next to me tells his friend how his grandfather was taken away. Down the hill, I look over to the artist's house from a high covered walkway, wondering which room was his, where his parrot flapped her wings and his monkey scampered about.

In the square, they've set up a stage in the shadow of the church. The crowd huddles under umbrellas. A young couple tell me what is happening. They're waiting, excited to hear the speakers. Everything is grey. A stall has leaflets with rainbows on them.

The rain keeps falling. It makes the stones shine.

GRACE

Back to the city of lights at dawn, I step off the quay and into the river. It's an outrageous act, without witnesses. The black water is no longer forbidding now I'm part of it, along with the weeds and the fishes and the poets down there.

Up in the apartment the books tumble out of the shelves. Adam tells me they sometimes do it of their own accord. Some of them belonged to de Beauvoir; Burroughs and Ginsberg slept in this bed. I read how Baudelaire took a room on the island, from where he looked down and saw his Haitian lover bathing in the river. Melville passes by in his green coat. My bike has been stolen (seven hundred euros), I walk to the gallery in the midday heat (ticket: seventeen euros). I push my way through the crowd, only to be held back at every turn. Each attendant professes ignorance or sends me in another direction. Their instructions get more specific; they seem to be urging me on. I bound up stairs, back out of dead-ends. Finally I reach the room.

He isn't there.

Philip Hoare

He's been taken away again. He's trying to tell you he doesn't want the game to end, says Michael, my friend.

That night we wander through the city, the four of us. The sky is dark blue. I'm wearing my new yellow shirt. We're sitting outside a restaurant; the tables tilt down the hill. Three of us have known each other most of our lives. A dog from the neighbouring table joins us, sitting up between me and Charlie as our guest. The night blurs in the haze. The dog addresses us. The young waiter is supercilious. He lays a raspberry tart before us. We proclaim it a work of art. He nods, imperceptibly. My wine glass falls over. Mark sees a monkey in the street. We return to the river and walk along it, into the night. The police patrol the burnt-out church, its towers cast a long lonely shadow.

People dance around us. The rats scamper in and out, and the water runs on.

It took me all this time to work it out. He was waiting for me, back home. I've been around the world, and here he was, up the road.

In the last summer before the war, Thomas Mann was taken on a tour of this museum. He saw all sorts of wonders, but never made it this far. But Marianne Moore did. At the top of the stairs, behind a false wall displaying a giant map of Venice, I find the secret door and ring the bell. It opens into a great long hall, silent and bright, lit by natural light from above. I sign the book, just as Marianne signed it, on 27 July 1911.

Waiting on a desk is an atlas-sized portfolio, stamped in gold, *Guard Book*. Ganda comes galloping out. I follow Dürer's hand, breathlessly, like a score. His words trail sepia ink from the sea. The lines ride the ridges of his back, slide down his stegosaurean side, snag on his stubby tusk, and come to a halt on his horn. A work of faith, endlessly reproduced, an apparition of splendour.

Partaking of the miraculous
since never known literally,
Dürer's rhinoceros

as Marianne Moore saw him, three thousand miles away.

Out of another folder comes our other performer. The walrus. Right there, in front of me. Watery fur, huge tusks, shiny like ivory chessmen; her squishy mouth with a surprising pink tinge. It's this flush that makes her lurch into life. I might feed her a fish. She's absolutely here and quite ghostly in the city light.

The most extraordinary thing is not that these things have survived. It is that they may survive the things that they represent.

An ox's muzzle, still wet; an elk's steady stance; a young hare, drawn from all sides. They all make their appearance in this bright room, these old friends. And last of all, a dog, sitting in his big brass collar, his face, those eyes, that brow. Waiting.

No one ever drew such beauty. No one was ever loved like this before.

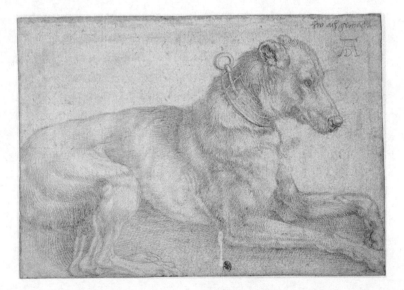

Philip Hoare

Back home, a few days later, by chance I meet my old teacher from primary school. She was the second most glamorous woman I knew, with her silvery blonde hair piled up in a candy-floss beehive and her smart nineteen-sixties clothes. Now elderly and infirm, eyes still bright, she hugs me like a long-lost son. It's like meeting my mother again, in the school hall.

I remember you well, she says, your mouth was always black from sucking the ink in your pen.

You were always sitting there, in the classroom, looking out of the window.

I look out of the window, waiting.

If what you have been reading savors of mythology, could
I make it up? and if I could, would I impose on you?

Marianne Moore, 1961

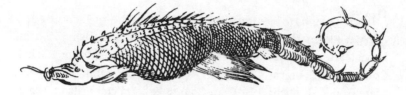

Albrecht Dürer, Book of Hours, 1515

Albert and the Whale

CREDITS

Editor: Nicholas Pearson. Project editor: Marigold Atkey. Copy editor: Tim Waller. Book design: Richard Marston. Cover design: Charles Brock. Photography: Andrew Sutton, Jeroen Hoekendijk. Publicity: Patrick Hargadon. Representation: Georgina Capel, with Rachel Conway and Irene Boldini. Editor, Pegasus Books: Jessica Case.

THANKS

Europe: Jeroen Hoekendijk; Ellen Gallagher; Edgar Clejine; Adam Low; Martin Rosenbaum; James Norton; Andrew Sutton; Rachel Collingwood; Angela Cockayne; Robert Fearn; Sarah Chapman; Clare Goddard; Michael Holden; Charlie Baker; Peter Wilson; Clara Fuquen; Sam Goonetillake; Nigel Larcombe-Williams; Neil Tennant; Michael Bracewell; Gareth Evans; George Shaw; Jeremy Millar; Volker Eichelmann; Katia Scholtz; Christian Goeschel; Laura Cumming; Olivia Laing; Tim Dee; Robert Macfarlane; Max Porter; Nicholas Redman; Iain Sinclair; Hugo Vickers; Marc Rees; Edward Parnell; James Dowthwaite; Ruth Wilson; Mary Hallett; Anna Eades; Woodrow Kernohan, Ros Carter, the John Hansard Gallery and the University of Southampton; Tobie Charlton, Bike Guy.

Dr Christof Metzger and The Albertina, Vienna; Dr Martin Kreuz and Andrássy, Akademie der bildenden Künste Wien, Universitatsbibliothek, Vienna; Dr Martin Schawe, Bayerische Staatsgemäldesammlungen and the Alte Pinakothek, Munich; Dr Thomas Schauerte and the Albrecht Dürer House, Nuremberg; Pastor Dr Petra Seegets, St. Sebald, Nuremberg; Dr Florike Egmond for her work on Conrad Gesner; Dr Klaas van der Hoek, Curator of Manuscripts and Modern Literature, Allard Pierson, University of Amsterdam; Dr Katrin Keller and the Thomas-Mann-Archiv, Zurich; Alexandra Urruty-Vaquero, Musée Bonnat-Helleu, Bayonne; Neil Evans, National Gallery, London; Liam Browne, Arts Over Borders; Heather White and Project Oscar

Wilde, Enniskillen; Rob Deaville, Matt Perkins, Cetacean Strandings Investigation, Zoological Society of London; Jan Beiboer; Annemarie van den Berg, SOS Dolfijn, Netherlands; Adrie and Ineke Vonk, Vonk Whale and Whaling Collection, Texel; the late Serge Viallelle, João Quaresma, Espaço Talassa, the Azores.

North America: John Waters; Mary Martin; Dennis Minsky and Dory; John Gullett; James Balla; Albert Merola; Duane Slick, Martin Smick, Andrew Raftery, Hawk McNabb and the Rhode Island School of Design; Skott Daltonic; David Neiwert; James Russell, Nantucket Historical Association; Christine Colnett Brophy, Mark Procknik, Sara Rose and the New Bedford Whaling Museum; David Lowe, Print Collections, New York Public Library; Professor Edward Mendelson, Literary Executor of the W.H. Auden Estate, Columbia University, New York; Jobi Zink, Cathleen Chandler and Elizabeth E. Fuller and the Marianne Moore Collection, Rosenbach Museum, Philadelphia; Prof Linda Leavell; Prof Stephen Brockmann; Dr Elizabeth Garner.

Atlantic, Indian & Pacific Oceans: Stormy Mayo and the Provincetown Center for Coastal Studies; Dolphin Whalewatch, Provincetown; Ranil P. Nanayakkara, Manura Fonseka, Joseph Warnakulasooriya and Little Adventures, Sri Lanka; Rachael King, Word Christchurch and Kaikoura Whale Watch, New Zealand.

Home: My sisters Christina and Katherine; my brothers Lawrence and Stephen; Oliver, Harriet, Jacob, Lydia and Max; Mark Ashurst, Lilian and Freddie; Tangle; and Cyrus Larcombe-Moore, for introducing me to Marianne Moore.

In memory of Pat de Groot, 1930–2017

And in honour of Albert's expedition, 500 years ago.

Philip Hoare, Southampton, December 2020

SOURCES

Please go to www.4thestate.co.uk/albert&thewhalesources/ and www.philiphoare.co.uk for source notes and image details.

IMAGES

3, 4, 5, 34, 41, 53, 61, 93, 96, 101, 103, 104, 108, 115, 119, 131, 143, 189, 190, 278, Metropolitan Museum of Art, New York; 30 top, Marc Rees; 30 bottom, Musée Bonnat-Helleu, Bayonne; 14, Rijksmuseum; 27, 238-242, New Bedford Whaling Museum; 23, 229, Walter L. Strauss, *The Complete Drawings of Albrecht Dürer*, Abaris, 1974; 36, 123, 263, 265, Alamy; 41, 194, *The Roman Alphabet of Albrecht Dürer*, 1538, translated by Guy Coates, London College of Printing, 1969; 51, Kunsthistoriches Museum, Vienna; 70, Fitzwilliam Museum, Cambridge; 77, 245, Jeroen Hoekendijk; 80, Martin Rosenbaum; 82, 163, Getty Images; 98, Clark Art Institute; 106, 291, British Museum; 107, Rockwell Kent, *Moby-Dick*, Random House, 1930; 109, BPK Bildagentur; 118, 205, 242 bottom, 293, Wellcome Institute; 129, 140, 159, Thomas-Mann-Archiv, Zurich; 145, 155, 230, Wilhelm Waetzoldt, *Albrecht Dürer*, Phaidon Verlag, 1936; 150, Wikimedia Commons; 168, George Platt Lynes, Library of Congress; 169, *The Selected Letters of Marianne Moore*, Faber, 1998; 180, W. H. Auden and Louis MacNeice, *Letters from Iceland*, Faber, 1937; 184, George Platt Lynes, *A Marianne Moore Reader*, Viking, 1961; 218, Maurithuis, The Hague; 227, Masayoshi Sukita, Getty Images; 236, William Martin Conway, *Literary Remains of Albrecht Dürer*, Cambridge University Press, 1889; 246-248, Allard Pierson, University of Amsterdam, Ms.III C 22 and 23; 249, 250, Andrew Sutton, ECO 2; 253, courtesy Academy of Fine Arts Vienna, Library; 257, 258, 259, 260, Albertina Museum, Vienna; 264, 266, Museo del Prado, Madrid; 271, Stephen Spender, *W. H. Auden: A Tribute*, Weidenfeld & Nicolson, 1975; 282, 285, Alte Pinakothek, Munich.

Plate section: I A & B, British Museum, London; II A & B, III A & B, Albertina, Vienna/Alamy; IV, The Louvre, Paris; V, Prado, Madrid; VI, Alte Pinakothek, Munich/BPK; VII, National Gallery, London; VIII A, Uffizi, Florence/Alamy; b, Gemäldegalerie, Berlin/Alamy; C, Prado/Alamy

All other images from the author's own or private collections. While every effort has been made to trace holders of copyright material, in some cases this has proved impossible. The publishers would be grateful for any information that would allow any omissions to be rectified in future editions of this book.